For our grandparents

Francis Griffith Hufford and Shirley Lamson Hufford
Francis Xavier Strong and Edith Mellon Strong

Ira Augustus Hunt and Marjorie Williams Hunt
Pasquale Peronace and Margaret Bieble Dobbins

Samuel Zeitlin and Minnie Zeitlin
Harry Stein and Bella Brodsky Stein

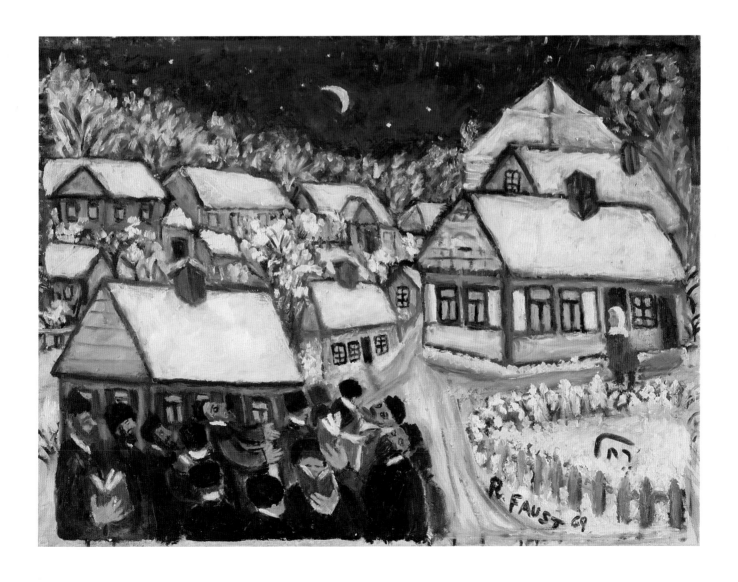

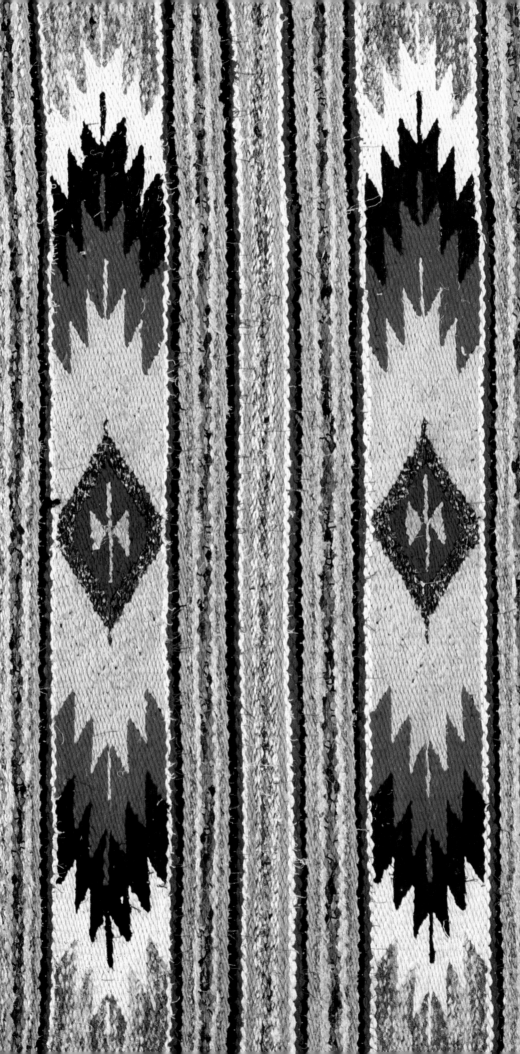

The Grand Generation:
Memory, Mastery, Legacy

Mary Hufford

Marjorie Hunt

Steven Zeitlin

Introduction by Barbara Kirshenblatt-Gimblett

Smithsonian Institution Traveling Exhibition Service
and Office of Folklife Programs
Washington, D.C.

In association with
University of Washington Press
Seattle and London

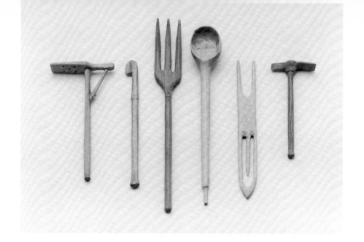

The exhibition, The Grand Generation: Memory, Mastery, Legacy, *was made possible by the support of the Administration on Aging, Department of Health and Human Services; the National Institute on Aging, National Institutes of Health; the May Department Stores Company; and the American Association of Retired Persons. The exhibition was organized by the Office of Folklife Programs, Smithsonian Institution, and the Smithsonian Institution Traveling Exhibition Service.*

Library of Congress Cataloging-in-Publication Data
Hufford, Mary, 1952–
 The grand generation.

 Bibliography: p.
 1. Aged as artists—United States—Exhibitions.
2. Folk art—United States—Exhibitions.
I. Hunt, Marjorie, 1954– . II. Zeitlin, Steven J. III. Smithsonian Institution. Traveling Exhibition Service. IV. Title.
NK805.H84 1987 745'.0880565 87-28532
ISBN 0-295-96610-6
ISBN 0-295-96611-4 (pbk.)

Manufactured in the United States of America

Distributed by University of Washington Press
P.O. Box 50096, Seattle, Washington 98145-5096

Cover: "Tumbling Blocks" friendship quilt, cat. 38.
Dedication page: *Blessing the New Moon in the Wintertime,* cat. 10.
Frontispiece: Rag rug, cat. 21.
Back cover: Basket weaver Ellen Jumbo with grandson, photograph by Ulli Steltzer, from *Indian Artists at Work.*

Prepared by the Smithsonian Institution Traveling Exhibition Service
Andrea Price Stevens, Publications Director

Edited by David Andrews, SITES

Designed by Polly Sexton, Washington, D.C.

Studio Photography by Smithsonian Office of Photographic Services:
Joe Goulait, Eric Long, Mary Ellen McCaffrey, Laurie Minor, Dane Penland, Jeff Tinsley, and Rick Vargas

Above: Jackstraws made by Appalachian cooper Alex Stewart, Hancock County, Tennessee, ca. 1970 (cat. 44).

Contents

Once a young man asked me,
'What was it like in your
day?' 'My day?' I said, 'This
is my day!'
Rosina Tucker, *age 104*

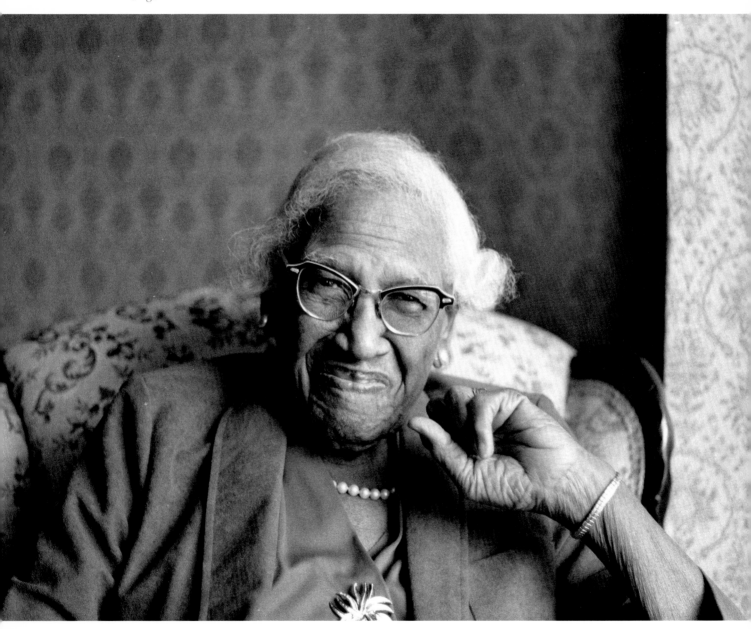

Rosina Tucker, civil rights
activist, Washington, D.C.,
1982.
Photograph by Paul Wagner.

Foreword

The Office of Folklife Programs and the Smithsonian Institution Traveling Exhibition Service are pleased to collaborate in bringing *The Grand Generation: Memory, Mastery, Legacy* to communities across our nation. This seminal exhibition evokes the culture and creativity of older Americans and advances our understanding of these elders, who comprise our society's premier cohort of tradition bearers. Through the objects, images, and words of the exhibition, we explore the beauty and meaning of these mature talents.

We are gratified whenever the fruits of intense research and planning for finite and sometimes evanescent Smithsonian engagements can extend beyond the bounds of the National Mall. The roots of this project run deep: over the past several years, Marjorie Hunt, Mary Hufford, and Steven Zeitlin have provided the principal expertise and enthusiasm for the Office of Folklife Programs' involvement with folklife and aging, from an oral traditions project for the 1981 White House Conference on Aging to a living museum presentation, entitled "The Grand Generation," at the 1984 Festival of American Folklife. Marjorie Hunt, who served as the project director and curator, skillfully rose to the challenge of combining her administrative and research talents to develop this exhibition.

For their support and encouragement toward bringing the accomplishments of our elders to the attention of a national audience, we express our gratitude to the sponsors of this project: the Administration on Aging, Department of Health and Human Services; the National Institute on Aging, National Institutes of Health; the May Department Stores Company; the American Association of Retired Persons; the Educational Outreach Fund, Smithsonian Institution; and the Women's Committee of the Smithsonian Associates.

Peter Seitel
Director, Office of Folklife Programs

Eileen Rose
Acting Director, SITES

Acknowledgements

If books could have grandmothers, *The Grand Generation* would be a direct descendant of two pioneering thinkers in the realm of folklore, culture, and aging. As models and advisors, Barbara Kirshenblatt-Gimblett and the late Barbara Myerhoff inspired our research at every turn, shedding new light on old traditions and helping us to see the interplay of life cycle, narrative, community, and the creativity of elders. Their critical spirit of inquiry and infectious enthusiasm for the topic have richly infused and sustained our work since we began it together in 1981.

This project also had many aunts and uncles who generously offered their ideas and support. For their insights, discoveries, and thoughtful analyses we are indebted to Jane Beck, C. Kurt Dewhurst, Elaine Eff, Suzi Jones, Marsha MacDowell, Steve Ohrn, Leslie Prosterman, and Margaret Yocom. We would also like to express our sincere gratitude to Roger Abrahams, whose insightful comments and suggestions helped to shape our perspective.

The multicultural sampling of artists, artifacts, stories, and photographs presented here draws upon the excellent fieldwork and scholarship of folklorists across the nation. We owe a great debt to Michael Alpert, Barbara Babcock, Bob Bethke, Toby Blum-Dopkin, Carole Boughter, Simon Bronner, Kim Burdick, Charlie Camp, Hal Cannon, Varick Chittenden, Elizabeth Dear, Susan Dyal, Bill Ferris, Doris Francis-Erhard, Henry Glassie, Kenneth S. Goldstein, Bess Lomax Hawes, Alan Jabbour, Geraldine Johnson, Jack Kugelmass, Maxine Miska, John Moe, Rita Moonsammy, Joanne Mulcahy, Kathy Mundell, Sally Peterson, I. Sheldon Posen, Ralph Rinzler, Jack Santino, Joseph Sciorra, Elly Shodell, Steve Siporin, Robert Teske, and John Vlach.

Like the links of a whittled chain, the exhibition and catalogue are connected to previous projects. *The Grand Generation* benefitted greatly from the many individuals who helped with the "Tools for the Harvest" program at the 1981 White House Conference on Aging and the "Grand Generation: Folklore and Aging" program at the 1984 Festival of American Folklife. We owe special thanks to Beverly Brannon, Kathy Condon, Amanda Dargan, Gary Floyd, Gretchen Frick, Susan Kalčik, Cheryl Brauner LaBerge, Marsha Maguire, Martha Oyler, Gregory Sharrow, Paul Wagner, and Amy Kotkin Warner. Ann Dancy, as festival program assistant for the "Grand Generation," brought her cheerful energy and enthusiasm to every phase of the project.

The Grand Generation was developed by the Smithsonian Institution's Office of Folklife Programs as part of its ongoing efforts to preserve and present the rich diversity of traditional culture in the United States. Our deepest appreciation goes to its director, Peter Seitel, and deputy director, Richard

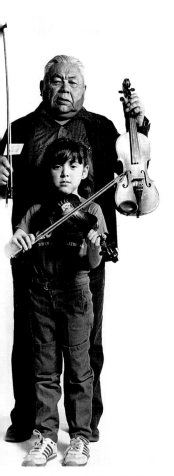

Athabascan Indian fiddlers Kilburn George, age 76, and Katrina Frank, age 6, Alaska. Photograph by Rob Stapleton, courtesy of the Institute of Alaska Native Arts.

Kurin, whose critical thought and continued encouragement have been invaluable. We are especially grateful to Jewell Dulaney and Barbara Strickland for their expert administering of the project in all its incarnations; Pete Magoon for his great help in processing and archiving photographs; Arlene Liebenau for her assistance with fundraising; and Alicia Gonzalez and Phyllis May-Machunda for their friendship and collegial support.

We are also grateful to our colleagues within other Smithsonian bureaus who so generously lent their scholarly expertise and ideas to *The Grand Generation* and who helped us in locating artifacts. For this we offer warm thanks to Richard Ahlborn, Rayna Green, Rodris Roth, Elizabeth Sharpe, Elliot Sivowitch, and Lonn Taylor of the National Museum of American History; Ralph Rinzler and Jeffrey LaRiche of the Office of the Assistant Secretary for Public Service; Lynda Hartigan of the National Museum of American Art; and Michael Monroe of the Renwick Gallery. In addition, we would like to acknowledge Laurence Hoffman of the Hirshhorn Museum and Sculpture Garden for his expert advice on the preparation of artifacts for tour.

For their assistance in securing loans from collectors and museums we are indebted to Caroline de Mauriac of the Con Foster Museum in Traverse City, Michigan; Reed Cherington of the Orleans County Historical Society, Old Stone House Museum in Orleans, Vermont; Myles Libhart of the U.S. Department of the Interior, Indian Arts and Crafts Board; Thelma Pettegrew of the Chetco Valley Historical Society Museum in Harbor, Oregon; Lynn Adkins and Marsha Bol of the Museum of International Folk Art in Santa Fe; Selma Shapiro of the Children's Museum of Oak Ridge in Oak Ridge, Tennessee; Viola Sparagna of the Tabernacle Historical Society in Tabernacle, New Jersey; Bill Henry of Oak Ridge, Tennessee; and Sandra Miller of Bend, Oregon.

The Grand Generation benefitted from the generous help of a number of agencies. We would especially like to acknowledge Alan Jabbour and Carl Fleischhauer of the American Folklife Center, Library of Congress, for sharing their ideas and suggestions for photo illustrations; City Lore: The New York Center for Urban Folk Culture, for assisting with logistical support, and, in particular, its photographer Martha Cooper, for providing photographic materials; and Bess Lomax Hawes, Barry Bergey, and Dan Sheehy of the National Endowment for the Arts Folk Arts Program, for directing us to key programs, researchers, and elderly artists throughout the country.

For their enthusiastic support and commitment to the project we would like to thank Dr. T. Franklin Williams, director, the National Institute on Aging; Carol Fraser Fisk, commissioner, the United States Administration on Aging; Cyril Brickfield, executive director, and Horace Deets, director of the executive staff office, the American Association of Retired Persons; James Abrams, vice president, the May Company Department Stores; and Jack Ossofsky, president, the National Council on the Aging. We also wish to give special thanks to Clarissa Wittenberg, public information specialist at the National Institutes of Health; Dr. Barbara Fallon, project director at the Administration on Aging; Jane Shure, information officer at the National Institute on Aging; and Annette Buchanan, program specialist at the American Association of Retired Persons. They believed in *The Grand Generation* from the very start and worked hard and effectively to see it realized.

The Grand Generation could not have happened without the expertise of SITES staff who performed myriad tasks from generating educational programs to developing this publication. We would especially like to thank Gail Kaplan, the exhibition coordinator for *The Grand Generation*, whose careful and efficient attention to innumerable details kept the exhibition on track.

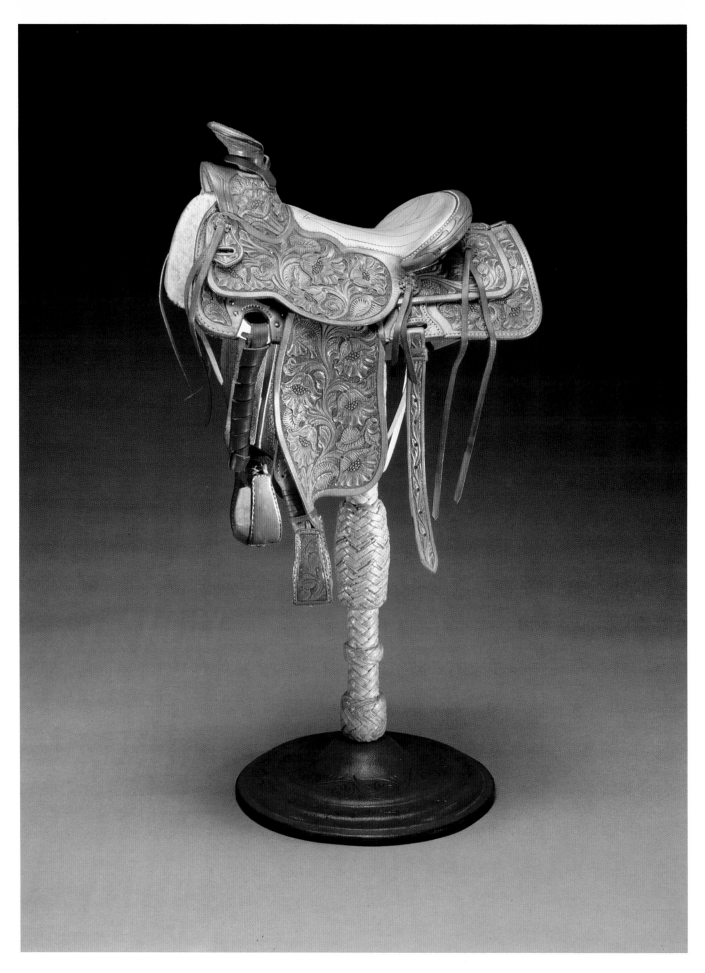

Special thanks are in order to the SITES registrars who administered loans of artifacts from 43 lenders across the country and who worked to ensure their safety on tour.

We are particularly grateful to Frederica Adelman, Rachel Bernhardt, Carol Harsh, Laurie May, Vicki Possoff, Myriam Springuel, and Fredric P. Williams for their valuable contributions to the project.

This book could not have been realized without the commitment and expertise of three key people. Our warmest thanks go to Andrea Stevens for supervising the publication of *The Grand Generation;* David Andrews for his skillful editing; and Polly Sexton for her imaginative and beautiful design.

For their superb images of the objects from the exhibition, we owe a debt of gratitude to the staff at the Smithsonian's Office of Photographic Services: Joe Goulait, Eric Long, Mary Ellen McCaffrey, Laurie Minor, Dane Penland, Jeff Tinsley, and Rick Vargas.

Our colleagues at the Smithsonian's Office of Exhibits Central provided their fine skills in producing the exhibition. We wish to extend our sincere gratitude to Ken Young for his creativity and understanding in designing *The Grand Generation* and to Diana Cohen for her careful editing of the script. Special thanks go to Karen Forte, Walter Sorrell, Ken Clevinger, and the staffs of the model and fabrication shops who lent their technical skills to preparing the artifacts for exhibit.

To Allen Carroll, Amanda Dargan, and Steven Oaks, who tested many of our thoughts before they were ready for public consumption and who washed a lot of dishes without complaining, we express our deepest gratitude.

Most of all, we are grateful to the folk artists and lenders for so generously sharing with us their knowledge and their art. We hope this book and exhibition will be a meeting ground on which viewers and readers may encounter not only objects of enduring beauty and worth, but the persons, communities, and lives in which they are rooted.

Mary Hufford
Marjorie Hunt
Steven Zeitlin

Miniature saddle made by Duff Severe, a saddlemaker and rawhide braider from Pendleton, Oregon (cat. 34).

Introduction

Barbara Kirshenblatt-Gimblett
Department of Performance Studies
Tisch School of the Arts, New York University

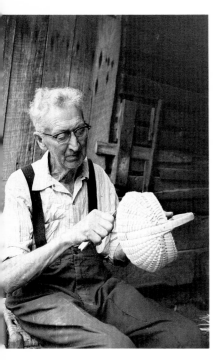

Jesse Jones, an 80-year-old master craftsman and farmer from Clinchport, Virginia, has been making baskets ever since he was "big enough to pull a split."
Photograph by Kenneth Murray, 1982.

The field of folklore has been built from the memories of the elderly. Folklorists, as experts in inscribing old folkways on the threshold of their disappearance, have long collaborated with the "grand generation" to fix in writing—and more recently on tape and film—traditions that would have been forgotten with the passing of their bearers. And for centuries, classic collections of ballads and folktales, proverbs and riddles, and games and customs have been harvested from individuals who have lived long and remembered much.

Even when younger performers were the actual source of the information, famous collectors often assumed that a venerable narrator would make the tales seem more authentic. The Brothers Grimm created the illusion that their star storyteller was a mature peasant woman, when in fact the Grimms had collected most of the stories from their own middle-class literate friends and family.[1]

As folklorists shifted their attention from cultural relics of the past to the process of creating tradition, they came to realize that the elderly are more than custodians of heritage. They are people in their own right, active in the present, and experts on what this period in the life cycle is all about. To focus on the elderly *in the present* is to discover their creative cultural responses to advancing years, with all of their challenges, and to rethink our basic assumptions about the nature of memory, tradition, and old age.

What are some of those assumptions? Reflecting on the infirmities that come with aging, Eliza Dargan of Darlington, South Carolina, as she reached her 70s, said: "If this is old age, I don't want any part of it." Though we would all like to live a long time, no one looks forward to the physical decline and social stigma of growing old. It is ironic that, in our time, the one thing admired about the elderly is their youth. As Moishe Sacks, a Bronx baker in his 70s, mused, "The business of the old is to be young." Although vigor is certainly to be admired, folklorists have long appreciated what older adults have to offer—not in spite of, but because of, their age. As Bess Hawes remarks, "So much of the gerontological literature . . . basically treats the elderly as a problem. . . . In folk arts, the elderly are, generally speaking, thought of as the solution. . . ."[2]

Similarly, we tend to assume that the elderly, having accumulated so much experience and wisdom over many years, are more connected to the past than the present. Rosina Tucker, a 104-year-old civil rights activist, is fond of telling about the time a young man asked her what the world was like in her day, to which she replied: "My day? This *is* my day!" The elderly are thus poised precariously between the stigma of infirmity and the romanticized image of wisdom, serenity, and eternal youth.[3]

The elderly also suffer from conflicting views on reminiscence. Is the inner experience of reviewing one's life in old age an aspect of the pathology of

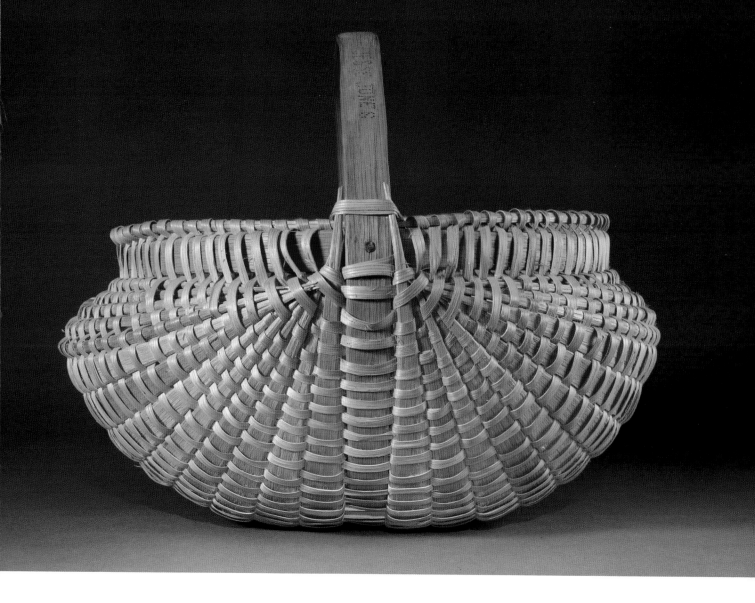

Split-oak basket made by Jesse Jones, Clinchport, Virginia, ca. 1980 (cat. 19).

advanced years or a therapeutic and culturally important part of aging? New directions in social gerontology, and particularly the pioneering work of Robert Butler,[4] now place as much emphasis on the constructive and adaptive dimensions of reminiscence as on the pathological aspect so often emphasized in the psychological literature. Building on this work, folklorists stress not only the value of reminiscence, but also the variety of forms that it can take, from vivid stories to memory paintings.[5]

Most ethnographic studies of the elderly in the United States and Europe have dealt with institutions and residential communities specially designed for older people, although the vast majority continue to live at home. To redress the balance, *The Grand Generation* has focussed on elderly individuals living at home and their relation to their families and local communities. Inspired by the late Barbara Myerhoff, whose book *Number Our Days* pays tribute to the resilience of the members of a senior center in Venice, California, the present project documents the resourcefulness of the elderly in coping with advancing age. There is much to be learned from their homegrown solutions.

This pioneering exhibition opens by looking at old age in relation to the entire life cycle. This perspective brings into focus not only the special circumstances and challenges of the last stages of life, but also the variety of cultural responses to them. We see how the elderly revive folk traditions

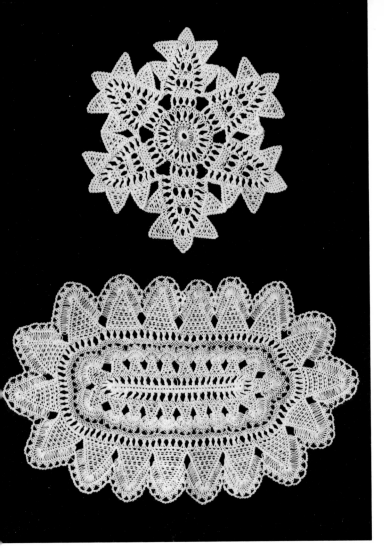

Needlelace doilies made by 71-year-old Genevieve Nahra Mougin, a Lebanese-American lacemaker from Bettendorf, Iowa. Mrs. Mougin carries on the tradition of lacemaking that she learned from her mother more than 60 years ago. Woven into her lacework are the threads of her Lebanese heritage, a legacy for future generations (cats. 26, 27).

I like to give lace to my family. It's our heritage.
Genevieve Mougin

Genevieve Nahra Mougin, Bettendorf, Iowa, 1984. Photograph by Steven Ohrn.

they had put aside during their busy middle years, whether singing or fiddling, and how they create such new forms in their later years as memory quilts and jokes about forgetfulness.

From the vantage point of the last stages of the life cycle, the exhibition then turns to the three themes of memory, mastery, and legacy. Prodigious memory applied to a long life is precisely what has always attracted folklorists to the elderly, but only recently have we appreciated the importance of reminscence in the aging process itself. And only now are we attending to the variety of forms that remembering can take. A lifetime of stories may be captured in the pieces of a quilt, a collection of recipes, a repertoire of songs or fiddle tunes, a carved cane, mementos on a mantlepiece, miniature recreations of old tools, and most commonly, in the sharing of experience through language. The successful integrating of a long lifetime of experience requires both a medium and witnesses. The individuals featured in this exhibition are masters at creating objects through which they can tell their story.

They are masters in other ways as well. Nothing less than a lifetime, often linked to several generations of preceding lifetimes, is necessary to refine the art of building a Barnegat Bay sneakbox, crafting a western saddle, weaving a Hispanic rug, making a split-oak basket, throwing voices for Sicilian marionettes, or baking Mamoo's famed "soggy coconut" cake. Such

masters are consummate exponents of their tradition: the refinement of technique, the economy and assurance of gesture, and the deepening of meaning are lifetime projects that often yield their finest harvests late in life.

The mastery that requires a lifetime is also a legacy for generations to come. More than mere skill is passed along, for such mastery is suffused with biography, with the art of life itself. To be deprived of the chance to pass the legacy on is one of the most painful experiences of old age. This exhibition explores both the crisis of legacy without beneficiary and how individuals mend breaks in the chain of transmission.

Though the many individuals represented in the exhibition are exemplary, they are not necessarily exceptional. Rather, we have failed in the past to recognize the exemplary in those around us. Ironically, folklorists have typically studied precisely the kinds of subjects immortalized by the elderly in their memory projects—folkways of a bygone era—but have had difficulty assimilating the memory objects themselves. Strictly speaking, these artifacts fail to meet the criteria of traditionality associated with folk art. They are too "personal." Ethel Mohamed of Belzoni, Mississippi, did not learn to stitch her memory pictures from her mother. Vincenzo Ancona, a Sicilian immigrant, did not learn to weave telephone wire scenes of his homeland from his father. They, and others like them, proudly take credit for their personal discovery of a medium and form for recasting their lives. They have forged distinctly individual solutions to common needs: in the process they affirm the creative potential in the expressive culture of the elderly and the centrality of life review to this period in the life course. From such indigenous modes of life review, folklorists have much to learn about the social construction of the self through time and the transformation of experience through material readily at hand. Such insights have the potential to reshape the boundaries of our discipline.[6]

The three authors of this catalog, Mary Hufford, Marjorie Hunt, and Steven Zeitlin, have a fine feeling for people and their artfulness. Thanks to them we can now see more clearly what we have overlooked among the older people in our own lives. Through their efforts, we become part of the chain of transmission, linked, even at a distance, to those whose words and works are on display. If we can measure the significance of an exhibition by the extent to which it changes how we see the world, *The Grand Generation* is an exhibition of the first importance.

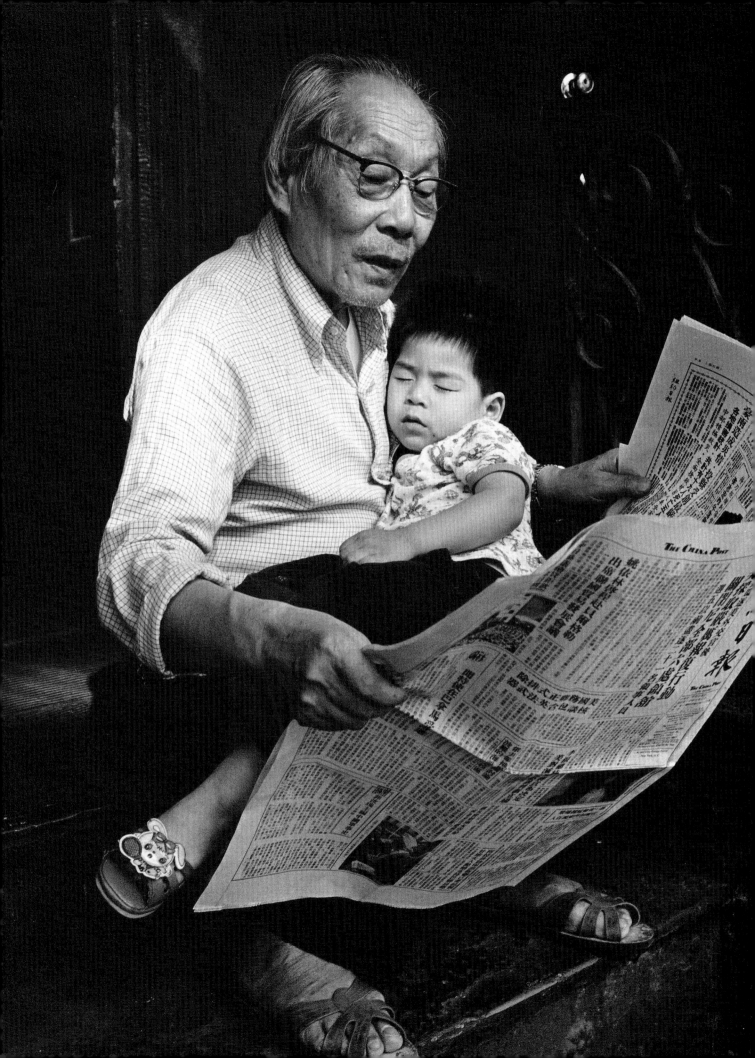

Traditional Culture and the Stages of Life

To mature we all have to "die" from a previous state; to enter an unknown state full of ordeal, growth, chance, and choice; and to be reborn finally as a person in control of our lives at a more challenging level.
Victor Turner, *Celebration*

We think of growing up as something that happens in stages. In the United States, the conventional stages of the human life cycle include infancy, childhood, adolescence, young adulthood, middle age, and old age. Some of our most elaborate rituals were devised to get us out of one stage and into another. With christenings, bar mitzvahs, commencements, weddings, retirement banquets, and funerals we symbolically cross the thresholds between the stages of life.[1]

The life cycle is a basic biological resource out of and around which we create culture. We see our lives unfold over the course of decades into a series of roles and responsibilities. Our culture is also a resource that gets us through the series: elaborating on discontinuities, transforming the raw stuff of the life course into an ensemble of discernible stages.

Over a lifetime, individuals create and share different kinds of traditional expressions. In each stage of life we respond to certain developmental tasks and shared cultural experiences. Framed by rites and customs of passage and characterized by particular genres of folklore, each stage brings specific developmental tasks that provide the basis for the creation of shared culture.

In this book our discussion focuses on members of the generation born in the first quarter of this century. They comprise today's "grand generation." They were affected by the same broad historic events like the world wars, the Great Depression, and the major advances in technology that they all witnessed as the 20th century progressed. Within their own communities, where their perspectives were also shaped by their shared geographic, ethnic, religious, cultural, and economic backgrounds, they experienced and interpreted national and world affairs. The biographies of Vincenzo Ancona, a 75-year-old Sicilian-American immigrant, Robert Burghardt, a 61-year-old teacher from New York City, Ethel Mohamed, an 80-year-old storekeeper in Belzoni, Mississippi, Janie Hunter, a 68-year-old black spiritual singer and storyteller from Johns Island, South Carolina, and Agueda Martínez, a 90-year-old Hispanic rancher and weaver from Medanales, New Mexico, have all been shaped in different cultural settings. Biologically speaking, however, the experience of aging unites them all.

Chinese-American elder with grandson, Chinatown, New York, 1982.
Photograph by Robert Glick, New York Chinatown History Project.

Milestones
We comment on the life cycle in our folklore—in our songs, stories, proverbs, and riddles. Children at the playground build ideas and insights

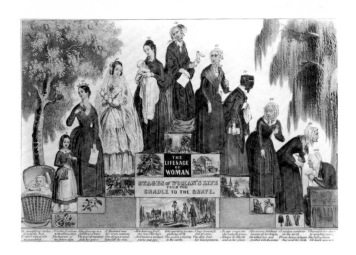

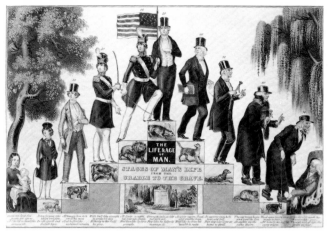

about the life cycle into their games and rhymes. They sing, "When I was a baby, a baby, a baby / When I was a baby, this is what I did." The verses of this song span the life cycle to grandmotherhood and death. One is reminded of the nursery rhyme about Solomon Grundy, "Born on a Monday / Christened on Tuesday / Married on Wednesday," and dying as early as Sunday, with a simple postscript: "This is the end of Solomon Grundy."[2] In proverbs, the expressive province of adults, we find more succinct comments on the stages of life: "If a man is 20 and not a revolutionary, he has no heart. If he is 40 and is a revolutionary, he has no mind."

Ways of thinking about and dividing up the life cycle vary over eras and across cultures. In some communities old age begins at 50, in others at 80. Philippe Ariès, in *Centuries of Childhood*, suggests that childhood historically has not always been regarded as a separate stage of life. In the Middle Ages, children were viewed as miniature adults who dressed and acted like smaller versions of their parents.

Adolescence and middle age are also relatively modern phenomenon. Ariès notes that the term "adolescence" did not exist until the 18th century. Only with the emergence of an extended educational system was this phase distinguished from adulthood.[3] Historian Tamara Hareven observes that in the United States, these stages of life were recognized gradually over the last century. American society, she writes,

. . . "discovered" childhood in the first half of the 19th century and "invented" adolescence toward the end of it, both emerging into public consciousness as a result of social crises associated with those age groups in a manner similar to the emergence of old age later on. However, despite the growing awareness of childhood, adolescence, and youth as pre-adult stages, no clear boundaries for adulthood in America emerged until much later, when interest in the "middle years" as a distinct segment of adult life arose out of the need to differentiate the social and psychological problems of "middle" from "old" age.[4]

The threshold between middle age and old age, however, is by no means clearly demarcated. Gerontologists are just beginning to explore yet another emerging division in the life cycle between the young-old and the old-old.[5]

Popular iconography divides the life cycle into differing numbers of stages. One common analogy compares the life cycle to the four seasons, with youth emerging and blooming in the spring, maturing through the summer, mellowing through the fall, and facing the vicissitudes of age in the winter. More abstract graphics depict life as a series of steps, ascending and descending through as few as 3 and as many as 10 stages. What we notice in both popular images is that old age is cast in a negative light, and in the ris-

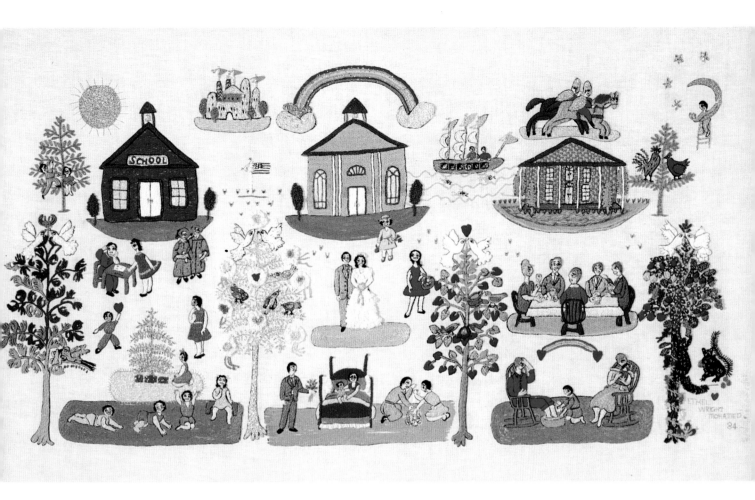

Three Stages of Life, *by Ethel Mohamed, Belzoni, Mississippi, 1984. Mrs. Mohamed embroidered this life cycle tableau depicting childhood, parenthood, and old age when she was 77 years old (cat. 22).*

ing and falling image we see the elderly person placed on a par with children—a parallel Shakespeare drew in *As You Like It* with his famed seven ages of man: "Last scene of all / That ends this strange eventful history / Is second childishness and mere oblivion / Sans teeth, sans eyes, sans taste, sans everything."[6] However, as the artists presented here illustrate, the rich and varied interplay in the cultures of childhood and old age—the imaginative recycling of childhood memories into a mature vision of life and the special teaching and learning relationship between young and old—is far more subtle and complex than Shakespeare's cynical stereotype implies.

We also think of life as a journey, a comparison that yields readily to the notion of the past as a place to explore and the future as a frontier sketchily staked out with ritual landmarks that psychologists call "milestones"— events "that stand out in a person's memory or future plans as a significant, age-related turning point. . . ."[7] Some milestones may be associated with physiological changes, like puberty, parenthood, and menopause, while others, like entry into school at age 6, voting at age 18, and retiring at age 65, are socially determined. The notion of the milestone contains within it the idea of gradual progress toward a goal. The milestones are Janus-faced, however, involving some looking back as well as looking forward.

Rites of passage are grounded in the life cycle, and bring together family and community members bound by their sense of a common history, identity, and destiny. It is in such settings that the interrelations of traditional culture and the life cycle may be expressed in heightened ways, as people learn or review their shared history, mythology, stories, and customs. Thus ways of getting through the life cycle become tightly intertwined with our notions of who we are.

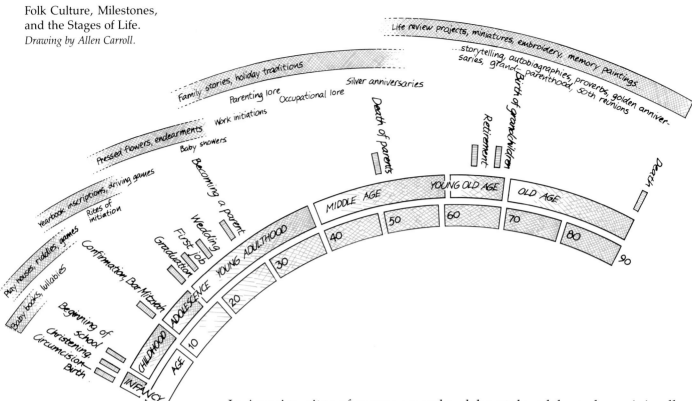

Folk Culture, Milestones,
and the Stages of Life.
Drawing by Allen Carroll.

In America, rites of passage may be elaborately celebrated or minimally observed. We may simply symbolize the transition from one stage of life to the next by shifting a tassel from one side of a cap to another, or blowing out the candles on a cake. Yet, so important are these ways of observing life's discontinuities that in the absence of formal rites of passage, people may invent them. Divorce and broken romance, while not thought of as conventional rites of passage, entail shifts in status, and may give rise to personal rituals of separation, such as the burning of love letters. Some older people invent their own rites of passage. Charles Swartz celebrated the coming of his "bonus years" by giving himself a bar mitzvah on his 71st birthday:

I turned 70 last February and I thought to myself, "You know, you have reached a point that is really significant—the biblical three score and ten. Anything beyond this is now a gift. I'm now in the bonus years." And I thought, what better way to recognize it than to recite the blessings and read the passage that I read when I was bar mitzvahed at 13. And so this is my private project—to become bar mitzvahed again at the age of 71—the beginning of the bonus years![8]

Whether the shift is major or minor, folk customs of passage pervade American culture, structuring lives and marking transitions in an increasingly complex society.

In his germinal book *Childhood and Society,* Erik Erikson divides the life cycle into eight stages. He describes four childhood and four adult stages, each characterized by a particular dilemma or issue. The adolescent stage is characterized by identity versus role confusion; adulthood by generativity versus stagnation; maturity by ego integrity versus despair. These phases do not necessarily begin or end at a particular age, but each must be traversed, according to Erikson, in one's journey towards maturity.[9]

Folklorists have found that the mastery of some genres like storytelling and riddling relates to the accomplishment of developmental tasks identified by psychologists.[10] The ability to tell stories, for instance, is rooted in the process of language acquisition, and is related to a child's perception of events in time.[11] Recent gerontological research on the other end of the life

cycle indicates that verbal and synthetic skills of the sort required for story-telling improve throughout the life span, in contrast to skills required for physical performance in the realm of sport or hard labor. "The ability to bring to mind and entertain many different facets of information improves in many people over their vital years," observes psychologist John Horn:

One way this shows up is in the ability of older people to wax eloquently. They have a rich evocative fluency; they can say the same thing in five different ways. In our research, they're better in this sort of knowledge than the young people we see.[12]

While riddling is a skill to master in childhood, the use of proverbs to manage social realities requires a much wiser mind. Proverbs were part of the standard social currency among elders at the Jewish Senior Center in Venice, California, where Barbara Myerhoff recorded the following exchange:

"Learning is what makes us stay young forever," said Abe. "So that a Jew, a real Jew, is ageless."

"This is true," said Sophie. "My grandfather used to tell me, 'If you are ignorant, old age is a famine. If you are learned, it is a harvest.'"

"And what do you think my grandfather said?" asked Nathan in return. "I'll tell you. 'When the brain is green, it does no good, even if the hair is gray.'"[13]

One of the reasons folklorists have spent so much time with older people is not just that they have time to spend, but that by dint of biology and their role as cultural caretakers, they are often masterful interpreters.

As Irish storyteller and *sean nós* ("old-style") singer Joe Heaney said, quoting his grandmother: "When you're young use your eyes and ears, when you're old, use your mouth."[14]

Jewish "stages of life" greeting card, early 20th century (cat. 51).

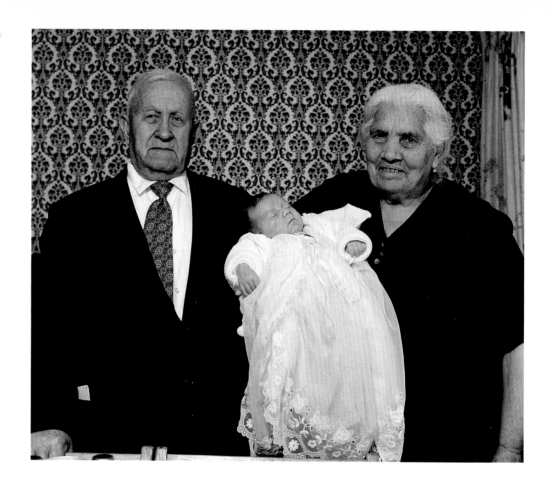

*Italian-American grandparents
with their newly baptized
grandson, Buffalo, New York,
1972.*

Photograph by Milton Rogovin.

The Interplay Among Stages of Life

Culture, then, is age-related in a number of ways. Age, like ethnicity, gender, geography, religion, and social class, is one of the variables that helps define culture for an individual in any given time and place.

We begin as children, and, for some Americans, our first scheduled activities may include baptism and the briss or circumcision. Then comes a host of firsts: first steps, first words, first birthday, first haircut, and the first day of school (by which time the first shoes have been bronzed.) The child also belongs to a community of peers, in a realm separate from the authorities in his life, a realm with its own conventions, secret societies, initiations, games, and rhymes.

In their material culture, children often produce ephemeral models of the adult world that surrounds them. They transform the materials of everyday life into paper airplanes, clothespin pistols and darts, grass-blade whistles, and daisy chain necklaces. Their playhouses and townscapes of sand are not meant to last, built as they are of scraps borrowed from the world of older people. Thus their play might be seen, in part, as a rehearsal for roles they will assume in later life.

Between adulthood and childhood, adolescents occupy a liminal stage, illuminated in the range of their customs, some controlled by parents and other figures of authority, others in the hands of youngsters themselves as they find their own ways to talk about and commemorate the signs of their developing sexuality and greater freedom from authority. Automobiles and shopping malls are among the settings for their culture, away from the home. In their language, hair styles, dress, and dance they find ways to sharply distinguish themselves from the generations that flank them. And in

their lore—scary stories about babysitting, being out in the car in isolated places, humor about sexuality—they dramatize the concerns of their age.

Rites connected with puberty in the United States are not highly visible. Within Catholic and Jewish communities, confirmations and bar mitzvahs confer the status of young adulthood on their subjects. While the passage from junior high school into high school comprises an important secular rite, the most highly charged gesture is the acquisition of a driver's license and the keys to the car.[15]

High school or post-secondary school graduations—hailing the end of a youth's years at school—are surrounded by rituals like the signing of year-books that bind together the people who share a particular journey through history. Such autographs, wherein friends enjoin each other never to change, may be pored over at future milestone events like the 20th and 50th class re-unions, where awareness of change is intensified.

Graduations mark our passage from students to workers, from positions of dependence to productive roles in the workforce. Our working life too is marked by customs of passage. In many occupations a novice is initiated into a work group by means of traditional pranks. New workers in a factory are asked to fetch a bucket of steam; in a garage, fledgling mechanics are sent for a nonexistent "duberator."[16]

Weddings carry a great deal of symbolic cargo in our society, and as milestones they are apt to be highly elaborated. Woven into the preparations for the ceremony may be education about social etiquette and family history. Weddings are also an occasion for the passing on of family heirlooms and lore. Artifacts, expressions, and garments from other milestone events may be stitched into the proceedings. One groom and his bride recently drank

Two generations dance at a wedding, Buffalo, New York, 1972.
Photograph by Milton Rogovin.

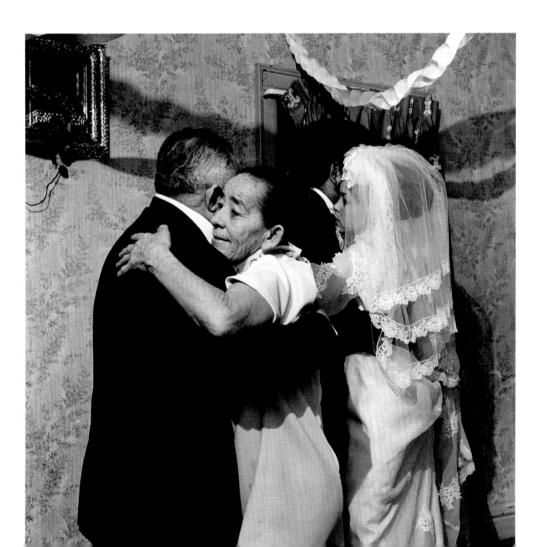

wine during the ceremony from the groom's baby cup. The "something old" worn by the bride may be a bit of lace from her grandmother's wedding gown. Young people move from a state of responsibility for themselves alone to one of responsibility for others. In a sense, weddings are also rites of separation for parents, who symbolically yield up their roles as primary caretakers for their offspring, though in reality such a transition may have begun years before the ceremony.

During the period of productivity inaugurated by graduations and weddings, often called the prime of life, the cycle of life begins again, but this time from the perspective of parenthood. Childhood is bracketed by parenthood, which confers milestone status on the trail of first events—the word, the step, the shoes. New customs such as "the quiet game" or "McDonald's night" or the "good-night bedtime ritual" are designed as part of a parenting plan. Gradually a realm of custom and lore unfolds as the family grows and the children celebrate their own milestones.

At some point in the middle years, the death of one's parents may occur, an event that, more than weddings, removes the vestiges of one's childhood. As 70-year-old Mayer Kirshenblatt said, "As long as you have a parent, you are still a child."[17]

Retirement is a harbinger of old age, which has its own rites of passage and landmark events, such as golden wedding anniversaries, 50th high school reunions, and retirement banquets. Grandparenthood and great-grandparenthood are among the milestones of this period, and the grandparenting role brings with it a set of new tasks. The role of presiding or advising at life cycle events, such as births and weddings, for example, often falls to the older women in the family.

In contrast to the children's expressions, the creative traditions of the elderly are characterized less by rehearsal, than by review. They invest their folk art and stories with memories from a long life and mastery of skills and knowledge drawn from years of experience, and their creations are made to endure beyond their lifetimes.

Death occasions the final rite of passage for an individual, but not for those who attend the funeral, for whom it is also a rite of passage. There are many informal rites surrounding death, which ease the transition for friends and relatives who assume responsibility for telling stories, reminiscing, and memorializing for and about the deceased. Folklorist Kenneth Goldstein speaks of the death of his father and the stories that were told during the seven-day formal Jewish mourning period, the "Shiva." The tales, he says, went through several stages. First, a period of speechless grief gave way to stories of his father as a saint; later they changed to stories of his father as an ordinary man; by the end, stories were told of his father as a trickster, a shrewd and funny man, good and bad by turns. These last entered the family repertoire as stories that maintain his father's spirit as a vital force in the life of the family.[18]

We progress through the life cycle individually, but we are bound into communities by sharing in the life cycles of others. We attend weddings, baptisms, bar mitzvahs, and funerals—and through them we rehearse our roles and our scripts.

The complex cycling and recycling of folklore genres and events throughout one's life reminds us of the children's toy, the slinky, which spirals as it curves. For along with the rites of passage that mark linear time, there are seasonal rites that shape for us a sense of recurrent time: holidays that, like Christmas, Channukah, Easter, and New Year's, cycle around each year with the seasons. Memory painters such as Grandma Moses, Bluma

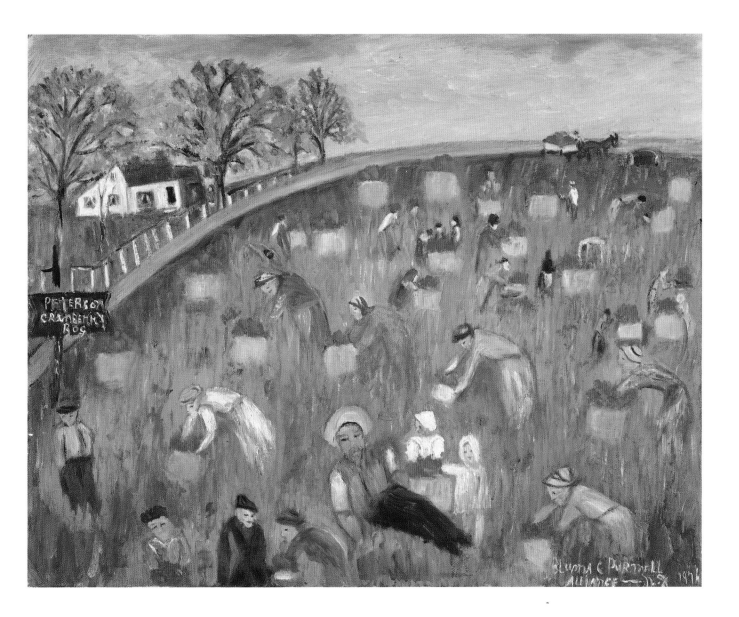

Picking Cranberries at Peterson's Bog *by Bluma Bayuk Rappoport Purmell, 1976. Bluma Purmell began painting at the age of 83. Her memory paintings commemorate the recurring aspects of daily life on her family's farm in Alliance, New Jersey, when she was a child, including seasonal activities such as harvesting cranberries (cat. 30).*

Purmell, or Ray Faust—and folk autobiographers working in other media— tend to emphasize such recurring and enduring moments of life in their work.[19] Scenes of sleigh rides or harvest time on the farm or hot summer days with fire-hydrant spritzing are common. There is the sense of an eternal childhood, with the seasons turning, but time standing still.

Recycled Traditions

One relationship between the early and later stages of life involves the recycling of traditions older artists learned in youth. Among older adults we find a kind of artistry that commences at some point in later life, often triggered by a life crisis such as retirement or the death of a loved one. For his medium as well as his content, the older artist often reaches back into his youth to the old people he knew then. A skill such as quilting, fiddling, canning, or carving may be revived. We saw that Charles Swartz even recycled his bar mitzvah. The revived skill may have been acquired in youth under the tutelage of an older relative or neighbor and abandoned in the busy middle years of earning a living and raising a family.

While many older people use retirement as an opportunity to strike out into new territory—to travel extensively, to begin a new business or second

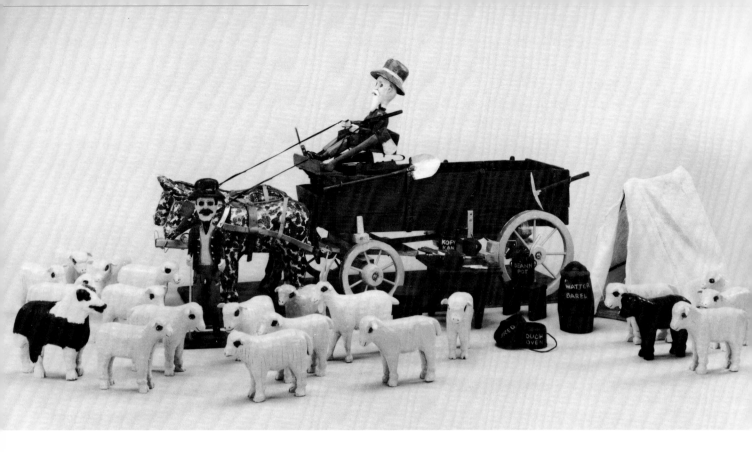

Sheepherders' Camp *made by Norman Rankin, a retired sheepherder, rancher, and cowpuncher from Visalia, California. Mr. Rankin began carving at the age of 86 as a way to overcome his feelings of loneliness after the death of his wife. He made this sheepherders' camp in 1975 at the age of 90 (cat. 32).*

career, or to serve society through volunteer work—the artists in this exhibit, in reviving skills learned earlier in life, strikingly exemplify this life cycle pattern.

William Richard, a retired logger from Phillips, Maine, whittled a few things when he was in his 30s, but only really began to carve in later life as a way to relieve his loneliness after his wife went into a nursing home. At age 87 he enjoys the reputation of master whittler. Working with his son and grandson, Rodney Sr. and Rodney Jr., also woodcarvers, he produces traditional fan towers.[20]

Similarly, Earnest Bennett, age 83, learned to whittle when he was a young boy in rural Kentucky. After his retirement, he returned to his woodcarving skills, whittling intricate chains from a single piece of wood and creating miniatures of tools he had once used on the family farm. The works of both carvers make their way into the hands of children, and through their traditional skills these men remain active in community life.[21]

Kathryne Petersen, of Arden, Delaware, grew up watching her mother quilt, but never really started quilting until she retired. The birth of a great-grandchild occasioned her first quilt. "My granddaughter is 20," she says, "and I made her a baby quilt, so that's when I really got into it. . . . I just started and I've been quilting ever since."[22]

The pattern challenges our perceptions of elderly artists as the "last of the old-time" practitioners of dying arts. Alan Jabbour, describing the pattern in the lives of traditional fiddlers, noted that frequently the instrument is learned from parents or grandparents in childhood, played as a young man, then put away for a number of years. Jabbour writes that each of the fiddlers he interviewed had his own reasons for quitting:

One quit because his wife couldn't stand the music. For another the combined burdens of long work hours and raising a family simply crowded the fiddle out. Yet another stopped playing for religious reasons. . . . By the time I heard 30 versions of the story from fiddlers scattered across the upper South, I began to realize that

something bigger and more fundamental was going on. . . . I was not simply finding a few [older fiddlers] who still played. Rather I was learning that old age was precisely when one played the fiddle.[23]

Lucy Long tells of her work with Appalachian cloggers. They all seemed so old, she said. With such aging practitioners, it seemed a wonder that the tradition didn't die out completely. Yet year after year, the feet still clogged. In time she realized that there at the feet of the grandparents small children were dancing. Though the middle-aged mountain people were busy working and raising children, the pool of active, older cloggers was always replenished.[24]

Susan Stewart, having made a similar discovery among quilting women in south-central Pennsylvania, took exception to one pastor's assessment of quilting as "a dying art here as it is everywhere":

This would not seem to be the case, as the women of the three Brethren churches I studied each year seem to bring more women in their 50s into the fellowship, women who have perhaps never quilted, but whose families are no longer home, and who need the friendship of the quilting group.[25]

The implications are astonishing. Fiddling, clogging, carving, and needlework, then, are not dying arts just because their practitioners are elderly. They are, in fact, the things that elderly people do.

As we will see in the chapter on memory, the use of traditional materials and skills acquired in childhood enables the elderly person to accomplish an important developmental task of old age: life integration, the pulling together of the disparate portions of a long life into a coherent whole. The synthetic vision, narrative skill, and traditional knowledge characteristic of old age uniquely equip the elderly person for this task, and for a related task, which is to communicate these to others. As one who has lived through life's other stages, the elderly person is also uniquely equipped for such communication. As Ethel Mohamed, an 80-year-old storekeeper, embroiderer, and grandmother from Belzoni, Mississippi, tells us:

You know, to be 80 is nothing to dread, because at 80 you can be the age of whoever you talk to. If I'm with my grandchildren, the little ones, I understand them because I've been there and I know. If I'm with a 24-year-old mother with young babies, I know exactly what she's talking about. I feel like I'm her age and I can understand

Mary Ann Mackay, age 89, with a portrait of herself as a young woman, Thorpe Senior Center, Sparkhill, New York, 1987.
Photograph by Hazel Hankin.

her world. That's one of the nice things about being old. You're the age of whoever you're with.[26]

Mrs. Mohamed's depiction of old age as the cumulation of all stages of life runs counter to the iconographic depictions of aging as a condition of steady decline. The elderly in our communities participate in a culture that is multigenerational, and from their vantage point they can—as Ethel Mohamed points out—empathize with other age groups in a unique way. However, there are two processes that distinguish their situation from that of the rest of society, providing the basis for the creation of new culture and the recycling of old culture in novel ways. One process is biological, and as such, is what unites them with the elderly who have gone before, and the elderly to come. "There is one form of experience that belongs only to those who are old," writes Simone de Beauvoir, "that of old age itself."[27] The second process is historical and is in some ways unsharable with other generations. These two aspects—a particular experience of history and an advanced position on the lifeline—contribute to the setting in which the culture of old age unfolds.

The Elderly as Culture Makers

Each generation occupies a unique position in the course of history, a position that endows its members with a particular perspective and set of experiences, and that distinguishes them—in gerontological parlance—as a "cohort," that is, "a set of people born at the same time."[28] "At any given point in time," writes Karl Mannheim, "we must always sort out the individual voices of the various generations, each attaining that point in time in its own way."[29]

As a result of this shared location in history, there are things the elderly can understand and communicate with each other that are inaccessible to other cohorts. Only people who entered the stream of history together can share their view of the same moment in time. Thus people of the same age need each other in a unique way, and where we find cohorts gathered we find resourceful people helping each other to grapple with the physical and social conditions that characterize old age.[30]

Playing cards in New York City, 1973.
Photograph by Michael Weisbrot, Black Star.

We're like a flock of birds. You see, we're all the same age and we stick close together. We understand one another. We have the same ideas.
Elderly Italian-American man, *New York*

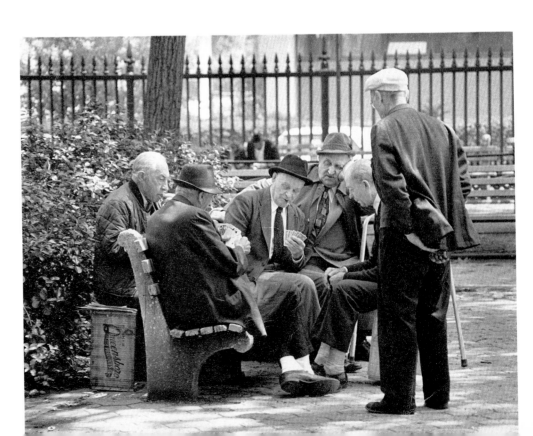

No one has yet figured out a way to stop aging, a point that 72-year-old Doris Kirshenblatt, of Downsview, Ontario, drove home with a story:

A man in his late 70s came into a lot of money, and he married a young woman. And he wanted to live a long time, and he didn't know how to do it, so he went to the doctor. And he says, "What shall I do so that I may really enjoy my wealth and live a lot longer?" So the doctor enumerated all these things: "Don't smoke, don't drink, don't eat all that fat food, those porterhouse steaks. Eat much less, steam your food, rest, no sex." All the good things in life. When the doctor finished, he said to him, "Doctor, if I do all this, will I live longer?" He says, "I don't know if you're gonna live longer, but it will seem like an awful long time."[31]

Mrs. Kirshenblatt's story alludes to a number of the crises facing all of us as we grow older: loss of physical vitality, the threat of isolation and loneliness, the shortening of the future, and the loss of stimulating and meaningful engagements. But while no one has figured out a way to stop aging, the elderly together come up with many resourceful solutions to the problems the elderly groom sought to avoid.

One of the points of the joke is that we can in some respects govern our experience of time. But in other respects, as Simone de Beauvoir writes, "age changes our relationship to time."[32] Time seems to move faster in later life because, with each passing year, the time remaining becomes a smaller percentage of one's total life. The span of time between birthdays may seem interminable to a child, while an older person accumulates birthdays at an accelerated tempo.

Paradoxically, time is what the elderly have, and do not have. This may be the first point in their lives where they have free time. "When one is young," writes 92-year-old Bluma Purmell, "there is never enough time—age gives us this gift. . . . Now I have enough time to pursue my postponed daydreams. No boss interrupts, no children clamor for attention, no deadline looms."[33]

And the concept of "free time" contains another paradox. We often hear it said that "time is money." Yet there is some time that no amount of money can buy. The awareness that time is limited increases as we grow older, an awareness that heightens the value of the remaining time in one's life—a quantity that for everyone is uncertain.

Whether they earn money or not, some older adults may turn to projects that become their true life's works—spending 20 or 30 years to produce family histories, organize museums, or build artful environments. They may also turn their time into a gift to bestow upon others. Older adults are highly visible in the nation's cadre of volunteers, donating their time to hospitals, to museums, and to environmental and political causes. Graham Rowles suggests that the current panoply of activist groups supports the idea of "emerging subcultures of the aged, defining appropriate roles for the older person."[34]

Perhaps we presage this changed relationship to time with the gold watch, traditionally bestowed on American retirees. Ironically, they are given a timepiece at precisely the moment when their lives will become less regulated by the clock. Yet there is nothing automatic about the move from a world of agendas structured by others into a world where one is responsible for building one's own agendas, and adjusting one's world to fit the changing circumstances of old age.

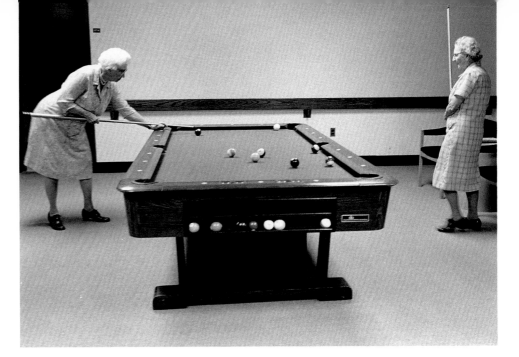

Elderly women playing pool in a nursing home.
Photograph by Abigail Heyman/ Archive.

Communities, Settings, and Routines

The geographies and cycles of the elderly have a coherence that may be invisible to younger people immersed in their own agendas. Such coherence is often hard won, a fabric painstakingly woven out of the resources at hand when the customary resources disappear. "I only have one blood relative," says Rosina Tucker, at the age of 103. "Do you think I'd be lonely? No! I've built myself a community. . . ."[35]

The fabric is constructed out of triumphs over what old age can bring. Ordinary daily rituals, performed with difficulty by someone of extreme old age, may carry a great deal of meaning, as Basha told Barbara Myerhoff:

Every morning I wake up in pain. I wiggle my toes. Good. They still obey. I open my eyes. Good. I can see. Everything hurts but I get dressed. I walk down to the ocean. Good. It's still there. Now my day can start. About tomorrow I never know. After all, I'm 89. I can't live forever.[36]

Familiar routines and settings become centers for organizing experience and social activities. The days when the old-timers gathered on the courthouse steps seem confined to memory, but gardens, front porches, sidewalks, park benches, bars, supermarkets, corner stores, church halls, ethnic clubs, doctors' offices, golf courses, and senior centers all provide settings in which older adults shape their own culture.

Robert Coles describes in detail the daily activities of an elderly Hispanic couple in New Mexico. Each day while the husband cares meticulously for his garden, the wife, after dusting and sweeping the house, turns her attention to the dozen or so plants that she has had for many years. She knows each one's idiosyncracies. "Maybe it is unnecessary nonsense, the amount of attention I give," she says, then disabuses us of any mistaken notions we may have about habits:

Habits are not crutches; habits are roads we have paved for ourselves. When we are old, and if we have done a good job, the roads last and make the remaining time useful: we get where we want to go, and without the delays we used to have when we were young.[37]

While one's orbit of travel may tighten, an infinity of detail still commands the attention, keeping the survival skills finely honed. Graham

Rowles marvels at the mastery of environmental detail demonstrated by the elderly men on Winchester Street arising from their need to maximize energy and to limit the possibility of injury. They are sensitive to traffic-light sequences, holes in fences, slight inclines, cracking sidewalks, and windy streets. Knowing how to bypass ice and mud, where to walk in the shade in hot weather, and where and when the traffic will be hazardous guides their navigation, as does the knowledge of where to find companionship.[38]

The elderly are structured into the spaces of Italian clubs in south Philadelphia where permanent card tables are set up for the games of older men—*tre-sette, scopa, briscola,* and *passatela*.[39] *Bocce* courts are essential features as well. Folklorist Elizabeth Mathias points out that not only do the clubs provide the elderly Italian immigrants with a setting in which to speak their language and play the traditional games, but they provide scheduled leisure activities and the opportunity to maintain lifelong friendships, while easing the transition from being active workers to retired pensioners. Mathias writes:

When I asked the old man, "What would you do if you didn't have the club to come to?" he responded, "I'd have no place to go; I'd just stay home and do nothing; I'd go crazy." . . . Several other old men approached us then and talked briefly about how, at their ages, 84 and 86, friends mean everything to them and the Club is their only place to get together.

Bocce, Mathias concludes, "has stopped the clock for the old men and has preserved a cultural setting for the new immigrants which is based upon the old country village values."[40]

Like bocce for the older men, quilting is a memory activity for older women, who, whether in church halls, senior centers, or private homes, gather all over the country to piece brightly colored scraps into an artifact that represents, among other things, their time spent together. Susan Stewart noted that most of the quilters she worked with in the Brethren churches of Pennsylvania are between the ages of 60 and 90:

For many of them, raising families and doing work in the home is the only life they have ever known. Thus a home-oriented craft in a social setting provides fellowship and a cure for potential loneliness. "You have to have free time to be in a quilting group. When your family is all gone it's nice to meet in fellowhip with a group," said Fannie Grove of Spring Creek Church.[41]

Quilting, as Susan Stewart observes, works as a creative expression on both communal and individual levels. It is also a way to serve others, since the quilts are often sold for the benefit of missions or donated to hospitals and nursing homes.

The impulse to create a meaningful culture with members of one's cohort is powerfully present in the elderly. With members of their own generation, seniors shape many creative responses to the circumstances of old age. Doris Kirshenblatt's joke about the elderly groom itself epitomizes a widely employed strategy for dealing with the vicissitudes of aging: humor. "You can't expect to have the memory, the eyesight, you had when you were young," says Mrs. Kirshenblatt, "but if you learn to laugh about it, some wonderful things can happen."[42]

Difficulties with health or problems with memory may furnish the subject matter for entertaining anecdotes and stories. Jehu Camper recalled the morning he and his wife looked high and low for a missing sock, only to discover he was wearing two socks on the same foot.[43] And when asked what he did at his 50th college reunion, Alan Kaynor, of Wilbraham, Massachusetts, slyly replied, "I forget!"

Italian-Americans playing bocce, *New York City, 1985. Photograph by Martha Cooper, courtesy of City Lore.*

The phenomenon reminded Doris Kirshenblatt of another story. "There were these three ladies," she begins:

Their memory wasn't too good. And they sat there complaining, but they weren't ashamed to talk about it. They thought each one would tell their story. And one says to the other, "I don't know what's happening to me. I get up in the morning. I try to put on my stockings. I don't know, am I putting them on to get up, or taking them off to go out! I can't remember what I'm doing with those stockings!" The other one says, "You know, I too have problems. I get up and I go to the door and I take the knob in my hand. I don't know, am I coming in, or am I going out! Problems." The third one says, "With me everything is wonderful. Fine. No problems. Touch wood." (knocks on wood) "Come in!"[44]

Physical ailments as well as memory lapses can become, in fact, grist for conversations of the sort that Mayer Kirshenblatt wryly refers to as "organ recitals," observing that they always begin with "my heart and move on to my liver and lungs." In Gary, Indiana, the doctor's office was a rich narrative resource for Katie Kis and Marge Kovacs, two elderly Hungarian storytellers. "They love to talk to doctors and nurses about their health condition," writes Linda Degh,

. . . and to watch other patients generates countless humorous stories with both women. They also like to talk about diseases and cures. In spite of their frequent visits to doctors and nurses, Mrs. Kis and Mrs. Kovacs are profoundly interested in traditional home remedies and occasionally resort to them in addition to modern health care.[45]

Park benches, church halls, senior centers, and ethnic clubs are not the only settings in which the elderly fashion their culture. Not everybody is mobile enough to get out regularly. For these two women, the telephone was a cultural lifeline. Accomplished raconteurs, and heirs to a venerable tradition, Katie Kis and Marge Kovacs found themselves in a world where, unlike the Hungarian villages of their birth, there was no ready niche for the storyteller. "What can they do," asks folklorist Linda Degh, "how can they make use of their talents, their fantasy, sense of humor, pleasure of narration, in this most unlikely spot of the world?"[46] The answer is the telephone, which, she points out, is nearly the sole avenue of communication among members of the immigrant generation. "As soon as she thinks of something worthy to tell," writes Degh of Mrs. Kovacs, "she immediately calls her acquaintances and tells it." In contrast, Degh also observed that conversations with busy young people were kept to a minimum.[47]

Mrs. Kis and Mrs. Kovacs spent hours entertaining each other on the telephone. They foraged tirelessly for narrative materials, shaping into traditional tale types the behavior of neighbors, events shown on television, celebrations they attended, and events from long ago.

Ritual Cohort Gatherings

Certain kinds of celebrations highlight the unique relationship among elderly peers—like 50th college reunions or reunions of veterans of World War I. Such events intensify one's experience of the passage of time, and contain rites of life review centered around photo albums, yearbooks, and the performance of well-known stories in the group's repertoire.

In South Carolina we find an annual event that brings together a group of elderly cousins. Each year, a generation of herring swims up the Pee Dee River in South Carolina to spawn and then die in fresh water. And each year a generation of the Dargan and Ervin families runs a net across a tributary of the Pee Dee and catches a few dozen. The herring are then brought back,

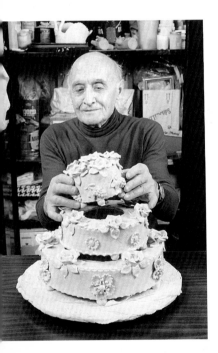

Inspired by his former career as a baker, Carlo Bergomi made this pottery cake for an arts and crafts project at the Latimer Senior Center in New York City. Photograph by Martha Cooper, courtesy of City Lore, 1987.

Depression Days, *an embroidery by Ethel Mohamed, age 80, Belzoni, Mississippi, 1970s (cat. 23).*

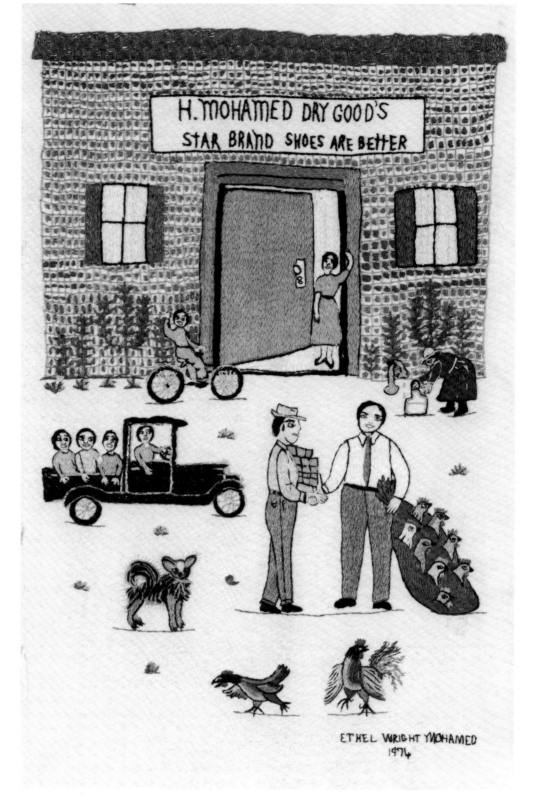

We loved our customers, and so during the depression days, my husband would often trade with them for chickens and corn and eggs, vegetables, freshly killed beef, or most anything they brought into trade.

Ethel Mohamed

and a few nights later that generation holds the annual fish fry, where the herring are cooked over charcoal, along with hominy, hush puppies, and the herring roe, a particular delicacy. To fend off the evening chill, a bonfire rises six feet in the air. Members of a generation relax around the picnic tables surrounded by tall pines near the Dargan home.

The Dargan/Ervin clan is part of a rural farming community in South Carolina. With generations born and raised on the same land, a strong sense of community prevails. As Amanda Dargan writes, the "community ends where the cousins end"—and there is seemingly no end to the cousins, who number in the hundreds. The annual round of activities includes weekly picnics at Black Creek, winter and summer field days for the children, Easter egg hunts, the "peanut boil," and elaborate rituals of Christmas visiting. Yet, the fish fry is unique among these events because it is attended by only one generation—the family elders.

It is a time for reminiscing and storytelling in the chill night air as the fire rises and the herring cooks until it can be eaten bones and all. The oldest member present says the blessing over the food. Often, Wilma Dargan or Suter Ervin coax the group into holding hands and singing the popular songs of their generation: "Down by the Old Mill Stream," "The Little Red Schoolhouse," and "The Anniversary Waltz."

As the fire dies and the fish fry draws to a close, 70-year-old Lucas Dargan traditionally shares a cigar with Henry Ware, one of the "mountain cousins." They tell stories about their World War II days, and share a common historical perspective on the world, a perspective formed in the days before television and jet liners and air conditioning. In fact, as Lucas Dargan says, it would suit them both if "they eliminated some of these modern 'conveniences.'"[48]

Although the Dargan elders gather as a generation only once a year, many elderly people associate with their cohorts on a daily basis. The growing number of senior citizen centers and nursing homes has served to emphasize the cohort links in our society. The centers, in particular, are often places where the "young old" can remain active. Seniors create a daily round of conviviality. They travel and participate in arts and crafts. They volunteer to work at hospitals and museums. They call the homebound elderly and create mutual support groups—often calling each other every day to make sure they are all right.

The work of Jack Kugelmass at the Intervale Jewish Center[49] in the South Bronx and Barbara Myerhoff's work with a senior center in Venice, California,[50] both illustrate how the elderly shape their culture by creatively adapting old cultural traditions to fit a new set of circumstances.

Kugelmass writes about Moishe Sacks, who struggles each week to put together a *minyan*—the minimum ten men required by Jewish law—for Sabbath services in a tiny synagogue trying to hold on in a burned-out area of the South Bronx. "When only nine men show up," Sacks says, "let God come down and see we only have nine. He can count. And when he comes down, we'll count him in."[51]

Myerhoff writes of the extraordinary 95th birthday of Jacob Koved, celebrated with his cohorts at a senior center on the boardwalk in Venice, California. "Extreme age," she writes, "had not cost Jacob his clarity of mind, determination of purpose, or passion in life." But he was extremely sick, and during the celebratory meal, before the speeches, he was administered oxygen several times. At one point, he said to a friend that he wished people would hurry up and eat, for he was wrestling with the Angel of Death. He began his speech vigorously, then he faltered, slowed, and finished word by word. "It is very hard for me to accept the idea that I am played out," he said.

Nature has a good way of expressing herself when bringing humanity to the end of its years, but when it touches you personally it is hard to comprehend. . . . I do

have a wish for today. . . . It is this: that my last five years, until I am one hundred, my birthday will be celebrated here with you . . . whether I am here or not.

When he died a few minutes later, the room was alive with quiet remarks:

"He's gone. That was how he wanted it. He said what he had to say and he finished."

"It was a beautiful life, a beautiful death."[52]

Even as he died with a dramatic flourish on his last birthday, Jacob Koved created a new tradition, a ritual that would bring the community together once a year to help him complete his century of living. Symbolically, as the raison d'être for their gatherings, not even death would deprive him of his goal.

Thus the elderly are not just repositories of old culture, but vigorous makers of culture. With imagination and verve they tackle the challenges of living, busily weaving out of the threads of biography, history, biology, tradition, and everyday living their particular and communal visions of life.

*When I was a child the
fastest thing we knew was
the speed of a horse. We
couldn't imagine that a man
would be walking on the
moon.*
Mayer Kirshenblatt
age 70, Ontario

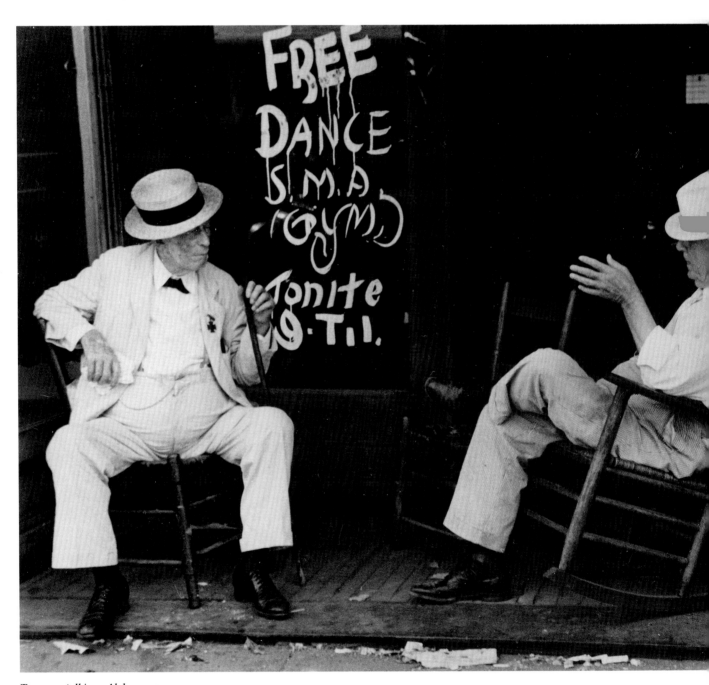

*Two men talking, Alabama, ca.
1936.*

Photograph by Walker Evans. Courtesy of
the Estate of Walker Evans.

Memory: The Living Past

Memories are an important part of living. Did you ever stop to consider the wonder of the mind that it's able to grab for things that happened long ago? That someone can say something like you just did, and the sound of your words makes my mind dance with memories. Not all of them good, mind you, but they come back as fast as you can imagine them. Very little of our lives goes away for good, you know, and that's a comfort to an old man.
Marcus Nathaniel Simpson, 79-year-old patient,
Boston Veterans Administration Hospital

If we could speak of a collective living past, we would find the bulk of it contained in the memories of elders. "I am a teeming library of reference," writes Bluma Purmell, 92 and the oldest living survivor of the 19th-century Jewish farming community founded at Alliance, New Jersey. "The sounds, sights, and tastes of yesterday are alive in my being."[1] The artists presented here are the dwelling places of the sights, sounds, and tastes of myriad yesterdays—the Sicily of pre-World War I; the urban New York and rural Mississippi of the Great Depression; and the East European Jewish communities of the time before the Holocaust.

The far past is a province uniquely assigned to old people. Being able to remember things that happened a very long time ago is something only the very old can do. As the wife of 90-year-old Jehu Camper, of Harrington, Delaware, says of him, "I used to tell people that if I didn't actually know how old he was, I would say he was as old as Methuselah to remember all of that way back."[2]

In old age, forgetfulness, occasioned in part by the weakening of short-term memory, seems offset by an enhanced long-term memory. "I can remember things that happened when I was a kid much better than I can yesterday or the day before," says Jehu Camper.[3] An inability to remember current names or phone numbers may accompany an ability to recount the events of more than 50 years ago in great detail. "My past is so real I can touch it," writes Mrs. Purmell:

I can hear the voices of my parents, sisters, brothers, and friends. The old farmhouse lives and throbs with the daily chores; Mother's good cooking spreads its pungent aroma from the woodburning stove; Father, Moses Bayuk, sits at the kitchen table, writing by the light of the oil lamp. The seasons of my yesterdays are here on parade brushing my heart as they pass in review.[4]

Such memories, resources of enormous importance both to the elderly and to those who witness them, have not been adequately recognized and appreciated. Until recently, our impulse has been to discourage reminiscence as an unhealthy sign of dwelling in the past. Marc Kaminsky writes that our

attitudes toward reminiscence are a measure of our attitudes toward the elderly:

In preliterate societies, elders often occupied positions of power and dignity because it was upon their memories that the transmission of culture depended. In present-day societies, however, many kinds of knowledge quickly become obsolete; books are a more reliable warehouse of the accumulated wisdom of the past; and memory is no longer an invaluable social asset. The position of old people has paralleled the declining fortunes of reminiscence; it is no longer held in high esteem as a store-house of cultural riches, and neither are they. What makes the recent reevaluation of reminiscence so culturally significant is that nothing less than our attitude towards old people is at stake.[5]

Recent research by gerontologists and others has shown that reviewing one's memories is essential to self-integration, especially in later life.[6] Anthropologist Barbara Myerhoff writes that:

To experience the self as a stable, continuous being through time, across continents and epochs, despite dramatic physical changes, is especially important to the old, burdened with such vast and disparate memories. Reminiscence is no mere escapist desire to live in the past, as some claim; rather it should be regarded as a major developmental task for the elderly, resulting in the integration that will allow them to age well and die well.[7]

Thus to conquer disparity elders may struggle to achieve connectedness. To relieve an isolation that is multifaceted they seek to connect the elderly self with the selves of other stages, the present and future with the past, and by extension, to reconnect with the forces, people, and places in which that self took shape. In retrieving the self from its many resting places, they rediscover—determine really—its location within a larger whole. Rather than dwelling in the past, they are concerned with bringing their indwelling pasts to light.

Myerhoff further points out that in order to achieve self-integration, one often has to return to the beginning:

. . . the individual must be capable of finding and reliving parts of his/her history. And often, the most important, charged pieces of personal history come up from the remote past, from the numinous events and experiences of early childhood.[8]

We actually spend much of our lives preparing for memories in old age, both deliberately and unwittingly. In old age, culture and biology combine to help us tap and give form to such events and experiences.

Touchstones and Life Cycle Events

In order for things to be memorable they must have both fixed and variable components.[9] The singular events of one's life may be cast into relief against a stable backdrop of daily and annual activities and life cycle experiences. Preparing and eating meals, planting and harvesting crops, and observing holidays and milestones with particular artifacts, words, and customs are activities that over a long life acquire a memory-evoking resonance. The presence of certain "catalytic features"[10]—an aroma, a song, a fabric, a seasonal event—are enough to reproduce powerful, emotionally charged experiences from the past.

A certain prayer, for example, may snowball in significance over a long life until many times and places become simultaneously present in its enactment. In her work with elderly people at a senior center in Venice, California, Barbara Myerhoff notes the Proustian power of the Kaddish prayer to arouse "deep involuntary memories,

those surges of remembrance that are not merely accurate and extensive but bring with them the essences and textures of their original context, transcending time and

Memories of Life on the Farm, *made by Afro-American quilter Emma Russell, Wilkinson County, Mississippi, 1976. Mrs. Russell's quilt captures some of her most treasured childhood memories: the one-room schoolhouse she used to attend; the farmyard animals; her pet squirrel and billy goat; vegetables from the garden and cotton from the fields; the creek where her family went fishing; and her favorite pastime—quilting with her good friend Mattie Lee. From the Roland L. Freeman Collection.*

change. This happened . . . to Moshe when he recited Kaddish the day Jacob died. As he chanted the ancient words, he relived the first time he had heard them and once more felt himself as the small boy wrapped snugly in his father's tallis, standing close to him against the cold, weeping and swaying over an open grave on a bright winter morning.[11]

In precipitating life-unifying moments, such folkloric items function as touchstones. What we are calling a touchstone is characterized by a kind of sensory experience—a smell, taste, sound, sight, or feeling—that unexpectedly and powerfully produces a complex of sensations from the past. "We cannot recapture fully the essential feel of a visual world belonging to our past," writes Yi Fu Tuan, "without the help of a sensory experience that has not changed, for instance, the strong odor of decaying seaweed."[12]

For example, most people have memory smells, many of them related to food. Bluma Purmell vividly recalls the aroma of her mother's cooking. Barbara Swenson tells us that she associates the smell of ludefisk with Christmas, and that it binds all of her Christmas memories together. "If we were

not to have ludefisk," she says, "I would feel like a stranger in the house."[13] Doris Kirshenblatt recalls that when she was younger she criticized her mother for using too much chicken fat, believing it was unhealthy. Now the smell of it makes her nostalgic. Frances Kitching tells us that when her grandchildren are coming to visit she always has something baking.[14] Certainly her grandchildren will someday share Frank Brady's experience with the smell of cornbread, which he associates with his grandmother:

I liked the smell of it as much as I liked eating it. That smell is one of the mementos of my childhood. If I smell it now (and it's so rare—it seems nobody's making cornbread anymore), it immediately plunges me back to those times.[15]

There is a strong physiological connection between memory and smell, as Yi Fu Tuan observes:

The power of an odor to cast us into the past may be related to the fact that the cortex with its vast memory store evolved from that part of the brain originally concerned with smell. For another, as children, not only were our noses more sensitive but they were closer to the earth, to flower beds, tall grass, and the damp soil that give off odors.[16]

Whereas the touchstone experience is largely involuntary, life cycle events often provide formal occasions for life review. In a deliberate way, they supply the grist for future life review as well, generating the keepsakes and souvenirs that in later life may be organized into compendia. Autographed yearbooks, for example, serve this function for adolescents. Events like the 50th wedding anniversary or the 50th high school reunion create high intensity settings for life review, with photographs or other memorabilia serving as ritual focal points. As Peggy Yocom points out:

. . . festivals and celebrations are recurring moments of special significance, junctures that seemingly exist outside of normal time. . . . Because these are special times, family members pause and look around at themselves, their growing children and their aging parents. As they pull out photographs of one another, they ponder the futures and reconsider the past. Stories appear.[17]

Through storytelling, which, as Yocom puts it, "recreates the gathering," families celebrate their own endurance over long periods of time. Such events and artifacts anticipate the need to remember, functioning, in an odd way, as memory in reverse.

Within many families the role of curating the past seems to fall to certain individuals, reminding us that involvement with the past varies. "When you look back to when you were a child," says former medicine show performer Anna May Noell, "you have fond memories—and there are times when you wish you could go back to those days. . . . I would like to go back, but Bob [her husband] says no."

"I've done seen enough of that," Bob corroborates. "I want to see what's on ahead."[18]

Those who do want to go back may be guided by a concern that the past should be kept alive in the present. A number of individuals whose work is presented here relived parts of their past by recreating them, endowing the past with form in a wide range of media. While certain kinds of creative works by elderly artists are often thought of as folk art, they are also likely to be life review projects—an aspect of their work frequently overlooked in formal presentations of folk art. Another overlooked aspect of such works is the opportunities they provide the artist for self-presentation in contemporary settings.

Born in 1860, Martha Alice
Hunt of Springfield, Missouri,
began writing her
autobiography, The Life Story
of Mother Hunt, *at the age of
96. Her life story, which spans
over a century of family history,
is a treasured opportunity for
her grandchildren and great-
grandchildren to learn about
their identity and roots (cat. 16).*

*The longest days I have now
are when I can't find
anything to work with to
keep my hands busy, but I
can keep my mind busy
going back over the past and
recalling memories that give
me food for thought when
alone.*

Martha Alice Hunt

Telling One's Story: The Life Review Project

*One does not possess one's past as one possesses a thing one can hold in one's
hand, inspecting every side of it; in order to possess it I must bind it to existence by
a project.*
Jean Paul-Sartre

"I always had in the back of my mind: I got a story to tell," Arvid As-
plund told Roger Mitchell. "After I retired, I had a chance to tell it."[19] Thus
Asplund, who migrated to this country as a child from Finland, accounted
for the impulse that made him set down his life story on paper. Like the
Hungarian storyteller Katie Kis, he became an ethnographer of his own
childhood, organizing his recollection around traditional items like Finnish
language, customs, food, and games. When describing turning points in his
life he alludes to life cycle artifacts like birth and marriage certificates, the Bi-
ble, and his mother's grave.

Such items are, as Barbara Kirshenblatt-Gimblett points out, "enduring
and recurrent" rather than unique and singular, like the episodes surround-
ing the development or accomplishments of a remarkable protagonist.[20]
Through them the authors present not only themselves, but the culture in
which the self formed, creating an expanded context in which descendants
may understand and appreciate themselves and their forebears. Many fami-
lies possess such privately published autobiographies—perhaps written by a
grandparent at the urging of a grandchild, or written because the elderly au-
thor was inexplicably compelled to write it down.

Autobiographies and memoirs are not always found in books, however.
They emerge on canvas and in wood; on fabric and in stone. They may be
constructed and narrated collaboratively or individually. No matter how it
comes about, telling one's story seems an essential part of being an elder,
and culture provides an array of expressive forms for putting one's story
forth.

Helen Cordero, in later mid-life, turned to Pueblo pottery. She does not
make the conventional vessels—her Cochiti doll represents another kind of
vessel, the tradition bearer, and is based on her memories of her grandfather,

Walking stick made by Elijah Pierce, an Afro-American woodcarver from Columbus, Ohio, ca. 1950. Mr. Pierce referred to this cane as his "preaching stick." "Sometimes when I was asked to say something in church," he said, "I would turn this cane over and over until I found a story or message I wanted to use" (cat. 29).

and the stories he told her when she was a girl. Barbara Babcock points out that Cordero's pottery is autobiographical, giving her, as Henri Focillon put it, "the privilege to imagine, to recollect, to think and to feel in forms."[21]

Elijah Pierce, the son of an ex-slave, was born near Baldwyn, Mississippi, in 1892. He learned to carve wood as a child and continued to practice his art for 80 years, until his death in 1984. As a preacher and a barber, Pierce became a central figure in his community. At some point in his mid-60s, while working in his barbershop, he began a project that would take him 20 years to complete: an elaborate walking stick on which are carved incidents from his life. Pierce's carved past combines family history, biblical references, and life cycle events and images from everyday life—the tools of his trades (a comb, a barber's chair, a cross and bible), the funny story a customer once told him—all rescued from miscellany and uniquely combined into a statement that stands for his life.[22]

In order to tell their stories, Cordero, Pierce, Asplund, and the other artists presented here turned to traditional forms, investing them with autobiography. Despite differences in form, their life review projects share a crucial feature: they are all, in and of themselves, incomplete. They are frequently brought to life through narrative, the focal points of a vital interchange between artist and witnesses. Even in Asplund's written autobiography we find the audience creeping into the text. "Can you imagine," he asks his intended reader, presumably a grandchild, "me being a member of a notorious gang?"[23] As a corollary to this, the stories attached to each item are not necessarily fixed, but are newly formed during each interchange.

The life review project provides the artist with a new social currency. The object that embodies the past becomes a source of contemporary power for the artist. It generates audiences, stimulating interaction with grandchildren, neighbors, craft connoisseurs, local historians, and, of course, folklorists. Of Burleigh Woodard, a retired teamster and logger who carved miniature horses at work in the lumber industry, folklorist Jane Beck writes, "Through his carvings, Woodard continued to live and work in the woods long after he had lost the health or strength to do so." But, as she notes further, while the art connects the artist with other places and times, it also becomes a "means whereby the artist participates in local life."[24] Both social and economic venues for such work open up at crafts fairs, museums, flea markets, senior citizen centers, and in schools.

Radically different experiences may prompt a return to an earlier stage of life. Some elderly artists report that memory "surges" invite or even compel them to relive the past. Bluma Purmell writes:

Nine years ago, when I turned 83, I decided to become a painter. Detailed scenes were projecting themselves in my mind, windows of the past, waiting to be opened. . . . Ideas seemed to tumble over themselves in my mind, anxious to be put on canvas. Soon the walls of my apartment were covered with bright paintings.[25]

Among other elders the urge to recover the past may be set in motion by a life crisis like death, illness, or retirement. All of these crises entail losses of one sort or another—loss of loved ones, of abilities, of employment, of familiar settings and homes.

For those who want to go back, it is not only the wonderful memories that are resuscitated. Painful memories are often the subject of life review. Arvid Asplund entitled the story of his unhappy childhood, *Via Dolorosa* ("The Way of Sorrows"). But he ends with an affirmation. "I made it, despite the bad beginning," is his message. As folklorist Jeff Todd Titon points out, Asplund's story itself centers around the stock motif of the wicked step-

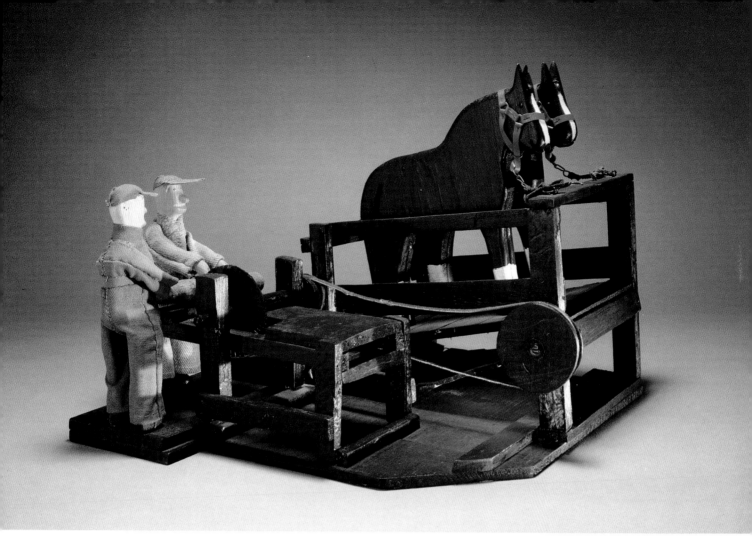

Horse-Powered Saw *made by Burleigh Woodard from West Charleston, Vermont, ca. 1950. Born in 1895, Burleigh Woodard spent most of his life working as a teamster and logger in the Vermont woods, where he was renowned for his well-groomed and finely harnessed teams. In the 1950s, when old age and poor health forced him to retire, he turned to whittling scale models of the teams of horses that had been such an important part of his life (cat. 48).*

mother.[26] The fairytale, in effect, becomes a form, like quilting or carving, for embodying Asplund's childhood. He ends the story with an account of a journey to his birth mother's grave, where he tells her, "Mother, you did not live in vain."

And in his retirement, John Hartter humorously gave form to the indignities inherent in his career as a plumber, steamfitter, and water-meter reader in papier-mâché tableaus. In one we see him putting his face behind a stranger's toilet to read the meter. In another he portrays the unjust distribution of labor among journeymen and their apprentice steamfitters. "It always seemed like the little guys had to do all the hard work," he says, "while the big, burly journeymen just took it easy oiling the threads."[27]

The things that don't go according to plan, that keep life from being as one imagines it should have been, may also provide the raison d'être for fantasy elements in life review—the ways of fixing flaws, mending ruptures, and reclaiming what is not lost beyond recall.

Lost Worlds Reclaimed

A number of artists presented here began their memory art directly in response to an experience that abruptly severed them from the world as they knew it, or that dramatically heightened their awareness of the passage of time. The art became a way to pull disparate moments and places together,

Elijah Pierce, Columbus, Ohio.
Photograph by Rick Kocks © 1987.

Bluma Bayuk Rappoport
Purmell of Philadelphia,
Pennsylvania, a 98-year-old
memory painter, 1986.
Photograph by Dennis McDonald,
courtesy of New Jersey State Council
on the Arts.

and to minimize the fissures created when the people or things on which life depended have suddenly disappeared. "Memory," writes Bluma Purmell, "is our wire to connect us to our absent loved ones."[28] Their art retrieves the experience of the original settings on which it is modelled.

Loss of Loved Ones
Ethel Mohamed says that when her husband died, after 41 years of marriage, she felt like a ship without a rudder:

I felt like the whole world had just fell in around me. . . . So, one night I said, "How do I feel?" I tried to study myself. I said, "Well, I feel just like a big old ship on the ocean, not knowing where it's going, just floatin' just like that." . . . So I said, "I must find something to do." . . . I thought, "You know, the thing I would rather do than anything in the world is relive my life again."[29]

Similarly, Thomas Jefferson Jarrell, of Surry County, North Carolina, picked up his fiddle at the age of 66 after it had laid practically unused for 40 some years, partly in response to his wife's death and his own retirement from highway construction. Norman Rankin carved some things out of wood first when he was 20, and then when he was 40. But it was at the age of 86, after his wife died, that he began to produce carved miniatures capturing his life and work as a sheepherder, rancher, and cowpuncher in the West.
When her husband died Ethel Mohamed returned to the art of embroi-

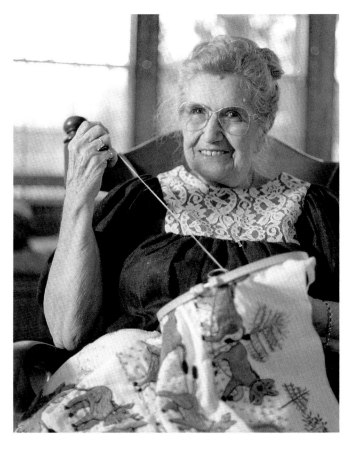

Ethel Mohamed, an 80-year-old
storekeeper, grandmother, and
embroiderer from Belzoni,
Mississippi, 1987.
Photograph by Paul Wagner.

My Husband in 1914, *an
embroidery by Ethel Mohamed,
Belzoni, Mississippi, ca. 1970.*

*This is my husband in 1914
with his new horse and
buggy. He was a handsome
man, but you can't do much
with a needle and thread. He
opened his first department
store in 1922 and we married
in 1924. He was a merchant
for 43 years, and he was a
good one. He passed away in
1965. We still have the store
in Belzoni.*

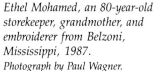

dery she learned as a young girl from her mother, as a way to relieve her feel-
ings of loneliness and deep loss. While she continued to run the family
store, a lifelong project she'd shared with her husband, she also began to
embroider a series of portraits of her family life. In her first memory picture
she depicted herself and her husband "flying around on the bluebird of hap-
piness."

Over the next decade, Mrs. Mohamed went on to produce 90 embroi-
dered memory pictures—enough to be her autobiography. In her collected
works she binds her past to her existence in the present, a past that incorpo-
rates life cycle events such as the birth of a new baby or a wedding day as
well as scenes evocative of everyday life in the past, like her husband's bed-
time story hours with the children, or sacred harp singing when she was a
girl. Her images spring not only from personal experience, but from the re-
ceived memories of her parents and grandparents. She portrays on fabric the
wedding of her great-grandparents and the departure of her great-grand-
father for the Civil War, as she imagines they experienced the events.

Not only is Mrs. Mohamed's personal past granted a form in her needle-
work, but it is tied to the great historical events comprising the national past.
Here we see that the received past—of the sort transmitted at family gather-
ings—is important, because it allows Mrs. Mohamed to present a part of her
life story that she never personally witnessed. We see this over and over in
autobiographical pieces that begin with the author's forebears.

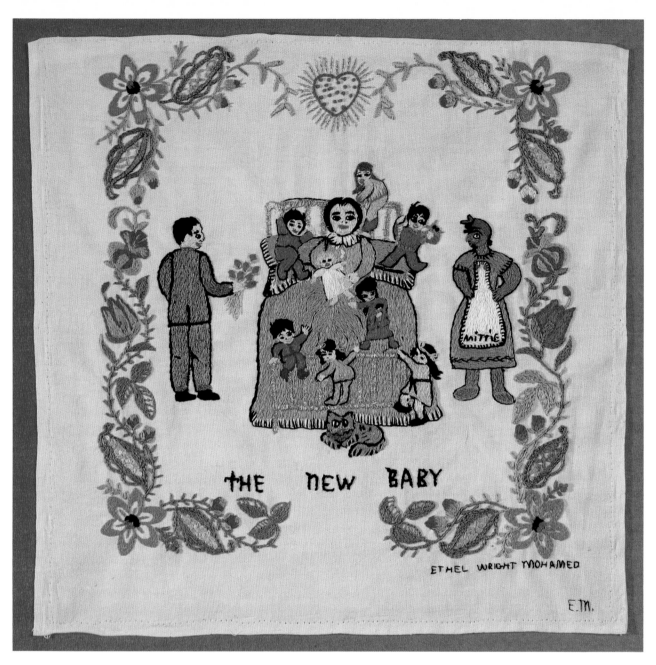

The New Baby, *an embroidery*
by Ethel Mohamed, Belzoni,
Mississippi, ca. 1970 (cat. 25).

This is a picture of the
morning after Carol, our last
baby, was born. I'm holding
her out on the bed on
exhibition. All the children
are there and my husband is
bringing me eight red roses—
one for each child. It was
such a happy moment.

Ethel Mohamed

Loss of Employment

Faced with loss of work, some artists create art that is about work, filling a volume of free time that suddenly engulfs them, whether their retirement comes on them early or late in life. While some may turn to early childhood, others may return to a later phase—the responsible years of mid-life and the work required of men and women raising families and modifying the world. A sudden expansion in time affords an opportunity to make sense of one's life and assign meaning and shape to events in the world of work. "I don't think you can start to think about the past," comments Abraham Lass, an 80-year-old retired teacher from Flushing, New York, "until you have time in the present."[30]

Whether the loss of work occurs through choice or through illness or injury, retirement may be considered a kind of crisis because it entails a shift in status with respect to society. In such times of crisis the tools and skills of one's trade may be recycled to serve in a new way.

When 75-year-old John Hartter retired from his work as a steamfitter and water-meter reader, he crafted scenes from his work, freezing in miniature aspects of his occupation that have since changed. "I guess I never really retired," he says, "mentally, from the job."[31] Thus he bridged the gap between his sense of himself as a working pipefitter and his new identity as a retired pipefitter.

Norman Rankin, who was born in 1884, spent his life mining, ranching,

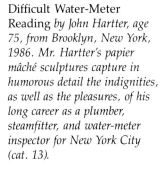

Difficult Water-Meter Reading *by John Hartter, age 75, from Brooklyn, New York, 1986. Mr. Hartter's papier mâché sculptures capture in humorous detail the indignities, as well as the pleasures, of his long career as a plumber, steamfitter, and water-meter inspector for New York City (cat. 13).*

Details of Farm and Home Memories, *a quilt by Ina Hackett Grant, 1939–46 (cat. 11).*

Stair rugs made by Viola Hanscam, age 90, of Harbor, Oregon. Begun in 1961, when she was 70 years old, Mrs. Hanscam's rag rugs commemorate 50 years of married life (cat. 12).

and farming in California. The tools and settings of those working years, like the sheepherding camp, became the objects of his reflection.

For women who have worked in the home most of their lives, retirement may be a more gradual process, signalled by graduations and weddings. Some of the women artists presented here began by recreating—in fabric—scenes from their busiest years as mothers and homemakers.

In 1939 in Chelsea, Vermont, when Ina Hackett Grant was in her late 50s, she began to stitch together a farm and home memories quilt. Her younger friend Amber Densmore began one at the same time. For 10 years they worked together and produced two very similar quilts, each with 172 brightly embroidered blocks. On the blocks are depicted various farmhouses, distinguished as the birthplaces of children or where much of life was lived; seasonal activities like maple sugaring, partridge hunting, and gardening; and vanished technologies dependent on horses and oxen.

In a letter, Ina Grant described some of the highlights of her quilt, including:

1. Wood-colored house and barn, at upper right, where I lived eight years. My oldest son was born here.
2. My full-blooded jersey cow, at lower left, her name is Susan, she gave very rich milk, and I have made delicious yellow butter and cottage cheese from it.
3. Sugar house with sap buckets hanging on trees, where we made such good Vermont maple sugar.
4. My son's registered redbone foxhound. I drawed her picture as she lay in front of the syringa bush in the front yard. A natural hunter and a great pet.[32]

In 1961, in Harbor, Oregon, Viola and Elmer Hanscam celebrated their 50th wedding anniversary. In that year they also retired, handing the family store over to their sons, in order "to catch up on their fishing," as Mrs. Hanscam puts it. While fishing with her husband for salmon in the Rogue River she began to make a set of stair rugs that would tell the story of their 50 years of married life. She writes later,

All I could think of was it is our fiftieth anniversary. Why not put the years down on stair rugs? I can cut up those old coats and dresses—starting on our first year of marriage—to the fiftieth. Children coming home can see where we were and [what we were] doing when they were born.[33]

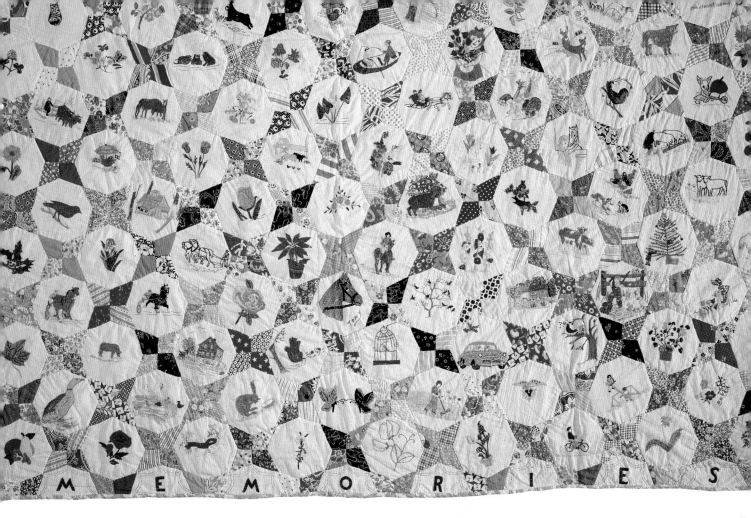

Detail of Farm and Home
Memories, *a quilt made by Ina
Hackett Grant of Chelsea,
Vermont. Born on a farm in
1881, Mrs. Grant was a
talented poet, gardener, quilter,
embroiderer, and rugmaker. One
of her most treasured pieces was
this "memory quilt," which she
began in 1939 and which took
her seven years to complete.
Each one of the 172 embroidered
blocks depicts a special memory
of her life on the farm (cat. 11).*

There are seven tableaus in all, each centered around a threshold experience like a wedding, a birth, or a move to a new home. The first rug portrays the beginning of their marriage in 1911. The rugs that follow, each on its own stair, document the expansion of the family to include six children, representing each place they lived through 50 years of married life, which began in Medford and ended up in Harbor, in 1961.

In a not-uncommon gesture she made the rugs from souvenirs—from her children's old coats and dresses and her husband's worn-out trousers. She also anticipates the need of her children to remember things they may not yet be curious about.

Serious illness may force retirement at any age, and trigger an artistic response. "It is not uncommon," writes Vermont folklorist Jane Beck, "to find an individual turning to his creative abilities and making things when mishap and injury strike."[34] The things they make may relate to former worlds of work. Whether through miniature reproductions, or through collections of old artifacts, the artists maintain their access to those worlds.

Confined to a wheelchair due to a kidney ailment, William Drain, of Michigan, intensified his carving, reproducing miniature scenes of the lumber camps of Muskegon, where he worked as a boy. He also carved a complete set of the tools formerly used by lumberjacks.[35]

In his 70s, Joe Reid, of Waretown, New Jersey, found he could no longer build boats as he used to. So he began to build miniature garveys, blunt-ended work boats indigenous to his region. "It kind of takes me back to my childhood," he comments. "I'd like to make a model of every kind of boat they used to use around here."[36]

Miniature garvey made by Joe Reid, a 77-year-old boatbuilder from Waretown, New Jersey, 1987. Joe Reid has devoted most of his life to building garveys— blunt-ended workboats indigenous to south Jersey. Now that advanced years have slowed his boatbuilding, he makes miniatures. Crafted from the same materials and according to the same methods as the full-size boats, these scale models encapsulate a lifetime of knowledge and experience.

Forced by illness to retire from ranching and blacksmithing in the late 1960s, Rod Rosebrook began to organize and present his collection of branding irons forged by blacksmiths like himself—each of which uniquely represented its owner, and the stamp its owner left on his aspect of the world. The tools for sorting, ordering, and distinguishing among cattle now help to distinguish among men.

Reid, Drain, and Rosebrook were actually recycling the tools associated with their former worlds of work. Tools, so pre-eminent as a subject in the work of elderly men, are, as folklorist John Dorst points out, "weapons of resistance to disorder in the material world."[37] When work has been lost, we find the implements used to conduct that work reproduced or represented in some way as carriers of earlier selves, and an earlier way of life. Mihalyi Csikszentmihalyi comments, "The tools of one's trade, perhaps more than any other set of objects, help to define who we are as individuals."[38] Tools that were formerly good to work with have become good to think with.[39]

This is also true of the traditionally feminine tools. We see the implements of housework—old wooden spoons, rolling pins, irons, thimbles, pie knives, and bread tins—achieving a heightened symbolic status, redolent with memory and significance. "I have that old rolling pin my mother gave me," says Rose Avadanian. "It knows just where to go all by itself."[40] Frances Kitching, of Smith Island, Maryland, testified that she would not know how to cut a piece of pie without her grandmother's pie knife.[41] Thus they transform old instruments into new symbols. In a new role as inventors of meaning, elders reconstitute tools for crafting the physical world into tools that embody that world, lures for the past that engender fresh interpretation.

Beyond giving tangible form to aspects of life that exist only in memory, the artists presented here seem especially compelled to show how the ways of shaping the world have changed, and how the world has changed, celebrating this generation's inimitable imprint on it. But the expression of this first-hand experience with outmoded tools is more than a lament for their passing. With their passing comes a heightened sense of the ephemeral nature of experience and an awareness that a body of knowledge and experience may be lost. The effort is to make the ephemeral enduring.

Men Sawing Logs, carved by William Drain, Muskegon, Michigan, early 20th century.

Miniature wheat cradle, flail, and winnower carved by Earnest Bennett, age 82, from Indianapolis, Indiana, 1987. Earnest Bennett learned to whittle as a young boy growing up on a Kentucky farm in the early 1900s. After his retirement, he returned to the woodcarving skills he had practiced as a boy, whittling intricate chains from a single piece of wood and creating miniatures of the farm tools he had once used. His miniature tools and chains link him to his Kentucky childhood and allow him to share that experience with others (cats. 6, 7, 8).

I've used all these tools. I remember when my Dad was cradling wheat, he'd lay down the bundles and I'd tie them. When I got larger, I cradled the wheat myself.
Earnest Bennett

Miniature loggers (partial set) carved by Rodney Richard, Sr., a woodsman from Rangeley, Maine, 1985 (cat. 33).

Rodney Richard, a 60-year-old woodsman from Maine, carved a set of lumberjacks, each one holding an old-fashioned hand tool—tools like peavies, cant hooks, caliper-scale rules, double-bit axes, cross-cut saws, choker chains, and pickaroons—many of which are now being outmoded by chain saws and hydraulic equipment. "I've used all of them," he says. "I cut my teeth on a spud."[42]

The objects celebrate generational distinctiveness, forecasting the loss of a unique generation. The saying heard among Irish elders, "Our likes will never be seen again," holds true for all elders in part because no future age groups will be shaped by the same experiences. Future lumberjacks are unlikely to cut their teeth on spuds. Each generation is distinguished in part by the ways available to it for shaping the world. The passing of such ways represents the passing of an era.

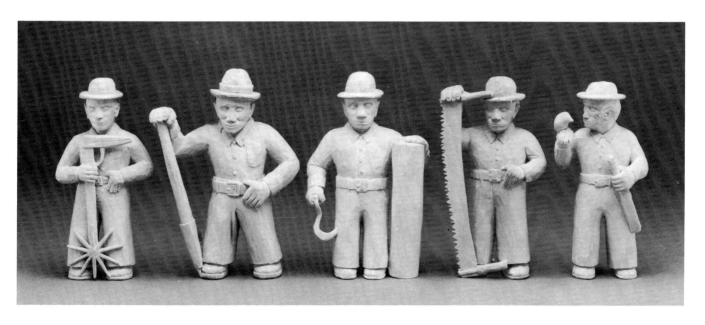

Farmyard scene whittled by Jehu Camper, age 90, of Harrington, Delaware, in 1974.

So many people don't know what a haystack is, and many other things that have gone by the wayside. People say, 'I don't know how you remember that!' Well, I grew up with it—I ought to remember it! I think of something that is about to become extinct and proceed to whittle it.
Jehu Camper

Loss of an Era

We cannot help noticing that similar depictions of life in America during the first part of this century are emerging simultaneously in many parts of the country, by artists who are spokespeople not only for themselves, but for an era. They commemorate a pre-industrial, rural past when horses were not yet replaced by cars and sophisticated farm equipment, when there was no indoor plumbing or electricity, when people butchered their own hogs, made their own molasses and maple sugar, and ground their corn with the help of wind, water, horses, mules, and oxen; when blacksmith shops and barbershops were community-gathering places, women gathered around quilting frames, and old men whittled chains and stories on the courthouse steps.

"The things I make," said Jehu Camper to folklorist Robert Bethke, "represent some part of the folklore-living our ancestors did when they were here on earth. There is history back of it."[43]

William Drain's carvings arose from a desire to retrieve some sense of the life and work he witnessed in childhood, which radically changed over the course of his life. "I was actuated in carving this work," he says, "through a desire to retain in wood the memory, which is fast dying out, of the tools and general outfit that were used in the lumber camps during the time when pine was being slaughtered in the forests here in Michigan when pine was king."[44]

This urge to capture a vanished era may be seen in a larger historical context. Susan Stewart suggests that modern miniatures arise from a heightened awareness of change, specifically the changes wrought by the industrial revolution:

We cannot separate the function of the miniature from a nostalgia for preindustrial labor, a nostalgia for craft. We see a rise in the production of miniature furniture at the same time that the plans of Adam, Chippendale, and Sheraton are becoming reproduced in mass and readily available form. Contemporary dollhouses are distinctly not contemporary; it is probably not accidental that it is the Victorian period which is presently so popular for reproduction in miniature.[45]

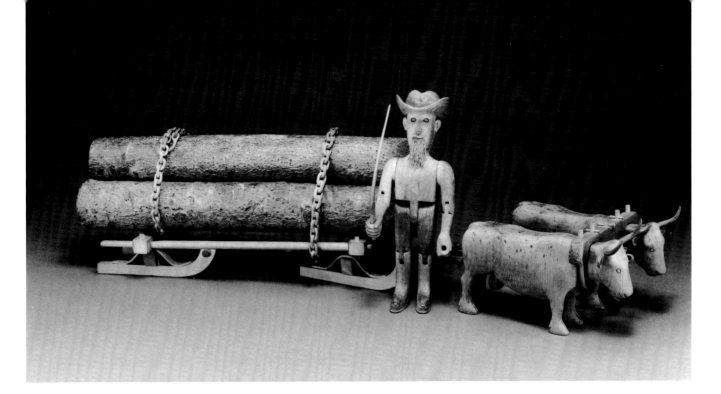

Logging Sled with Driver,
carved by William Drain of
Muskegon, Michigan, early
20th century.

Gulf Patton Lumber Company,
Honor, Michigan, 1899.
Photograph courtesy of Con Foster
Museum.

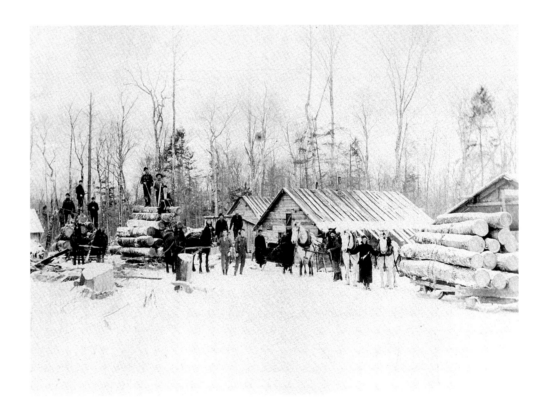

But in contrast to the young connoisseur of past eras, the elderly artist gives form to worlds directly witnessed, whether late Victorian or post-Victorian. Their old-fashioned miniature boats, farms, blacksmith shops, and logging scenes emerge as emblems of the ways of life that gave rise to the artists themselves. The crafts fairs and festivals that are part of a modern nostalgia for handmade items provide settings in which elderly artists perform.

When Ed Hazelton was a boy the old men were not making the miniature sneakboxes—boats for duckhunting—indigenous to New Jersey's Barnegat Bay. Most people had a full-sized one, built of "Jersey" cedar. "I cut my teeth on a sneakbox," he says. Now, he says, it seems as though all the men his age are making miniatures. "All of a sudden, it's in the air or something." They build the miniatures and race them. But they have to be made of cedar. "That's our wood." And they have to work, an attribute sometimes demonstrated in miniature sneakbox races held locally.[46]

The sneakboxes epitomize a way of life that is leaving. They represent a cohort that sees itself as the last generation to freely hunt and trap the disappearing coastal marshes, and as such the co-witnesses and curators of a vanishing way of life and the places in which it was staged.

Ed Hazelton, age 73, of Manahawkin, New Jersey, works on a decoy, one of the many crafts he learned from his father.
Photograph by Akira Suwa, courtesy of The Philadelphia Inquirer, 1987.

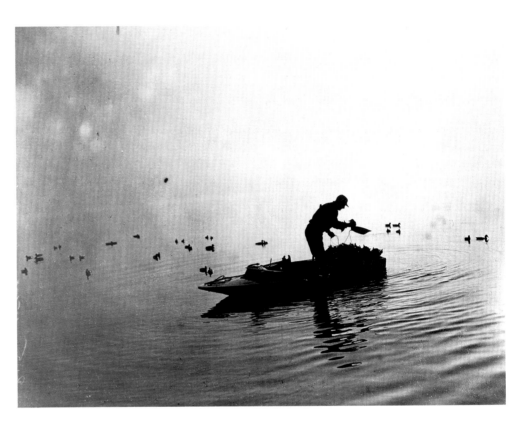

Duck hunting on the Forked River from a Barnegat Bay sneakbox, ca. 1940.
Photograph by Harry Dorer, courtesy of the Newark Public Library.

Miniature Barnegat Bay sneakbox made by Ed Hazelton of Manahawkin, New Jersey, 1987 (cat. 15).

It's hard to put into words in a few minutes what you've learned in a lifetime or somebody else's lifetime too.
Ed Hazelton

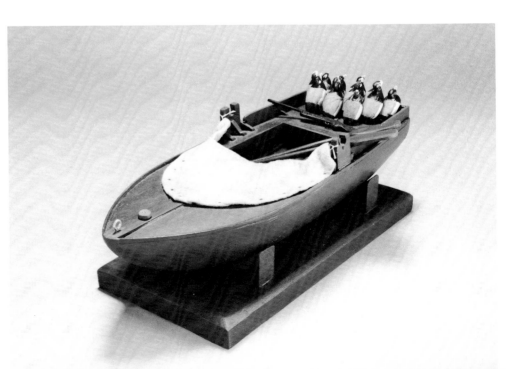

Detail of Growing Up in New York City, 1926–1938, *a mural painted by Robert Burghardt, age 61, Stony Point, New York, 1982.*

Loss of Place

A sense of the past is inseparable from a sense of place. "History," writes Martin Heidegger, "is the chronicle of man's concern for place."[47] The life review projects provide the artists with a means of connecting with eras, places, and people lost to them through change, passage of time, and death. "When I sing," says Bronya Sakina, a traditional Yiddish singer who has recently emigrated from Russia, to Michael Alpert, her student, "I don't see you, I see my little town where I come from."[48]

What we notice about the recreated places is that many of them are drawn from childhood. A number of life review projects recall lost aspects of childhood places. Thus, in a mural entitled *Growing Up in New York City, 1926–1938*, Robert Burghardt tells the story of childhood in Yorkville on Manhattan's Upper East Side. In contrast to urban artists like Pablo Falcon and Vincenzo Ancona, who remember rural childhoods, Burghardt, who now lives in a rural area, recalls his urban roots. Children on the canvas play the street games of that era: stickball, "Johnny on the pony," and marbles. They ice skate in Central Park and swim in the East River. They wait for the ice man and use fire escapes for patios. They pose with the artist himself, in one place painted into the scene as an infant in a wicker carriage, having his photo taken, in another dressed in white for First Holy Communion.[49]

Elderly immigrants may face the problem of a past that is entirely interior, with no buildings or landmarks to associate with childhood, and with forebears. The immigrant has to overcome three kinds of distance—spatial, temporal, and cultural, and his expressions emphasize a distinctiveness that is ethnic as well as generational. Both immigrant and native, however, grapple with distant worlds, transforming them into "independent universes," as Robert Cantwell puts it, often "freed of temporal order." The immigrant's journey, he further observes, reminds us of the journey we all undergo,

. . . the inward migration from youth to age, which carries us to that intellectual and imaginative shore from which we behold a world left behind, our world, or native land in which our identity is rooted and which has become, by virtue of inward or outward migration, an object of contemplation and a center of order which by reflection we can transform into a vision of existence.[50]

In his basement in Chicago, the 80-year-old Vilius Variakojis puts a stop to time, recreating in miniature scenes from his childhood village in Lithuania. The models, featuring the windmills typical of the region, very specifically recapture Variakojis' childhood, as Elena Bradunas noted:

The windmill model recreates one that stood near his family farm. He remembers swinging on the sails of the windmill with his childhood friend, the miller's son. The adjacent farmstead is his own: the family house, outdoor sauna, animal barn, granary sheds and outbuildings are constructed according to scale and arranged exactly as they once stood—even the flowerbeds, trees, and grandfather's bench under the birch.[51]

When he was a boy in western Sicily, Vincenzo Ancona learned to weave baskets, most of them containers for the fruits of Mediterranean vineyards.[52] However, by the time he immigrated to Brooklyn in 1956 at the age of 40, basket making was a thing of the past. The introduction of plastics after World War II had made the crafts that relied on natural materials obsolete. Even if Ancona had wanted to revive the skill he had learned in childhood, the materials were not readily available in Brooklyn, nor were there many grapes being harvested in the city.

The skill, however, remained within him, and when he was in his 50s a friend showed him some Sicilian baskets made of telephone wires, which inspired him to try basket weaving again, using the urban materials of industrial waste to reproduce the agrarian past they had supplanted. But the material, unlike the original fibers for baskets, was extremely thin, malleable, and brightly colored. His work was automatically miniaturized. In his hands the miniature baskets easily gave way to tableaus of scenes in which the original baskets were used. By the time he retired in 1979, he had gone beyond baskets to representations of traditional life.

With the *quadri*, as he calls the scenes, he can surround himself with evidence of the agrarian Sicily of his childhood, a world that is, in his words, *tramontato*: "faded," "vanished," "outmoded," or "forgotten."[53] "This is a world that now has vanished," he says, "I have it." Ancona's work isolates recurring activities associated with agrarian work and food production in Sicily: fishing, hunting, herding cows, harvesting grapes, threshing wheat, and drawing water from the town well.

Vincenzo Ancona's works are also cues for stories. "To hear Ancona speak about the subjects of his work is to see the quadri live," writes Joseph Sciorra.[54]

We notice that in some instances the artist breaks the time barrier by representing various periods of life simultaneously. "As I approach the

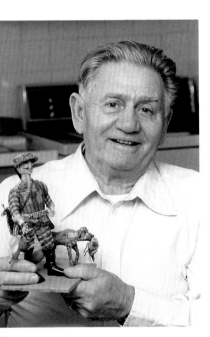

Vincenzo Ancona, age 72, Brooklyn, New York, 1987. Photograph by Martha Cooper.

The Hunter, *a telephone-wire sculpture by Vincenzo Ancona, Brooklyn, New York, ca. 1978 (cat. 2).*

I was able to make a hunter who is returning from the hunt with his rifle on his shoulder, the bag slung around his back, and carrying a pheasant in his hand. Satisfied, he smokes a cigarette.
Vincenzo Ancona

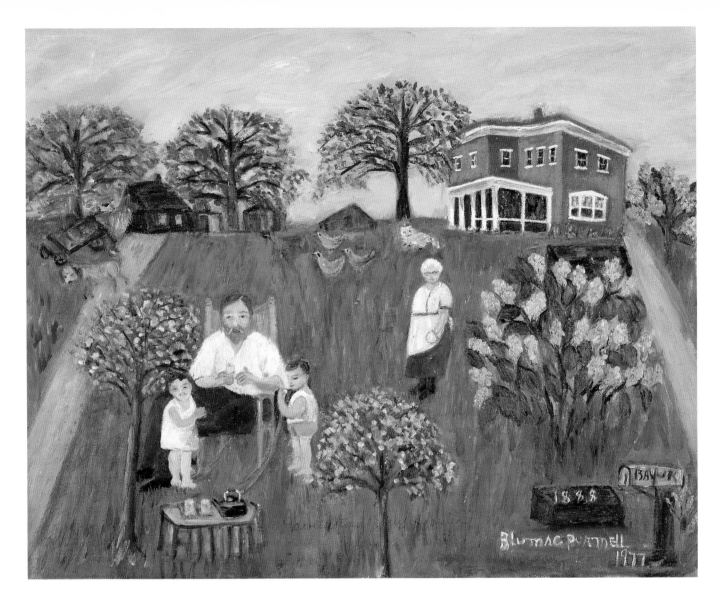

Recollections of My
Homestead, *a painting by*
Bluma Bayuk Rappoport
Purmell, age 98, Philadelphia,
Pennsylvania, 1977 (cat. 31).

Largely autobiographical, Ray Faust's paintings portray traditional aspects of small town life that she witnessed as a child in the now-vanished Jewish communities of Eastern Europe. This painting, Blessing the New Moon in the Wintertime, *depicts her childhood memories of Kiddush Levonnah, the monthly ritual blessing of the new moon (cat. 10).*

I am painting a life that is lost when I am painting Jewish life.
Ray Faust, *age 86*

Blessing the New Moon in the Wintertime
by Rachel Ray Lehrer Faust

When the astronauts
Made their first steps on the
moon
A scene of my childhood
 came to my mind:
Blessing the new moon on a
winter night:
 A very cold night,
The roofs with snow are white,
The frost is freezing,
A circle of Jews stand
With their prayerbooks in their
hands.
Their eyes are looking
 to the moon.

They give thanks,
And praise the Creator,
For the gift:
For the sun and the moon
And for all the stars
 in the skies
They bless His beloved name,

For determining the laws of
nature
They bless the Creator of the
world,
Who is very holy,
And commanded the moon,
To renew itself each month.

threshold of Completeness," writes Bluma Purmell, "I am all ages simultaneously. All my experiences live within the same framework."[55] We see this experience, dependent upon long living, vividly depicted in Burghardt's mural, and in the collected paintings by Bluma Purmell and Ray Faust.

Bluma Purmell, whose father founded the Jewish farming settlement at Alliance, New Jersey, in 1881, painted herself and her brother as children at their father's knee in 1888 in *Recollection of My Homestead*. Again, as we have seen in the work of other elderly artists, Bluma Purmell's art commemorates recurring aspects of life: the daily bath; her father's storytelling; the farm chores of planting, irrigating, and harvesting; doing laundry; and times and places for observing "the sacredness of life."

Like Robert Burghardt and Bluma Purmell, Ray Faust also paints herself into the scenes of a now vanished way of life she witnessed in childhood in the East European Jewish communities that were destroyed in the Holocaust. Born in Tomashow, Lubelsky, in Poland at the turn of the century, she immigrated in 1920 to New York City, where she resides to this day. Like Bluma Purmell's art, Ray Faust's paintings serve to illustrate portions of her oral and written memoirs, which she is busily engaged in writing.[56]

Around the time of the first moonwalk in 1969, Mrs. Faust wrote a poem, "Our Flag on the Moon." The poem, based on her girlhood memories of *Kiddush Levonnah*, the monthly blessing of the new moon, links the moonwalk with an ancient Jewish ritual. Long before the moon literally became a place, it was sanctified each month in its new phase. The moon's cycles were a reminder of the historical phases of the Jewish people, who, as the Birnbaum *siddur* ("prayerbook") puts it, "reappear after being eclipsed." Thus for Mrs. Faust, the moon, the gift of the Creator, an object of ritual, the source of the calendar, and a reflection of the Jewish people, was properly Jewish turf millennia before there were footprints on it. Both her painting, *Blessing the New Moon in the Wintertime*, and the moonwalk are seen in a fresh

*A circle of Jews
On a cold night
Give orders
To the Creator's splendor:
 Praise the Creator, you
heavens!
 Praise Him, you angels,
 Praise Him, sun and moon,
 Praise Him, all you stars,
 for the gift
 he gave us.
The Jews look at the Heavens
 and gaze,
For his creation,
They give Him praise.*

*A cold wind blows.
The pages of the prayerbooks
 flutter,
The hands freeze,
The circle of Jews,
Greet one another*

*Peace to you!
To you also peace!
Shalom!
A good omen, and good luck
To all of us.*

*A circle of Jews
Looking at the moon,
They praise the Creator
of the Heavens.
They say:
 David, King of Israel
 lives forever!
The Jewish people
Will also live forever,
As the sun and moon
And the bright stars.*

*In that circle of Jews,
I see my father.
The Jews are
The oldest astronauts.*

light in her poem. The little girl in a red dress, viewing the scene from behind a fence, is Mrs. Faust, the child witness to her life.[57]

Bestowing the Past

The forms that crystallize the past become focal points for interaction between the artist and his or her audience. Certain aspects of miniaturization, and the representation of salvage materials—the scraps and souvenirs comprising collections—into compendia merit close attention. What is it about miniatures and compendia of scraps and souvenirs that makes them bearers of selves, and under what circumstances do they carry the living past forward?

Miniatures

We have touched on the theme of the return to origins in life review projects. In miniatures this return is amplified. Stewart observes that the miniature is located at both ends of the life spectrum—"at a place of origins (the childhood of the self) and at a place of ending (knickknacks of the domestic collected by elderly women, or the model trains built by the retired engineer)."[58]

The miniature in some ways imitates the distant past, diminished in perspective as the miniature is diminished in size. The "old way" of doing things is recalled by the elder as it was first seen through the eyes of a child. Susan Stewart writes that

. . . the world of childhood . . . presents in some ways a miniature and fictive chapter in each life history; it is a world that is part of history . . . but remote from the presentness of adult life. We imagine childhood as if it were at the end of a tunnel—distanced, diminutive, and clearly framed.[59]

Her allusion to the "world" of childhood reminds us that each stage of life is a kind of world that envelops us in the present, but which in retrospect lives only within us. In miniatures we can exteriorize this interior world of the past, making it possible to share more fully with witnesses. "In their lifelike wholeness," writes Maxine Miska and I. Sheldon Posen, miniature artifacts "give us a sense of a world grasped in the hand and yet lost."[60]

Csikszentmihalyi writes, "Toys are important shapers of the self in childhood and often continue later in life as symbols of different 'leisure' pursuits."[61] For the adult, the miniature is an articulation of the self, and the toys they make for children are ways of influencing the development of young selves, by giving them gifts of the self. As Csikszentmihalyi notes:

One of the best ways to create bonds between people in most cultures is through gifts. . . . Embedded in the context of exchange, objects become containers for the being of the donor, who freely gives up part of him or herself to another. . . . This is not a metaphorical tie, for what has been exchanged is real energy.[62]

Some of the miniatures elders give to children are toys that encapsulate the places of their own childhoods. These toys—simultaneously for remembering the past and fantasizing about the future—are important tools of cultivation for helping the future generation to define itself. Thus Ed Hazelton gave to his grandson Jason, aged three, a sneakbox that was simpler and smaller than his other miniature sneakboxes. Pablo Falcon, a retired carpenter from Puerto Rico living in Brooklyn, makes toys that

. . . show Puerto Rican children raised in Brooklyn the kinds of Christmas presents their parents used to receive on the island, when people had little money, but had the time and skill to make beautiful objects from leftover materials. The toys are

miniatures of old-time farm machines and tools, and teach urban children about a world now gone.[63]

A passion for detail distinguishes adult miniatures from childhood toys. The elderly miniaturist and his peers are connoisseurs of such detail. In the face of a growing inability to affect the physical world on a grand scale, they attend closely and authoritatively to the world on a reduced scale.

William Drain's miniatures are widely admired for their detail. In substance, they are the stuff of the northern woods. His six-inch, articulated lumberjacks are made of maple and white pine. No two of them are alike. They wear "Smoky the Bear" hats and insignia on their bill caps. They ice the roads with water pumps. They harvest timber with cross-cut saws and haul it away on bobsleds driven by teams of horses. Each pine horse has a mane and tail of birch shavings.

Members of the same generation depend on each other for affirmation. Recalling the horse-drawn snow rollers he'd operated as a young man, Ed Cowdry of Vermont set about making one from memory. As he told Jane Beck, "When you start from nothing, just from memory—no patterns, nothing—you got to do a lot of figuring." Gradually the minutiae emerged, and a six-horse team, reduced in scale and properly harnessed was the result, but not the end of the story. "When I finished," he told Beck, "I took it over to Clyde Hastings 'cause he'd rolled the roads for a quite a while. He looked it all over and said 'That's pretty near perfect. That's what I call art.' "[64]

Salvage Art, Souvenirs, and Compendia
The materials used by some of the artists are worth noting. William Drain and Ed Hazelton, in commemorating the places of their youth, relied on native materials familiar to them in youth and still locally available. Drain used maple, pine, and birch to depict the scenes of the north woods, and Ed Hazelton used "Jersey cedar" because, as he says, "a sneakbox has to be made of cedar. That's our wood."[65] Local sawmills provide Hazelton with scraps of cedar for his miniatures.

Vincenzo Ancona's art is also a kind of salvage art, created from a different kind of leftover—the debris of contemporary urban life. Ironically, he makes the telephone wire bespeak the rural way of life it has usurped.[66] So does Pablo Falcon, who transforms cast-off tin cans, plastic containers, and glass bottles into miniature farm equipment, traditional instruments, and a scene of the sugar cane harvest as he remembers it. We notice too, that the bottom of Burghardt's mural is strewn with such toys, homemade from discarded materials.

In contrast to the salvage art of Ancona and Falcon, we have the compendia of souvenirs, a kind of salvage art that carries material aspects of the past forward.

Zenna Todd's crazy quilt, incorporating scraps of clothing from every member of her family, is a compendium made from the souvenirs of life experience. Susan Stewart points out that such souvenirs are "intimately mapped against the history of an individual . . . found in connection with rites of passage (birth, initiation, marriage, and death). . . .

Such souvenirs are rarely kept singly; instead they form a compendium which is an autobiography. Scrapbooks, memory quilts, photo albums, and baby books all serve as examples.[67]

Thus Zenna Todd folds into her quilt a piece of lace from her son's baby petticoat, a bit of the dress she wore to his wedding, and a scrap from a pair of pants she bought for her husband in 1948. The use of these souvenirs multi-

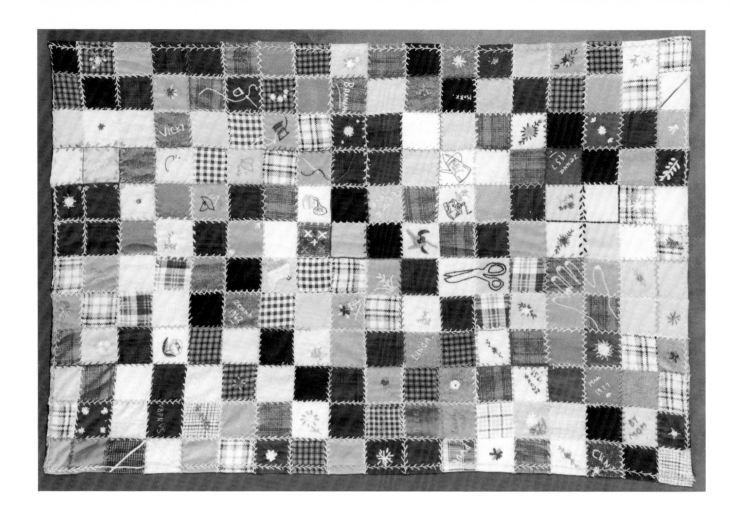

Crazy quilt made by Zenna Todd of Ennice, North Carolina, in 1978.

I put a whole lot of work into this quilt. I made it to last so that my children can pass it down to their children and grandchildren, and they'll have something to remember me by.
Zenna Todd

plies the significance of the quilt. The viewer can not only see and remember the family experiences depicted, but can also touch something that was physically part of the original environment or event.[68]

Forms assembled from souvenirs like quilts and tools forge-welded into gates enrich the potential for narrative, allowing entry into the past at any point. As with the other objects, they are completed in narrative, but the narrative is often the collaborative result of a dynamic interchange between artist and viewer.

Collections: Anticipated Memories

It's a poor sort of memory that only works backwards.
The Red Queen, *Through the Looking Glass*

Collections that represent lives may begin years before the actual work of presentation begins: in acts of prospective remembering, people save things, anticipating in a way just what they will remember. We see the impulse to spread the life out simultaneously—overcoming both discontinuity and entropy—in compendia of artifacts, photographs, etc. that recombine all of the items and give them fresh meaning.

Rod Rosebrook spent years gathering tools connected with his way of life: barbed wire, brands for sheep and cattle, horseshoes, leather punches, bits, bridles, hames, wrenches, pumps, pipes, and stove tops. When he retired he foraged for things in junk piles and on the old homestead to complete his collection. Then he set about the task of artfully displaying the tools.

Rod Rosebrook collected these branding irons, made by Oregon ranchers and blacksmiths, for his "home museum" of western tools and memorabilia (cat. 52).

Rod Rosebrook, an 86-year-old retired rancher from Redmond, Oregon, 1987.
Photograph by Karen Willard.

Rod Rosebrook's "home museum," Redmond, Oregon, 1979.
Photograph by Goodwin Harding.

For 20 years or so he arranged on his barn some of the miscellaneous fragments associated with his generation's past. Others he forge-welded into round montages bound by rims of buggy wheels, or reframed them into gates that are also portals to the past, especially for the old-timers.[69]

Like similar structures found in yards and gardens all over the country, Rosebrook's fence is a compendium of place and of the occupations and tools that shaped that place. In his case it is about the kind of work that most people associate with that part of the West—mining, ranching, agriculture, and the railroad. Such a structure, resembling those often displayed in yards and on home exteriors, whether urban, suburban, or rural, comprises what John Dorst has described, speaking of a similar fence elsewhere, as "a discourse on the human battle against entropy and disorder."[70]

Other artists presented here have created memory collections. Joe Reid has created a collection of miniature boats, representing the contributions his generation of boat-builders made to the design of local vessels. Mrs. Faust's collection of paintings depicts the complete cycle of Jewish holidays, together with her own biography. "Each painting," she says, "is a chapter of my life."[71]

Such collections, with which the elderly artist may surround him- or herself, make many phases of the past "simultaneously and enduringly present," as Barbara Kirshenblatt-Gimblett points out.[72]

Thus, presenting artifacts and settings on a reduced scale has one advantage over life-sized collections. With miniatures the artist can be surrounded with things that simply would not all fit in one place otherwise. In that way, they lend themselves to simultaneity in ways that life-sized collectible objects do not. Jehu Camper's home museum began in just this way:

In traveling around the neighborhood, and working, I would observe that the things our forefathers had used to make their livelihood were being destroyed. I knew that, someday, some people would want to see those things in their original form. I collected a few things, and I still have an old scything cradle and harrow. But it was just too costly and I didn't have the money. So I conceived the idea of making replicas of most of the things out of wood so I could put a lot of them in one place.[73]

Thus, constrained by the size of the originals, Mr. Camper reduces the world to a manageable scale, and then uses that reduced physical world to enlarge the social one. We notice that Camper made the miniatures in anticipation of the curiosity of others. The miniatures are not only lures for memories, they are lures for drawing the world in. "I use them to tell stories," says Rodney Richard of his carvings. Things that once were tools for shaping the world have become powerful social tools.

The Importance of Witnesses

Self-integration is, of course, only one reason for recovering the past. Sharing it is another. These two functions work in tandem, as to borrow from Robert Frost, "two eyes make one in sight."[74] Without witnesses the expressions are like one hand clapping. All of the forms displayed in this exhibit are catalysts for a dynamic interchange between creator and witnesses.

Sometimes these witnesses are members of the same cohort, for whom life review projects are like bookmarks in pages of the past. "My husband and I often take [the memory quilt] out and just look at it for hours," says Amber Densmore. "It brings back all our memories."[75]

Some people emerge as curators of the past for their cohorts. Through his music, Abraham Lass, who once played the piano for the silent movies, revives the past for elderly friends who love to dance to music from their courtship days. "Whenever Abe plays the piano," his wife says,

This music might not mean
a thing to you, but it's 1925,
it's the year I fell in love.
Abraham Lass

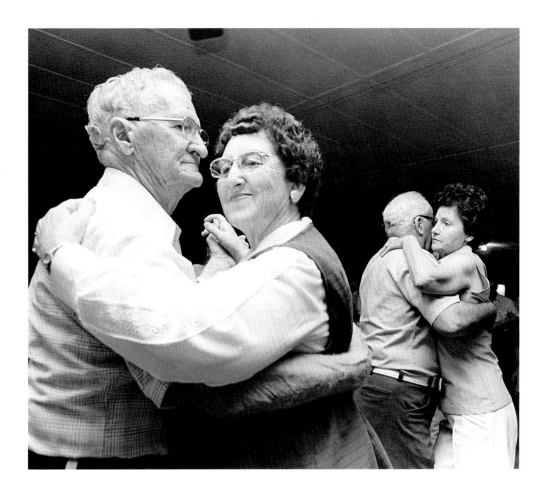

all the old girls just lose themselves—go back into memory. It awakens them. . . . Suddenly the years wash away. No wonder they're all daffy about Abe.[76]

Joe Reid, as a "memory wright" for his cohort, was asked to make a scale model of a garvey he'd built for a man who could no longer work the bay, but wanted to keep the boat as a memento. Reid replicates the process he uses for building full-size boats in his miniature, which he builds "by eye" on a miniature form in a room in his house. And Reid himself was one of Ed Hazelton's "memory clients," agreeing to trade a miniature garvey for a miniature sneakbox.

Other artists point out the intended worth of their work for the younger generations. Ethel Mohamed and Viola Hanscam produced scenes of the past with their children in mind.

Roland Rochette of Vermont, whose working life as a logger and farmer is captured in collages, did it with youngsters in mind. His work is motivated in part by an awareness of how different the world is for the present generation of children, and to bridge the gulf between such disparate experiences of childhood. "I like to do things that the younger generation haven't seen," says Roland Rochette. "I think it's kind of instructive for the younger people. Younger people, a lot of them, don't believe what the older people did and how hard they worked."[77]

But often we find that both groups of witnesses—peers and progeny— are simultaneously implied, as Burghardt observes of his canvas:

I hope that everyone can get something out of this mural—that older people will re-member things from their old neighborhoods and that young people will be better

able to understand what their parents and grandparents went through. I would like my descendants to say someday, "So this was what life was like in New York. . . ."[78]

Audiences interact with the creator differently, depending upon whether or not they are contemporaries of the artist. Of his dual audiences, Rod Rosebrook observes, "Seems like young folks that come don't seem to appreciate it like the older folks do. The older folks will come through: 'Well, Uncle Jim had one like that—wonder what happened to it?' They lived it."[79]

Similarly, Vincenzo Ancona depends on his older audience for a kind of affirmation the younger audience cannot give. "Those who know it will admire it and say, 'Oh, he even thought to put. . . .' The little things are beauty." This kind of response is deeply gratifying.

"When I tell my poetry to old people like me," says Mr. Ancona, "from the first word to the last word they nod their heads, saying, 'Yes, yes.' They know—they have lived it too."[80]

Where there are compendia of souvenirs we find a rich environment for storytelling. The home museums of many of the featured elders in this exhibit provide such settings.

Living Museums and Their Curators
Earnest Bennett, Ethel Mohamed, Rod Rosebrook, and other artists have created "living museums" in their homes, where they are the curators of a tradition. "If you want to see a living museum, come here!" says Vincenzo Ancona.

The Old Well, *a telephone-wire sculpture made by Vincenzo Ancona, Brooklyn, New York, ca. 1978. Mr. Ancona creates miniature scenes of his Sicilian homeland in brightly colored telephone wire, using basket weaving techniques he learned as a boy. Through his " little scenes" he shows his grandchildren something of what life was like in the agrarian Sicily of his youth.*

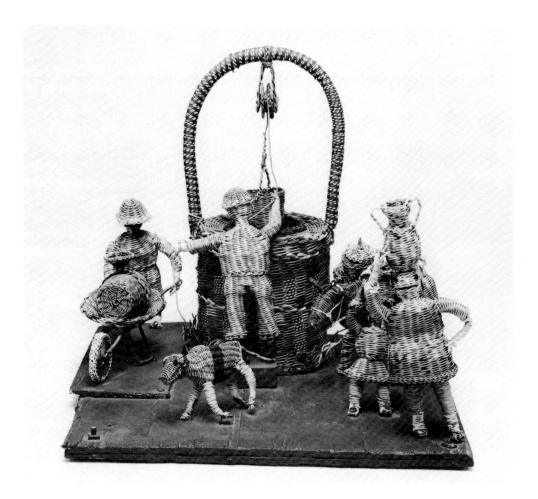

The Cowherd, *a telephone-wire sculpture by Vincenzo Ancona, Brooklyn, New York, ca. 1978 (cat. 1).*

The seated cowherd works patiently milking the cow. Afterwards, the milk is set aside to be brought to where the cheese is made. The cow wears a collar with a beautiful bell. When the cow moves, it rings and attracts the customers' attention in town.

Vincenzo Ancona

Ed Hazelton, a retired carpenter in his 70s, has deliberately concentrated many regional and cohort keepsakes in a room off to one side of his house, which he calls the "Bull Room." It is the setting in which he entertains visitors. The visitors who give the room its name are the elderly men with whom he grew up. These men are intimately acquainted with the items that cover every surface in the room and hang from the ceiling—artifacts snatched from the world as it grew older: decoys made by old masters like Joe Paul and Joe Tom Cramer; spears for harvesting eels in winter or summer, and split-oak pots to put them in; ice-hooks for hauling sneakboxes over various kinds of ice; dozens of carpenter's planes worn down by the hands of master boatbuilders like Rube Corlies; a painting of hunters the men all know gunning on Sandy Point for ducks, flanked by a drake and a hen decoy that Ed made and carefully arranged there.

All of the artifacts become ways to teach visitors who are too young to have known this world, or who grew up outside of it. The place and its past are distilled—freeze-dried, actually—to be fully comprehended when narrative is added.

To encapsulate and speak about culture is properly the work of elders. Elijah Pierce's cane, Ancona's wire people, Ethel Mohamed's embroideries, Rodney Richard's whittled lumberjacks—all celebrate the traditional cultures that produced the skills of their makers. They are not only enacting tradition, they are reflecting on it—curators of tradition.

As Vincenzo Ancona says, "The older people enjoy the taste of the past, and young people who have never enjoyed it, never seen it, they say, 'You have a photograph inside you. For you older people it's a life, but for us it's a story.' And they want to know."[81]

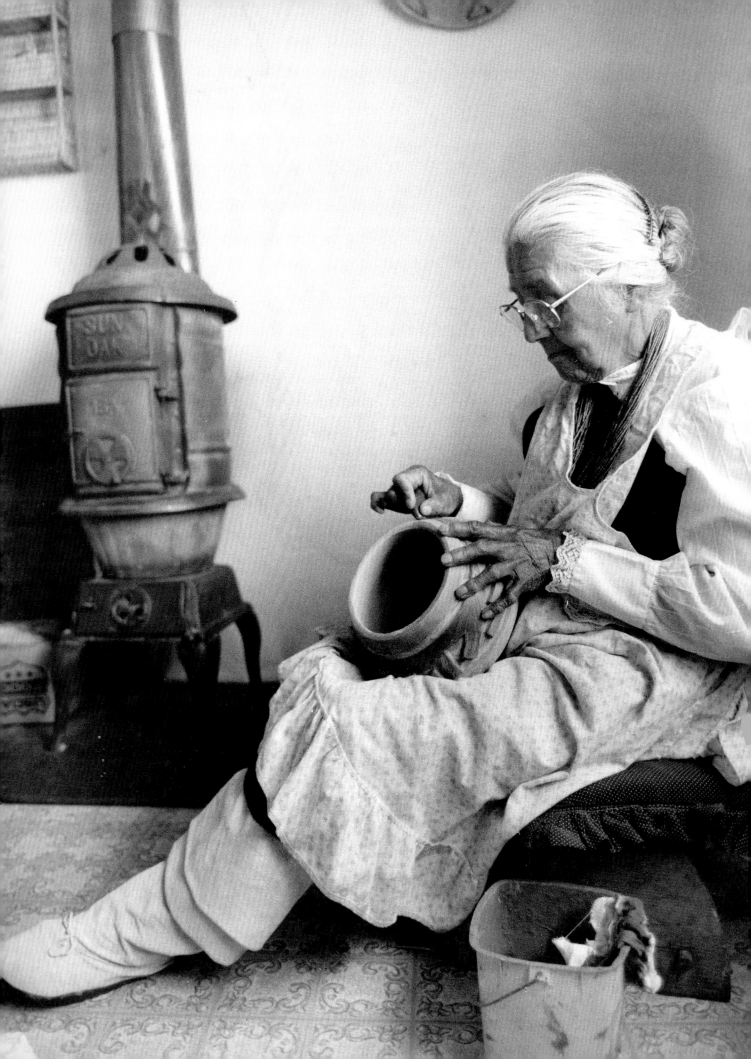

Chapter 3

Mastery: A Lifetime of Knowledge and Experience

A fox is smart because he is old, not because he is a fox.
Argentinian proverb

"Old" is an adjective that often accompanies the noun "master." Stone carvers, woodworkers, and other highly skilled artisans speak of learning from the "old masters" almost automatically, as if the two words were not only inseparable, but synonymous.[1] In the fishing communities of New Jersey's Delaware Bay, the captain of a schooner, no matter what his age, is called the "old man," as if he has to be thought of as old in order to occupy the position of authority.[2] Even the Brothers Grimm, as Barbara Kirshenblatt-Gimblett points out, portrayed their star narrator as a mature peasant woman, when in fact most of the tales were collected from their own friends and family. They assumed that, in her words, "a venerable storyteller would make the tales seem more authentic."

Why is it that old age is so often associated with mastery? Is it that mastering a tradition requires time? There are certainly many young masters who exhibit great virtuosity of technique in their chosen medium. Is it then honorific? Do we simply admire longevity? What is the nature of mastery in old age?

Robert Plant Armstrong in *The Powers of Presence* distinguishes between two kinds of works that bear power—those governed by an aesthetic of virtuosity and those governed by an aesthetic of invocation. Works of virtuosity, he writes, are characterized by excellence of technique and expression. Works of invocation, on the other hand, bear "the presence either of identity . . . or of effective process (management of the universe). . . . They have both social role and status." Very importantly, Armstrong tells us, "the work-in-invocation tends to exist in an ambient of time; what has happened to it in the past is a portion of its being." These artifacts are "empowered by their history."[3]

Old people, like works-in-invocation, are also "empowered by their history"—their past is a vital part of their being, a source of strength and knowledge, of wisdom and maturity. We call upon them for their skill and experience, we invoke their powers of discernment and judgment, we summon them forward to help us manage our universe, to provide us with a sense of continuity, connection, and belonging.

The old also know the power of virtuosity. After years of practice and refinement, many older artists achieve mastery of their traditional art form, whether it be cooking, quilting, carving, or fiddling. But more than techniques and skills are mastered. Older artists and craftspeople also accumulate a breadth of knowledge, insight, and understanding born of a lifetime of learning. And while old age may eventually bring a decline in physical

Margaret Tafoya, an 83-year-old Pueblo potter from Santa Clara, New Mexico, 1987.
Photograph by Barbaraellen Koch.

69

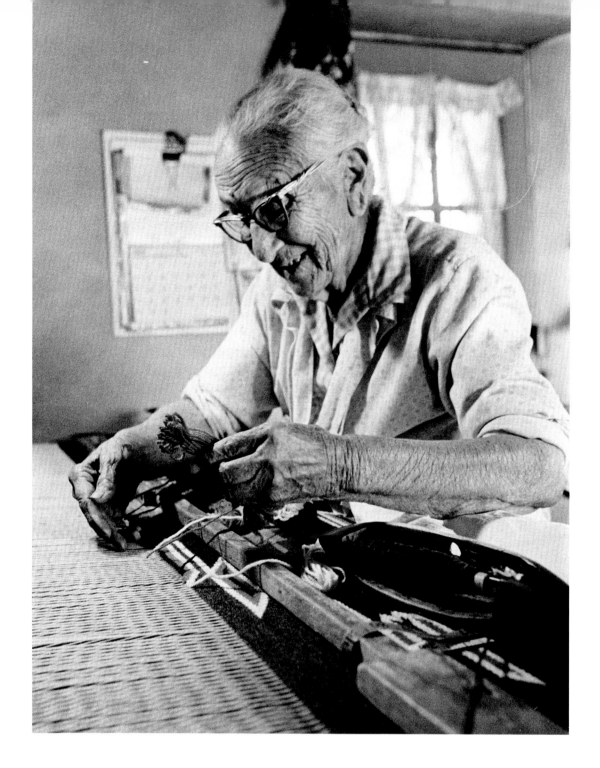

*I love to weave. I'll stop
weaving when I can't move
anymore. Until then, you'll
find me dancing on the loom.*
Agueda Martinez

strength and ability, older artists continue to grow in knowledge. "Perhaps
the older musicians and dancers could not jump so high nor move so quick-
ly," writes Bess Hawes, "but the smaller movements and less frequent notes
so often had the elegance and authority that come only from mastery and
from experience."[4]

In every community, there are older people who are recognized and
sought out as authorities on a myriad of subjects from local history to farm-
ing, from boatbuilding to making soggy coconut cake. For her family and
neighbors, Agueda Martinez, a 90-year-old Hispanic rancher and weaver
from Medanales, New Mexico, is an invaluable resource, not only for the
weaving skills that she has perfected over a lifetime, but for her mastery of

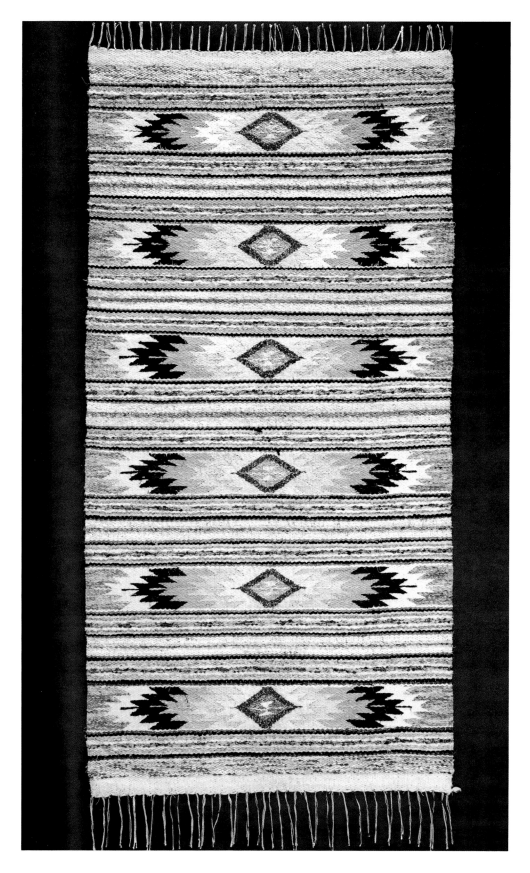

Rag rug made by Agueda Martinez from Medanales, New Mexico. (Detail in color on pages 2 and 3.) Doña Agueda is widely known for her brightly colored rag rugs woven in traditional Hispanic designs. She made this rug in 1987 at the age of 90 (cat. 21).

the craft of life—of cooking, canning, ranching, raising children, planning weddings, making adobe bricks, leading town meetings, and much more. "We go to her for everything," says her granddaughter Norma Medina. "Even if we think we're pretty good, we don't have it all. We still need to go to her."[5] Doña Agueda's mastery is in her mind, as well as in her hands.[6]

Similarly, Abraham Hunter, an older farmer from Percy Creek, Mississippi, is a central figure in his community: "He's a master of the crafts of necessity," says folklorist Worth Long, "a sorghum maker, a blacksmith, a master farmer, a toolmaker, basketmaker, chairmaker—he does everything!"[7]

At age 83, master butcher Albert Weisfeld still works an eight-hour day along with his wife, Sarah, and their two sons in the small neighborhood grocery store that they have owned and operated in Washington, D.C., for over 50 years. They are not only purveyors of groceries and finely cut meats, but of recipes, friendly advice, neighborhood news, and local history. Rooted in one place for more than half a century, the Weisfelds are valued by their customers as an important source of knowledge about the community and about life in general. "He's not only a great butcher," says one of Mr. Weisfeld's customers, "he's a philosopher, advisor, and friend."[8]

The knowledge and experience that the elderly have accumulated over the years gives them a broad perspective and synthetic vision that, unlike technical virtuosity, is unique to old age. Simone de Beauvoir observes that

Abraham Hunter, a farmer from Percy Creek, Mississippi, shows his grandson Stevie how to make a cornshuck mule collar, 1975. Photograph by Roland L. Freeman.

Albert Weisfeld, an 83-year-old master butcher from Washington, D.C., has been cutting meat ever since he was "big enough to reach the meat block"—about 75 years. Photograph by Karen Kasmauski, 1987.

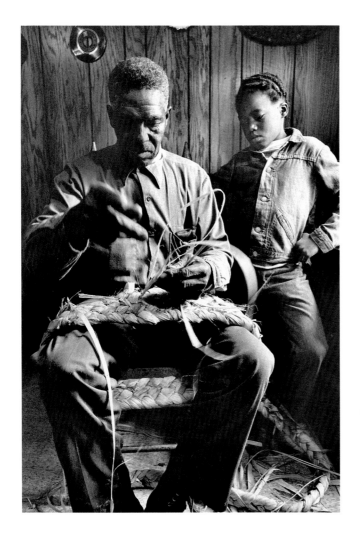

. . . the elderly man is capable of a synthetic vision forbidden to the young. In order to be able to appreciate the importance or unimportance of some particular case, to reduce the exception to the rule or allot it its place, to subordinate details to the whole . . . one must have observed an enormous number of facts in all their aspects of likeness and difference.[9]

After years of observation and trial and error, thought and action, elders gain the ability to manipulate a broad range of variables and can speak with authority on a diversity of approaches to their life's work. They have acquired, writes Karl Mannheim, a "framework of usable past experience" with which to evaluate and handle the many different situations that come before them, a framework not readily available to the young for whom "life is new" and "formative forces are just coming into being. . . ."[10]

Rick Stewart, a young Appalachian cooper who learned his traditional skills from his grandfather Alex Stewart, says:

I've been coopering for 11 years now, but grandpa had 75 years on me. He knew any situation that came around. When I had a problem with a piece of wood, I could say, "What's goin' on?" And he'd explain it to me. He knew all these things because he'd actually lived them.[11]

Joe Reid, a 77-year-old bayman and boatbuilder from Waretown, New Jersey, is an acknowledged master of his tradition. Over his long career, he

Joe Reid, a 77-year-old bayman and boatbuilder from Waretown, New Jersey, in the workshop behind his house, 1986.
Photograph by Joseph Czarnecki, American Folklife Center, Library of Congress.

Mrs. T. A. "Mamoo" Lewis with her famed soggy coconut cake, Knoxville, Tennessee, ca. 1979.
Photograph by Harlan Hambright.

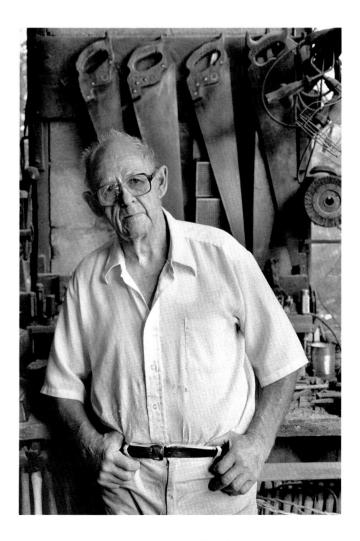

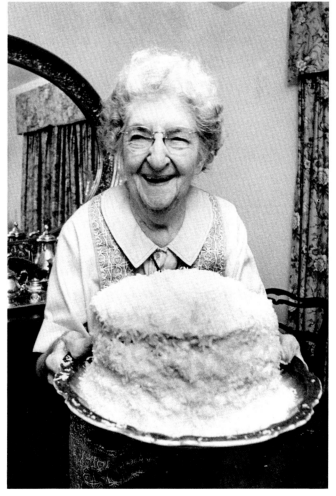

has experimented with many different kinds of wood and can hold forth with authority on the merits and shortcomings of each:

Oak, maple, ash, hickory, that's one class. Then spruce, cedar, white pine, that's in another class. They're soft woods. Red cedar is in between—not as soft as white cedar, and holds together better—the grain doesn't split off like white cedar. . . . Our [Jersey] cedar has a long grain, and you can steam it. Every night we'd steam a board up in the bow, clamp it, and leave it overnight, next morning it'd be shaped. If we did that with southern cedar, next day it'd be broke right in two. We didn't know that until we started using it. . . . White cedar's the nicest wood to work with, for boatwork or anything like that."[12]

In another artistic realm, Mrs. T.A. "Mamoo" Lewis of Knoxville, Tennessee, is renowned among family members, neighbors, and friends for her mastery of the art of making the perfect soggy coconut cake. Mamoo devoted years of practice and experimentation to refining her cake, working hard to get all the many variables—ingredients, cooking temperatures, measurements—just right, striving for excellence in her medium. Her children write of her abundant knowledge of her main ingredient—the coconut:

In working with the coconuts, when she would punch a hole in it and let the juice come out, the first thing she was interested in was whether the juice was sweet. So she'd taste it. And if it was a sweet milk, she'd say, "Well, this may be a coconut." Then after we cracked it, she'd take a little taste of the meat to see if the meat was sweet. Sometimes the juice is sweet and the meat is like wood or soap. And then sometimes the juice tastes like soap, but the meat will be just as sweet as it can be. She was always a great taster in all her cooking. And she would make a judgment as to whether she would use the juice or the meat or both or neither.[13]

Mamoo, in her inimitable style, set the standard for soggy coconut cake in her family, and try as they might, no one can duplicate it. Like master boatbuilder Joe Reid, who shuns blueprints and builds all his boats "by eye," Mamoo never used a recipe. "She was a taster and a tester," her children say with pride. "A recipe and a dress pattern, she lived above them!"[14]

Captain Alex Kellam, an expert fisherman from Crisfield, Maryland, was highly regarded for his extensive knowledge of fishing and crabbing garnered from 70 years of experience working the waters of the Chesapeake Bay. "I learned fishin' from observin'," he said.

Those crabs know where to go when they molt or shed. They don't go on the bare bottom. It's got to be grass, because when they're soft, they're vulnerable. They get in that grass and hide so their enemies can't find them. And 'course, I know where they go, and all the old-timers do. . . . It all boils down to experience. You don't get that much of it in your youth. You only get that in later years when you're out.[15]

Growing old, we can see, is not only a matter of the accumulation of years, but the cultivation of experience. As an 83-year-old Hispanic farmer from Cordova, New Mexico, said of his wife of over 50 years:

She is not just an old woman, you know. She is old, advanced in years, *vieja*, but in Spanish we have another word for her, a word which tells you that she has grown with all those years . . . to become not only older but a bigger person . . . she is *una anciana*.[16]

Authenticity: A Certain Kind of Knowledge
The old are a "primary source" of culture and tradition in their families and communities. They are, as Barbara Kirshenblatt-Gimblett writes, "living links in the historical chain, eyewitnesses to history, shapers of a vital and indigenous way of life. They are unparalleled in the vividness and authenticity they can bring to the study of local history and culture."[17]

Michael Alpert, a young Jewish violin player and singer from New York, described his excitement when he learned that he could study *klezmer* music, an old-style Eastern European Jewish instrumental tradition, from "the source"—85-year-old Leon Schwartz, a master violin player who had learned and performed this old traditional music more than half a century earlier in Eastern Europe:

We had discovered the old 78s and started hearing the music again, but the fact that there were living practitioners like Leon Schwartz, Dave Tarras, and others—then, all of a sudden, that was a major step. There we were right next to the source. These were the old masters of the tradition and we could study with them![18]

Leon Schwartz is one of few living traditional practitioners of this old-style music left, for the communities in which this tradition flourished were destroyed by the Holocaust. He is not only a master of old tunes and techniques, but of a way of life, of a world that has now vanished. Through his old repertoire, his traditional skills, and his memories of life in the "old country," Mr. Schwartz enables young people like Michael Alpert to gain direct access to their cultural heritage. "It's really been a second chance at grandparents, aunts, and uncles," says Alpert. "Along with my parents, he's given me a sense of my roots."[19]

As witnesses to the life in a region or a family over an extended period of time, the old have a unique perspective on local history and family tradition. "Kings have their wise men, and our family has Uncle Jack," says a young man about his great-uncle who was the keeper of the family lore and oral history.[20] Ed Hazelton, himself a well-respected old-timer at age 73, actively seeks out "old folks" 10 years his senior for what they can tell him about the local area. Through them he enjoys "the best of two worlds":

Every time I visit with them I learn something new, because they were born and raised and spent all of their lives here. They can tell me who married who, who farmed what land, how people lived and how things have changed. . . . They keep me up to date with what is out of date.[21]

Rick Stewart of Hancock County, Tennessee, understands the history of his family because of the stories he heard from his grandfather:

Being with grandpa was almost like reading a history book. He just didn't do the coopering, he taught me a little bit about herbs, and how to make furniture, and he'd tell stories—about family history, community history things that actually happened. I feel like I know my great-great grandfather almost, even though I never met him.[22]

Through his grandfather's lively stories and anecdotes the past came to life in the present, filled with vivid images of people, places, and activities.

Like souvenirs, which allow us to literally touch a part of the past, there is a power associated with older people who carry with them into the present a first-hand knowledge of the past. Like original works of art, the elderly are imbued with the "power of the authentic"; they are a living testimony to the history that they have experienced.[23] For them, as 75-year-old Vincenzo Ancona remarks, the past is not a story, it is a life, and they can describe in vivid and extensive detail all that they have witnessed and experienced over many years. "I came along in the sailboat era," says Captain Kellam. "Life is changed now, it's all mechanized, but in my younger day, it was nothing but sail. You got there by sail or you didn't get there."[24]

Very importantly then, we see that old people have not only accumulated a vast store of knowledge over a lifetime, they are masters of a certain *kind* of knowledge—of traditional repertoires and styles, of old technologies, of

Whittled doll and shoes made by
Alex Stewart, Hancock County,
Tennessee, ca. 1975 (cats. 42,
43).

*I can make anything that can
be made out of wood and I
don't use nails or glue. It's
better than the stuff you buy,
and it makes me feel good
too.*
Alex Stewart

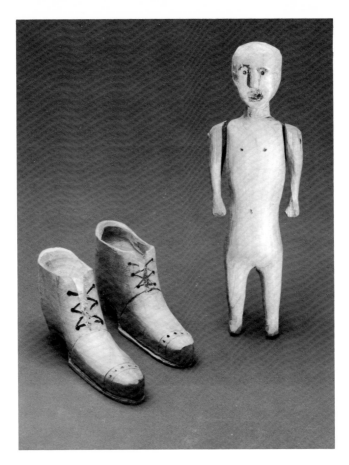

Churn crafted by Appalachian
cooper Alex Stewart and bucket
made by Alex Stewart's
grandson, Rick Stewart, both of
Hancock County, Tennessee
(cats. 41, 45).

*Appalachian cooper Alex
Stewart, age 84, crafts a churn,
Hancock County, Tennessee, ca.
1975.*
Photograph by Robert Kollar,
Tennessee Valley Authority.

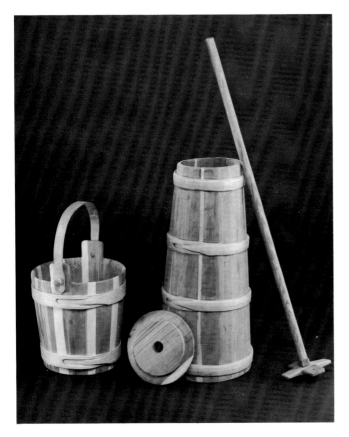

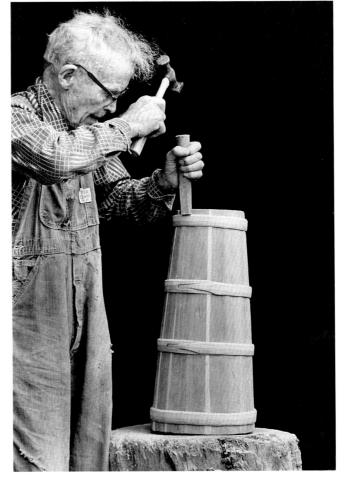

local dialects, customs, and history that, in many cases, because of breaks in the chain of cultural transmission, have been lost to the younger generations.

For example, Sicilian townspeople who want to learn their traditional dialect, proverbs, sayings, songs, crafts, customs, lullabies, children's rhymes, and other expressive traditions that have "vanished" from current usage turn to older people like Vincenzo Ancona to help them recover this lost heritage. "They come to me," says Mr. Ancona, "because I am a jewel for these things."[25] Of the basketry tradition that he learned as a boy he says:

After the war, other materials were introduced to make these things. Plastic destroyed everything. This art is dead. This doesn't exist anymore, even in Sicily where it was born. Now, only the old people know of these things.[26]

Similarly, 84-year-old Luiseño elder Villiana Hyde, one of the last native speakers of the Luiseño language, has written a dictionary for her people so that their language will not disappear with her passing. She is sought out by both young and old for her knowledge of plants, medicines, foodways, songs, and customs and has been instrumental in helping her tribe to recapture their lost cultural patrimony, interpreting materials for the Luiseño "culture bank"—three suitcases that contain archival photographs of the Luiseño people; duplicate recordings of Luiseño music, songs, and speech; slides of traditional Luiseño artifacts; and other reclaimed cultural materials.[27]

When Cherokee basketmaker Lottie Stamper wanted to revive the tradition of double-weave river-cane basketry that had long died out on the Cherokee reservation, she went to the elder women of her tribe to draw upon their knowledge and memories of the old ways. With their help, she was able to work out the complex double-weave techniques and designs, and once again the tradition flourishes among the Cherokee.

And Pang Xiong Sirirathasuk, a recent Hmong immigrant to the United States striving to preserve her culture in a new land, actively seeks out Hmong elders in order to learn traditional embroidery designs and techniques. "I like to interview the old Hmong ladies," she says, "to learn the old designs, to keep Hmong culture alive. The old people know these things."[28]

Like Jewish fiddler Leon Schwartz, Appalachian fiddler Tommy Jarrell is renowned for his old-style repertoire and fiddling techniques that he learned in the early part of this century from his older relatives and neighbors in Surry County, North Carolina. "When you get into them old tunes, ain't nobody in the world can beat Tommy Jarrell!" says his 70-year-old neighbor Robert Sykes.[29] "He's carrying a music that younger people don't have," says Alice Gerrard, one of his students and a long-time friend. Until his death at age of 83 in 1985, Tommy Jarrell taught scores of interested young learners the traditional mountain music of his forebears. But what he taught them went beyond technical virtuosity. A whole world came to life through his stories of people and events, of musical gatherings and dances, of foodways and local customs, of the daily round of life and work in his Appalachian community over the course of his more than 80 years. "His music was bound up with his experience," says Alice Gerrard. "Learning from Tommy, we got the benefit of all those years and all those experiences that were a part of him."[30]

Many times the skills and knowledge that older people have acquired become outmoded by rapid technological and social change. The pace of progress has fallen out of step with the rhythm of the human life cycle. As Simone de Beauvoir writes, "The acceleration of history has caused an immense upheaval in the relationship between the aged man and his activities."[31] Captain Kellam speaks of this dilemma:

In my day, we had respect for the old-timers and we listened to them. It used to be that you had your old expert fishermen who people looked up to. And he knew his marks, and he knew the tides. But now, they've got those depth finders—sonar devices—and those fast motorboats. And so it's equalized it. It's solely eliminated the need for your old-timey expert.[32]

But we cannot afford to waste this knowledge. What one generation wants to forget, the next may wish to remember. The old are a vital resource of cultural information and understanding—living evidence of the rich variety of human cultural possibilities available to us in the world. Their knowledge is an antidote against the threat of homogeneity. By learning what the old have to teach us, we bear a diversity of options into the future, keeping fully supplied a reservoir of possible solutions to inescapable human problems.

Virtuosity: Mastery of Technique

In some spheres of activity, there is a direct correlation between mastery of technique and years of practice and experience. This is especially true of traditions that involve what David Pye has termed "the workmanship of risk"— crafts such as stone carving, woodworking, cooking, blacksmithing, and pottery that are characterized by a great diversity of form, function, materials, tools, and techniques, and that require a high degree of dexterity, judgment, and care on the part of the craftsperson.[33] In these art forms, the attainment of technical virtuosity has everything to do with practice and the accumulation of knowledge over time, and thus, many of the best practitioners are old practitioners.

For artists and workers engaged in such activities, the learning process is an ongoing one. Each day can bring a new problem to solve, new materials to master, or a new technique to practice and refine. When 79-year-old master stone carver Roger Morigi was asked how long he served as an apprentice, he replied, "I've worked for 60 years and I'm still learning! Every time you carve it's a different subject, a different kind of stone. In this trade, you're never complete." Stone carver Vincent Palumbo agrees. "You learn from your mistakes," he says, "all those things you accumulate in your mind and you keep with you, so the next time, you remember, and you change

Double-weave river-cane basket made by Cherokee basketmaker Lottie Stamper of Cherokee, North Carolina, ca. 1968 (cat. 40).

Master stone carver Roger Morigi puts the finishing touches on a statue for the Washington Cathedral, Washington, D.C., ca. 1974. Photograph by Morton Broffman.

technique, you change how to work."[34] Perhaps one of the major differences between an old stone carver and a young stone carver is that one has most of his mistakes behind him, while the other has them before him.

This notion of lifelong learning is echoed by other highly skilled crafts-people. James Reid says of his father and teacher Joe Reid, "I can't think of a single boat that we've done in the last five years that we haven't thought of something that could've been done a little different. Only thing, my father would agree and say that you never really stop learning how to do it until you die."[35] And 85-year-old blacksmith Philip Simmons told folklorist John Vlach, "After those many years, after 50 years, I'm still learning things. . . . I'm still doing things I have never done before."[36]

After years of continuous practice and refinement, many older artists achieve an authoritative mastery of their traditional skills and techniques. Roger Morigi was considered to be at the pinnacle of his career when he stopped working at the age of 71. "When I retired," he tells us, "all the other guys said, 'you're foolish to quit now, you're doing better work than you did 20 years ago!'"[37] And at the age of 82 Appalachian fiddler Tommy Jarrell was said to be playing "some of his most authoritative music ever," each tune "lovingly polished over a lifetime."[38]

With excellence of practice comes the ability and freedom to move artfully within one's tradition. Duff Severe, a 58-year-old saddlemaker and rawhide worker known throughout the West for his expert craftsmanship, is a good example. His nephew and former apprentice Randy Severe describes his saddlemaking abilities with awe:

He's a real master. When he works on his bench, there's no waste, not in motion or materials, it's all fluid. It's really something to watch. And everything comes out the first time to perfection.[39]

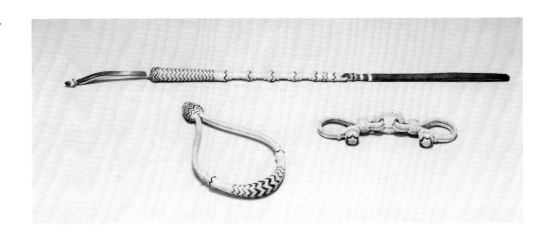

Miniature rawhide quirt, bosal, and hobbles crafted by Duff Severe, Pendleton, Oregon, 1984 (cats. 35, 36, 37).

Miniature saddle made by Duff Severe, a saddlemaker and rawhide braider from Pendleton, Oregon. (Also in color on page 10.) Now that he is older, Duff likes to make miniature versions of the saddles, quirts, and other items of western gear that he has made and used during his long career. Emblems of mastery, the miniatures stand for a lifetime of achievement in his trade (cat. 34).

Making miniatures is ten times harder than the full size work. That's why I like to make them. It really tests your skill.
Duff Severe, *age 58*

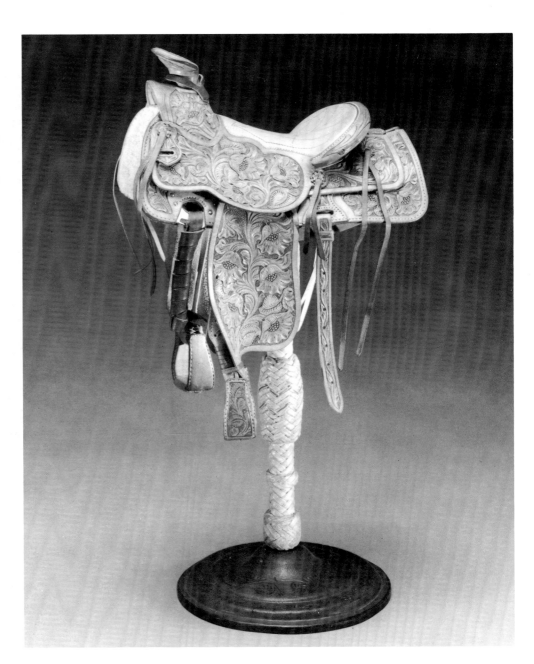

Saddlemaker Duff Severe in his
workshop in Pendleton, Oregon,
1979.
Photograph by Goodwin Harding.

But Duff Severe's technical virtuosity is only one part of the sum total of his knowledge and skill. After 50 years as a horseman and saddlemaker, he has a depth of insight and understanding of his craft that can only come from a lifetime of experience. Randy Severe says:

He was such a valuable teacher because he had the working knowledge and experience. He could not only teach me how to make a saddle, but he had the perspective on why a saddle should be made a certain way, on how you make a saddle adapted for cutting rather than roping. . . . He's an encyclopedia of knowledge that way.

As Duff Severe's apprentice, Randy Severe was the beneficiary of more than 50 years of saddlemaking wisdom and know-how:

I'm really fortunate just to have been able to work with him. . . . By telling me things that he had learned, he was saving me 50 years of trial and error. And, of course, he had the same things passed on to him by the old-timers he learned from. That's a lot of experience![40]

Here we see the chain of traditional knowledge extending across several generations of saddlemakers, each generation benefiting from and building on the experience of those who went before them.

Margaret Tafoya, an 83-year-old pueblo potter from Santa Clara, New Mexico, is another example of an older craftsperson whose traditional knowledge and technical mastery are held in high regard by her family and community. "Her pieces are so thin-walled, it's incredible," says her granddaughter Susan Roller Whittington:

Santa Clara blackware jar made by Margaret Tafoya, Santa Clara, New Mexico, ca. 1982 (cat. 46).

And she knows about all the different kinds of slips, what color they'll become when fired, how to prepare them, where to get the clay—all these things. She's done that with 60 years of experience.[41]

A dedicated teacher, Margaret Tafoya has taught her skills to her children and granchildren, and today, four generations of the Tafoya family actively carry on the ancient pottery tradition of their forebears.

Mastery of tradition, of course, is not simply a function of years of practice. Not all older practitioners are masterful. Much depends on individual talent and on the pride and commitment that one has for his or her tradition. As stone carver Roger Morigi points out, "It's not just the years, it's the man!"[42]

Authority: New Roles in Old Age

The young give muscle, the old give knowledge to the maintenance of life. . . . Born in new power, they fill a crucial role in their community. They preserve its wisdom, settle its disputes, create its entertainment, speak its culture. Without them, local people would have no way to discover themselves. . . .
Henry Glassie, *Passing the Time in Ballymenone*

In old age, we often find an inverse relationship between the loss of physical abilities and the increase of knowledge. As a traditional Sicilian proverb states: "Vigor to the young and wisdom to the old."[43] The older generations, with their first-hand knowledge of the past and the skills and experiences that they bring with them into the present, take on a new and vital role in their families and ethnic, regional, and occupational communities. They not only perform culture, they are in the position to interpret it; they not only speak culture, they comment on it. Born in new power, they often become advisors and master teachers—the tellers of tales, not the listeners.

Seventy-year-old Moishe Sacks, a Jewish baker and leader of a congregation in the South Bronx, points to a biblical teaching that highlights the new role of the elderly as advisors and teachers in their communities:

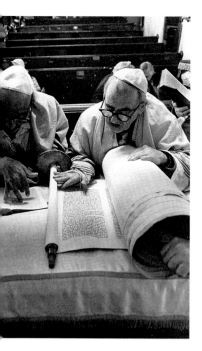

Moishe Sacks reads from the Torah at the Intervale Jewish Center, the Bronx, New York, ca. 1984.
Photograph by Jack Kugelmass.

So with age is wisdom,
And with length of days,
understanding.
Job XII, 12

Moses was the first one that formulated a form of retirement. He said the Levites could work up to the age of 50. At 50 he told them they should retire from *hard* work, but *not* from work. They became sort of supervisors to the others coming up—the younger ones. And to their last years, they were occupied in teaching the successive generations.[44]

Now that advanced age has slowed down his boatbuilding, 77-year-old Joe Reid performs a vital supervisory role imparting his skills and extensive knowledge of materials, methods, and techniques to his son and apprentice James Reid and to the many people who seek his expert advice. "Reid's judgment is so well regarded," writes Rita Moonsammy, "that people bring their boats to his yard so they can work on them under his practiced eye."[45]

And at age 70, Philip Simmons, a blacksmith from Charleston, South Carolina, found himself taking on the advisory role that his master teacher, Peter Simmons, had once played with him. "Young man got muscles," he says, "I've got brain power. What I do now is thinking."[46]

"Old-timers with the proper authority make the best foremen," says Mark Darlington, a cranberry grower from New Jersey. "Retiring an old-timer is tricky business," says another grower. "First of all, you can't replace them, because they know so much. . . ."[47]

It is not unusual for former athletes to become managers or coaches in older age—positions that allow them to put to good use their first-hand knowledge of a sport and their broad perspective based on years of observing the many different situations and variables that can come into play. As Simone de Beauvoir writes, "In those callings that require great physical qualifications, old age is decisive. Very early the athlete is debarred from competition. He often carries out a reconversion in his own branch—the skiing champion becomes a trainer; the professional boxer a manager. . . ."[48]

In some traditional, multigenerational events, there is a structured progression from youth to old age through a series of different roles and responsibilities. Each generation has its own part to play. The Italian-American Feast of St. Paulinus in Brooklyn, New York, is a good example. The focus of the celebration is the dancing of the *giglio,* a brightly decorated, 65-foot-high tower that is lifted through the streets near Our Lady of Mount Carmel Church. Young men of the community work their way "up a ladder" to become, in old age, the *capo paranza* or leader of the giglio. Sam Cangiano describes the process:

When I first started it was about 30 years ago. I started as a member of the rope gang. The rope gang consists of kids that are too small to lift the giglio. . . . They put a rope around the structure to keep the people away, for safety purposes. And as you grow older and you get tall enough, they will put you on as a lifter. . . . And you work up a ladder. You got to be a "lieutenant." You work up from a "lieutenant" to an "apprentice capo" to a number-three capo, to number two, and then number one. *Capo paranza* in Italian is the number-one leader."[49]

The capo paranza, wielding his cane of authority, leads the giglio through the streets. At his command the young men lift the giglio and the small boys in the rope gang clear a path. The capos are old men who are respected in their community, men who have been through all the stages and mastered every aspect of the giglio celebration.

It takes as much power to wield the cane as it does to lift the giglio, but it is a different kind of power. . . . The capo's performance, like the conductor's, is a culmination of long work and association, force of personality and style. At the heart of the performance is the willingness of the lifters to follow the capo, allowing him to exercise his power effortlessly and with consummate grace.[50]

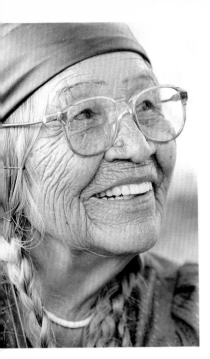

*Flathead Indian elder Agnes
Vanderburg from Arlee,
Montana, 1984.
Photograph by Dane Penland,
Smithsonian Institution.*

In many cultures and communities, it is the old who are the storytellers. "Stories are signs of the power of the mature mind," writes Henry Glassie.[51] In the village of Ballymenone in Northern Ireland where Glassie conducted his fieldwork, he observed that "stories of history" are the special preserve of the elderly. Hugh Nolan, Ballymenone's great old "historian," was "a poet in his youth when he was famed for great physical strength, a historian in old age when he was famed for deep religious faith. . . ."[52]

When they were young, Hugh Nolan and Michael Boyle were not noted storytellers. They would not have performed for a visiting folkorist. Their elders, George Armstrong and Hugh McGiveney, would have told the tales, while the folklorist foretold the demise of the art and young Hugh and Mick cut turf and hay. But now they are the tellers.[53]

Through their tales of local history, old storytellers and oral historians like Hugh Nolan and Michael Boyle perform a vital role in their community, giving "knowledge to the maintenance of life."[54]

American Indian elders are often the special teachers of the traditional knowledge and customs of their tribes. Respectfully referred to as "grandmothers" and "grandfathers," they impart tribal wisdom and moral values to the younger generations. Anthropologist Keith Basso writes of an Apache grandmother who "shot" her granddaughter with a moral anecdote when she dressed inappropriately for a tribal ceremony. "I shot her with an arrow," the grandmother said, likening her didactic tale to a weapon against the deterioration of cultural values. For the Western Apache, a central role for elders is to "stalk with stories," to show the people of their tribe how to "live right."[55]

Similar cultural and social roles are played by elders in communities across the nation. Margaret Mead in her autobiography *Blackberry Winter* writes of the influential role that her paternal grandmother played in her life. "Grandma was a wonderful storyteller," she writes, "and she had a set of priceless, individually tailored anecdotes with which American grandparents of her day brought up children."[56] Through her grandmother's stories about the children who obeyed their father and were saved from a prairie fire or the man who was so lazy his neighbors buried him alive, Mead learned moral values and attitudes that set the course for her life. And as she followed her active grandmother through her busy day of cooking, gardening, sewing, preserving fruits and vegetables, and observing nature, she also learned about the little things that help one navigate through the chores of daily living:

Because Grandma did so many things with her hands, a little girl could always tag after her, talking and asking questions and listening. Side by side with Grandma, I learned to peel apples, to take the skin off tomatoes by plunging them into scalding water, to do simple embroidery stitches, and to knit.[57]

Dennis Folly writes that his great-grandmother, Mrs. Clara Abrams, used proverbs and wise sayings "as a way of letting us know that in spite of our formal education or our familiarity with the modern and mechanized world, there is another level of knowing that we need to pay attention to." Mrs. Abrams would say, "You reap what you sow," or "If it's for you, you'll get it." In order to teach her grandchildren and great-grandchildren to pick their associates carefully, she would remark, "You're known by the company you keep," or "If you fool with trash it will get in your eyes." Through her proverbs, Mrs. Abrams taught her family a code of moral behavior and imparted wisdom gleaned over a lifetime of learning.[58]

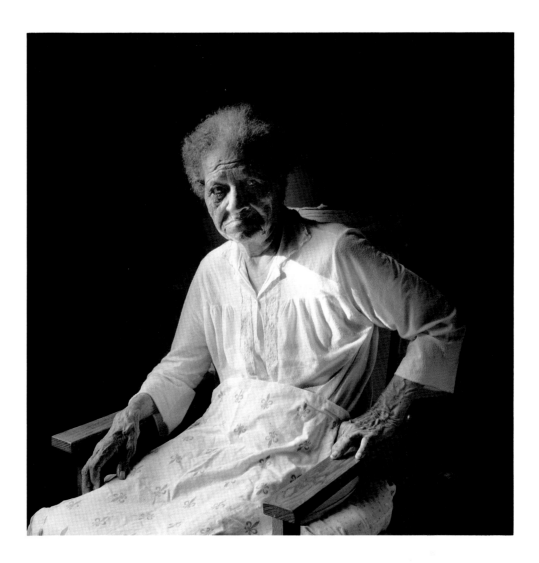

Grandmother Burrell,
Mississippi, 1976.
Photograph by Roland L. Freeman.

The elderly are also masters, as no others can be, of the experience of old age itself. "One must have lived a long time to have a true idea of the human condition," writes Simone de Beauvoir, "and to have a broad view of the way in which things can happen: it is only then that one can 'foresee the task of the present.'"[59]

Long life with its attendant experience of many changes brings with it a deeper understanding of change itself. Distance in time and space lends perspective and heightens a sense of contrast. It teaches one how to view change. The old have lived through all life's stages and thus have a personally acquired knowledge of the conditions and tasks of each phase of life. For the younger generations, they can serve as important models for growing old. "The young have to see what is ahead," says an 83-year-old Hispanic woman from New Mexico. "They have to know that there is youth and middle age and old age."[60]

Nimrod Workman, an 91-year-old coal miner and ballad singer from Mascot, Tennessee, describes a letter that he received from a young student after giving a performance at a local high school:

There's one letter that I really, really enjoyed from a young boy. It said: "Mr. Workman, I've listened to lots of mountain singers, but you're the best and I'd rather hear you. Before I heard you, I used to study [worry] about getting old, but seeing all the things that you can do and all the things you said that doesn't worry my mind any more." I thought that was lovely.[61]

Invocation: From Generation to Generation

There is an especially close relationship between the grandparent generation and young people seeking to learn a tradition or skill. As Bess Lomax Hawes writes, "The longer term, more serious learning relationships generally skip a generation."[62] Most often it is the old who have the time, the knowledge, and the desire to teach the young, passing down to them what they have learned over a lifetime. And very importantly, it is younger learners who are an impetus for cultural transmission. They invoke the knowledge of the old, calling on them to teach and perform, challenging them to be elders. Their curiosity and interest help to prime the pump, encouraging the flow of memories and skills from one generation to another.

Michael Alpert's desire to learn traditional *klezmer* music not only prompted Leon Schwartz to start playing that part of his repertoire again, but it restored his sense of pride in the music as an important and viable artistic tradition. "Through my questions and the process of playing the music," says Michael Alpert, "he unearthed his old repertoire. He's constantly in a process of remembering things."[63]

Bess Hawes writes of a grandmother in Anaheim, California, whose children never knew she played the guitar; "her fascinated grandson was her first audience in over 50 years."[64] And it was Alex Stewart's grandson, Rick, who wanted to learn and carry on his grandfather's coopering skills:

He had six sons and numerous grandsons and no one was taking interest in it. . . . And I got to thinking, maybe I should learn how to do this, to keep it in the family. So I went over one day and said, "Grandpa, I believe I'm ready to try one." Boy, that's all it took. He set down what he was doing and began to teach me.[65]

The flow of information and knowledge from generation to generation does not only move in one direction. As Karl Mannheim points out, each generation has its own unique perspective and "subjective center of vital ori-

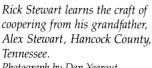

Rick Stewart learns the craft of coopering from his grandfather, Alex Stewart, Hancock County, Tennessee.
Photograph by Dan Yearout, courtesy Tennessee Valley Authority.

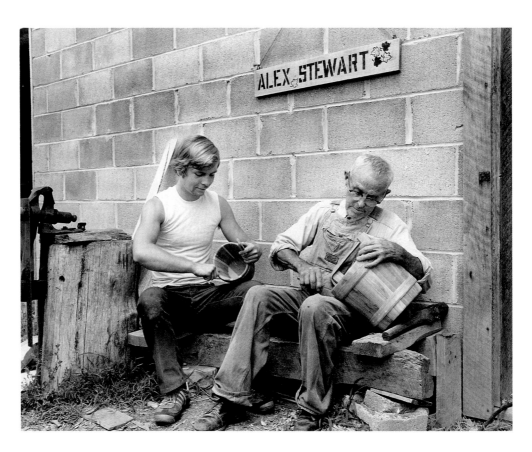

entation" with respect to history, culture, and society. "Not only does the teacher educate his pupil," he writes, "but the pupil educates his teacher, too. Generations are in a constant state of interaction."[66] The learning relationship between young and old is thus a symbiotic one characterized by reciprocity.

When Alex Stewart became too old and frail to physically continue his coopering work, his grandson's lively interest in making the old vessels kept him actively involved on a conceptual level. "I wanted to make some of the things that he hadn't made since he was young," Rick Stewart says, "and he would get so excited about that, it was if he had a million dollars." Rick's favorite vessel is an old-fashioned keg that he and his grandfather worked out together. "It was built completely from his mind and my hands," he says with pride.[67] Such collaborative efforts build deep and lasting intergenerational bonds.

Unfortunately, there are many older people eager to transmit their personal histories and accumulated knowledge to others, yet they have no audience. Barbara Myerhoff writes:

. . . there are elderly people all over America, waiting only to be asked about their stories and folk art. Their memories and works are stored in boxes in cellars, in trunks, in attics . . . needing only a witness to bring them to light, a recipient to complete the interchange that is requisite to all cultural transmission.[68]

As long as older people have younger witnesses who actively seek out their knowledge and expertise, they can continue to play a vital role in their communities, transmitting cultural values and skills to future generations. "They'll carry it on after I'm gone," says Tommy Jarrell of the many young people who learned his old-style fiddle music from him. "I've left a little something behind, I reckon."[69]

Chapter 4

Legacy: The Human Unit of Time

In the presence of grandparent and grandchild, past and future merge in the present.
Margaret Mead,
Blackberry Winter

In 1979, the evening of the Passover Seder in Philadelphia was the snowiest night of the year. Three feet of snow lay on the ground and it was still falling. Bella Stein's grandchildren carried their 79-year-old grandmother in a wheelchair up the icy incline into the hall. Recently, her foot had been amputated and she was living at the Philadelphia geriatric center, but it was important that she be at the Seder, if only to talk briefly with each person. She was silent for the ceremony, but presiding nonetheless. By simply witnessing the occasion she was connecting herself to the present and the family to its past. The last surviving relative of a generation, she was witness to their history, the one who had been there for all the great Seders at the house on Drexel Road in the '50s and '60s, and at her mother's house on Wanaker street in the '30s and '40s, and she was the one who still could recall Russia, the family home until the early part of the century.

In 1965, Bella Stein's husband, Harry, died of a stroke. He was a beloved family figure, who had helped preside over the Seder, and hosted at their home, and he was the first of a generation of 10 brothers and sisters to die. That year, the Seder was held at the Lebanon Arms apartment house, and Bella's sister, Rose, stood and said tearfully, "The captain is dead, but somehow the ship must sail on."

Richard Wallace recalled that line when he presided over the Seder in 1987, a few months after Bella, the last of her generation, died. "Now," he said, "the captain is dead and the whole crew is gone, but the ship must sail on."

The space of 20 years marked for one family the passing of a generation. After Richard spoke, Martin Wernick, Bella's son-in-law, stood and said to his contemporaries in the audience, "I guess we are now the older generation."

From a far corner of the long table, a cousin of his exclaimed, "I resent that!"

"You resemble that!" Martin humorously countered.

This passage into the older generation often serves as a startling reminder of one's own mortality, and of the mortality of a generation along with the places and forms they loved. Yet, the significance of death is different from the perspective of an intergenerational family. The ship sails on. Living memory connects members of different generations in time periods that transcend the individual life span.

Following the sociologist Emile Durkheim, Mihayli Csikszentmihalyi writes, "The miracle of sociability . . . is first experienced in the continuity of generations: although individuals die, the lineage continues."[1]

The possibility of the simultaneous presence of multiple generations has not been granted to all species. The 18th-century philosopher David Hume

Grandmother and grandchild.
Photograph by Michael O'Brien,
Archive.

observed that if human generations succeeded one another in the manner of most butterflies, culture, creativity, and tradition as we know them would be radically different. The older generation, having deposited its eggs, would entirely disappear before the new generation emerged all at once some time later. There would be no intergenerational exchange.[2]

In contrast to the insects, our social world is generationally polyphonic.[3] Each generation has a part to play, and a perspective to voice. Events like the Seder supper ritualize the experience of the simultaneity of generations, creating a setting in which individuals know themselves to be part of a larger body, an indivisible body that Margaret Mead has seen as the minimal unit for the survival of culture.[4]

This multigenerational body spans what she describes as the human unit of time: "the space between a grandfather's memory of his own childhood and a grandson's knowledge of those memories as he heard about them."[5] This idea places elders at the center of the human unit of time, with their memories on one side and their legacies on the other. Mead writes of a young boy who told her that for him "long ago was before his grandfather's grandfather's time. His own grandfather had told him the stories that *his* grandfather had told *him* about his boyhood. So real and lively were these tales that the boy felt he could reach out his own hand and touch that distant time four generations ago."[6] Similarly, Benjamin Zeitlin, age 4, could learn from his grandfather, Lucas Dargan, age 70, that his great-great grandfather had, according to family legend, fired the last shot at Appomattox during the Civil War, 122 years ago.

Settings and Events

Our legacies speak to us of our identities and roles within the expanded framework of the human unit of time. Legacies make these identities and roles tangible, encapsulating and intensifying our sense of them. In situations where three or more generations are present, traditions like the Seder supper place the oldest and youngest generations in particular roles necessary for conducting the event. The youngest member present at a Seder, for example, ritually requests cultural information, beginning with the question "Why is this night different from all other nights?"

We might see such forms, found in communities held together by familial, religious, ethnic, or geographic ties, as indigenous responses to two crisis conditions in modern society. The first is what modern society sees as the problem of old age—of how to accommodate the needs of the elderly. The second is what members of both older and younger generations see as a kind of cultural identity crisis—brought on by crises in transmission. Traditional forms that require the simultaneous presence of all generations in the community and that provide points of entry for the young person, while placing the elderly in positions of leadership and authority, contain built-in solutions to both problems.

A grandmother entertains her young grandson, Montpelier, Vermont, 1942.
Photograph by Fritz Henle, courtesy of Library of Congress.

My grandmother planted my roots in this earth.
Young Boy

Four generations of an Ozark farming family.
Photograph by Nina Leen, Life Magazine © 1948, Time, Inc.

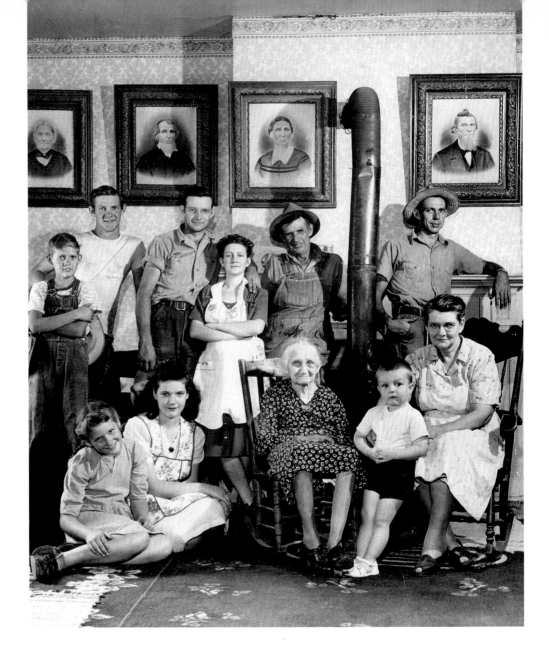

Family reunions, for example, are elaborate events that bring the generations together, placing the eldest member of the family in the position of honor. This gerontocratic hierarchy is visualized in generic reunion photographs that group the younger generations around the oldest member of the family who is front and center. The eldest may be honored as the true generator of this community, even if in an avuncular sense, because he or she may represent an entire generation, and the generations before. As Roland Freeman said, "It all began with great-great-aunt Ella!"[7]

Family reunions often evolve their own customs. At one family reunion held annually in Wilbraham, Massachusetts, a president is elected each year. The oldest member of the family always wins, as if to imply that the oldest is also the most fit for office. In other words, the head of the family is not in charge because he is old, but because he is worthy. Theresa Roach, 64, described the election:

There's kind of a tradition here. The elder is the head of the family anyway, he's the don. He always has been and he always will be. But every year, he's got to get elected! And every year a couple of the brothers will put up a fight, and they'll mount a

campaign to get themselves elected president. They will go through all kinds of contortions and slogans and campaign songs and everything to get themselves elected. Then comes the day of an election and everybody will listen to their slogans and appeal and promptly vote Uncle John president again.[8]

We saw how the young Italian males at Our Lady of Mount Carmel in Brooklyn's Williamsburg section progress through the ranks as they move through the life cycle to become *capo paranza* in their old age. The *giglio* tradition, described in the chapter on mastery, provides one indigenous example of an elaborate and polyphonic display of generational role playing. In other cases, we find fewer steps in the series, but there are, nonetheless, clearly articulated roles for older and younger participants.

Near Coney Island, New York—in a Sicilian puppet theater—life-sized marionettes enact the medieval epic of Charlemagne. Behind the theater on a scaffolding reminiscent of the stairs of life, each generation is given its role to play. To one side of the stage, members of the youngest generation are charged to watch the sand bucket, kept there in case of fire. On the scaffolding, "the bridge," the young men hoist the marionettes into action, using their muscle to slam the knights into one another, causing wooden heads to roll. On the ground the far side of the scaffold stands the grandfather and director, Mike "Papa" Manteo, continuing the tradition started by his grandfather. He continues to throw the voices for the marionettes, using an antiquated Sicilian dialect. The configuration of generations behind the stage impressed the young Papa Manteo deeply. "I graduated slowly, slowly, they allow me. It's something like, if you aren't of age, you can't drink.

When I was a little boy, the first thing I do, when I started to walk, I get on stage, and I sit by a pail of sand (you know, you got the fire department rules), and I sit there and I look. I'm just about seven, eight years old. And I look at my father, and I look at the men that were working on the bridge and you gather all this and you gather the language too. The same thing with my sister. My sister at the age of, not even fifteen, already she started to throw voices at my father's tuition. . . . And then I was envying those people up there that manipulated those heavy marionettes. . . . Then as I got old, I got promoted. I was allowed to get on the bridge.[9]

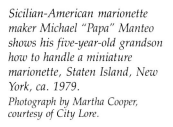

Sicilian-American marionette maker Michael "Papa" Manteo shows his five-year-old grandson how to handle a miniature marionette, Staten Island, New York, ca. 1979.
Photograph by Martha Cooper, courtesy of City Lore.

Now he teaches his young progeny using scaled-down models of the life-sized marionettes.

The generational series is similarly framed by boats in the fishing communities along New Jersey's Delaware Bay. As waterman Belford Blackman told folklorist Rita Moonsammy, a youth would begin learning

. . . "how to work and how to work the boats" in the "middle deck" of a family boat. There he would cull (sort and separate oysters from debris) and clean up. But John DuBois noted that this was occupationally the "wrong end of the boat." Most men aspired to the role of captain. Becoming captain represented maturity and manhood in the work community. . . . When the captain became too frail to continue as "master" of the boat, he would usually become the cook, a role that kept him aboard in a useful capacity.[10]

The puppet theater and the boat are stages on which intergenerational roles may be played out. They incorporate their players, in contrast to the artifacts presented below, which allow their makers and owners to hold and contemplate an encapsulated human unit of time. Manteo's use of the miniature marionette to introduce future puppeteers to the craft, and Ed Hazelton's gift of a miniature boat to his grandson, make it possible for those entering the human unit of time to grasp a version of the whole while just beginning to master its parts.[11]

Elsewhere, in everyday settings that bring the very young together with the older generations, we see children modelling their play on the work of adults, producing their own miniaturized versions of what adults do. Annie Lee Harris, an elderly quilter from Clinton, Alabama, "played" at quilting as a very young child in the presence of older quilters:

When I was small, people used to visit people back in time. They'd take their quilt pieces and come to my mother's house and they'd be sitting down sewing. They cut off little strings, and they'd just throw them away. And I'd be sitting down there on the floor, and I'd take them up and sew them on my quilt. What they'd be doing, I'd be doing the same thing.[12]

Similarly, Gudren Berg, age 70, of Bemidji, Minnesota, gave scraps of dough to her granddaughter while she was baking, "so she could make little buns and little loaves of bread in little tins."[13]

In Brooklyn during the Feast of St. Paulinus, children dance a miniaturized giglio. Directed by adults, they replicate the adult hierarchy, with young *capos* orchestrating the younger lifters, gesturing with their canes of authority. "In all these activities," Maxine Miska and I. Sheldon Posen point out, "children are mastering skills . . . that will encourage them to continue the tradition."[14]

Broken Chains and the Challenge to Legacy

Cultural lineages do not continue effortlessly, and they do not always correspond to biological lineages. While biology grants us the possibility of knowing our grandparents, history is not always so generous. Global disasters like war, the holocaust, political upheaval, slavery, and economic depression cause ruptures in the generational chain, sometimes silencing whole generations whose voices we need hear.

Elders teach us, however, that while ruptures in the chain of continuity are inevitable, they are not irreparable. In their legacies are their echoes, the tools whereby we continue to have a sense of who came before us, and how to guide those who come after. There is a desire to transcend the barriers that history and biology erect between generations. "If only I could put my head on your shoulders for one moment," said Isaac Steinberg to his grand-

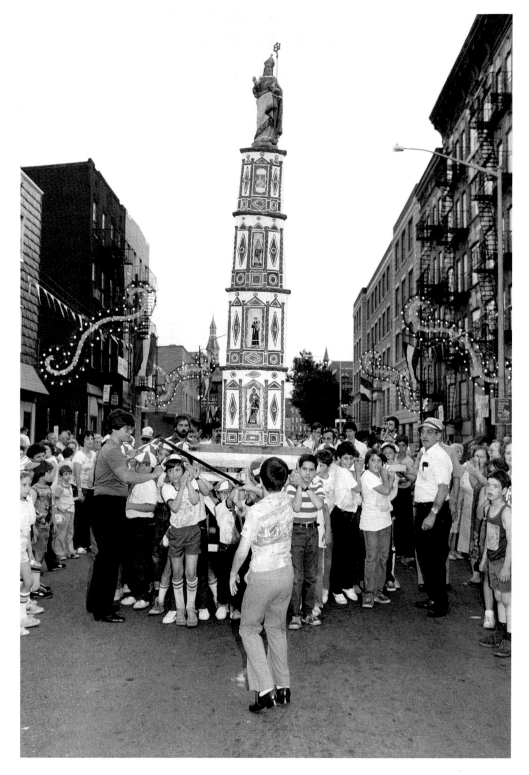

children, "you could see a whole different world."[15] And, as we saw in the
section on memory, this desire gives rise to invention.

Traditions do not just pass along. As they come into the hands of suc-
ceeding generations, they are handled and remodelled. They are actively
woven into the present, products of the conservative and reforming influ-
ences that converge in intergenerational settings.

When history erects barriers between generations, ways of compensat-
ing may be found. On one side or the other of the chain of transmission

someone grows alarmed by the prospect of cultural impoverishment. Elders feel the weight of treasures they need to pass on, or young heirs become suddenly aware of the transactions that need to occur.

Barriers of language and culture often deprive elderly immigrants of their natural audiences. Their knowledge of how to survive in the mother country becomes irrelevant to the second and third generations who now possess the knowledge needed for survival in the new country, in an inversion of the traditional order. For elderly immigrants the removal from the homeland creates a gulf not only between themselves and the past, but between themselves and the future, as embodied in their descendants. Neng Vang, a member of the Hmong community in Michigan, speaks of the difficulty of bridging those twin chasms:

It is difficult for us since we are not Americans. We were not born here, we have migrated here. There is no good way for us [elders] to look to the future . . . the only way is through the young. It is the hope of all the heads of the families that the youngest sons and daughters will learn so that they will help us.[16]

Uprooted from their native land, Hmong elders are denied the cultural role they would have performed in highland Laos. Yet, they are the only ones who can give their descendants a true sense of cultural identity. In the

Salish Indian weaver Mary
Peters works at her loom as a
young relative looks on, Seabird
Island Reserve, British
Columbia, 1974.
Photograph by Ulli Steltzer from
Indian Artists at Work.

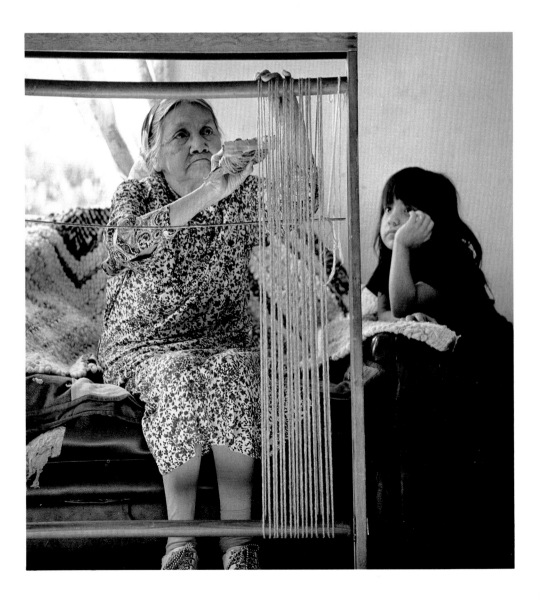

Hmong decorative square stitched by Pang Xiong Sirirathasuk as a special presentation piece for her children, Philadelphia, Pennsylvania, 1984 (cat. 39).

traditional textile form known as *paj ntaub*, or "flower cloth," Pang Xiong Sir-irathasuk, of Philadelphia, hopes to keep her descendants mindful of their tribal culture and values. "Someday," she promised, "I will make a piece for each of my children.

And they will think of me, my sewing.
And I will put my name,
I will put the letters in Hmong,
 in English, in Lao, and in Thai.
And it will say,
 "Don't forget your culture!
 All your whole life,
 and your children's life,
 and your grandchildren's life!"[17]

This embroidered and reverse-appliqued apron sash—made in 1953 by Bao Yang, a Hmong elder from Xieng Khouang, Laos, as part of her traditional costume—is a source of inspiration for Pang Xiong Sirirathasuk and other Hmong women who are striving to preserve their cultural traditions in a new land (cat. 49).

Even in healthy communities untouched for many generations by catastrophes that elsewhere rupture cultural ties, awareness of the vulnerability of traditional knowledge is heightened in the face of impending separation. Take Mamoo for example.

"Mamoo gave us a scare," writes Mamoo's children, accounting for the initiation of their project to document her famed soggy coconut cake. "She had a little setback in the early summer after her grand season in Florida."[18] Everyone agreed that no one would ever replicate Mamoo's soggy coconut cake, and when she grew very old her family decided to document the making of that cake. A recipe would not be good enough. They decided to capture—on tape and film—the talk, attitudes, and gestures incorporated in the making of the cake.

A sudden illness made Austin Hammond, a Tlingit elder from Haines, Alaska, realize the fragility of the knowledge he had gathered as a boy from

Frances Hurley documents her mother, Mrs. T.A. "Mamoo" Lewis, making the family's favorite soggy coconut cake, Knoxville, Tennessee, ca. 1979. Photograph by Harlan Hambright.

his grandfather. Like Pang Xiong, he feared that important cultural information would be lost to his descendants, and he began to teach his grandchildren what they needed to know:

My grandfather taught me things about our Tlingit ways. My grandfather said, "The time will come when these things we tell you will need to be heard again." . . . For a long time I didn't think about what my grandfather had taught me. I was busy with my family and I was working hard as a fisherman. But then, I had a heart attack. Feeling I was near death, I could only think of my grandchildren and what I had to do for them. There is so much for them to learn about their Tlingit culture. All the lessons I learned from my grandfather came back to me. . . . My granchildren need to know these things.[19]

However, the rightful heirs to tradition are not always interested in being heirs, and in such cases we may find elders rewriting the cultural will.[20] In south Philadelphia, Elizabeth Mathias discovered that second- and third-generation Italian men tended to ignore the *bocce* courts. Moreover, they rejected the newly arrived Italian immigrants and their fumbling attempts to adjust to American living. The old men, however, took the young immigrants under their wings, rejoicing in their newfound audience. The bocce courts provided a buffer zone in which the older generation could help the new immigrants to adjust—and the new immigrants became willing partners in the enterprise of cultural transmission. Mathias writes:

When I asked one of the old men if he did not fear that bocce would gradually disappear . . . he answered emphatically, "That won't ever happen. As long as they [the younger immigrants] keep getting off of those boats, we'll have bocce![21]

Thus bocce continues by sidestepping direct descendants, remaining within the context of the Italian culture and language of first-generation immigrants.

For those who choose not to revise the cultural will, disinterest on the part of designated heirs could lead to the death of tradition. George Heinrichs, a noted builder of Barnegat Bay sneakboxes, guards the family secret of building that is lodged in his grandfather's "jig" and his father's patterns, keeping a promise he made to his dying father that he would never let them out of the family. "I made a promise to my father," says George, "that if I didn't build boats and my brother didn't, that I'd cut up the patterns and destroy them, because it's his pattern and no one has ever copied it. The Heinrichs sneakbox will die if I don't continue."[22] If no one in the family were interested, he might consider teaching someone else, but only after consulting with others in the family.

This was a decision faced by Newton Washburn, the last splint-ash basketmaker in the Sweetzer family of Morrisville, Vermont. The heir to a tradition that began with his great-grandfather Gilman Sweetzer, Newton Washburn had no one among his children or grandchildren to teach the craft to. "I feel very bad about it," he told folklorist Jane Beck, "I feel real bad my two sons don't do it. I feel badly that the old basket tradition is gone. It's gone really."[23] Confronted with the prospect of a dying tradition, he decided to consult with his aunt, "the only living member of the older generation."

"What to hell am I going to do," he asked her, "let it drop or teach it?" "Well," she said, "we never did." I said, "I know it. If someone doesn't the art's going to go." "Well," she said, "use your own judgment."[24]

Two years later, Beck tells us, Washburn began to take on dozens of pupils from the new generation of crafts people, spawned in the craft revival of recent decades. This new breed of craftsman has launched Newton Wash-

burn on a second career, a lucrative source of income and recognition that ensures the survival of his great-grandfather's craft—with the exception of one feature. He has carefully reserved for potential family heirs the "demijohn" basket bottom that is a hallmark of the Sweetzer baskets.[25]

Storing and Retrieving Cultural Identity

Some elders may devise innovative ways to store knowledge and information until the heirs develop an interest. The interference of modern technology with the passing of tradition is notorious. We often hear the lament that television sets have usurped the hearth. "Today there's television and movies," says Helen Fretz Jarrett, 83, "and we never seem to have the time to sit down and converse with each other like we used to. My kids don't know anything about our past—who was who and where we came from."[26]

The craving to eavesdrop on the past may come too late, as it did for Wayne Dionne who says, "I remember my relatives talking and talking and yet as a kid I didn't listen. I'd love to go back now and listen."[27]

Mrs. Jarrett knows that someday her descendants will want to know what she knows. And, in a lavish act of prospective remembering, she is waiting for them, in the *Collier-Fretz-Jarrett Family History*, a 28-volume work-in-progress that she began more than 30 years ago—virtually a second career. In the span of time that it takes a generation to grow from infancy to adulthood she assembled the story of 17 generations of her family. Her magnum opus is a compendium of many things embodying her family's past: genealogical charts, her mother's recipes and songs, excerpts from her father's childhood diary, old family photos, her grandfather's discharge from the Civil War, and anecdotes and recollections about family members and events.

Whole generations die out. "All the old-timers are gone," says Albert Reeves, himself an old-timer in his 90s.[28] "When it is our elders who die," writes Simone de Beauvoir, "then it is our own past that they carry away with them."[29] Funerals may not only be rites of passage for the deceased, but they may be rites of generational passage, in which someone becomes the

Helen Fretz Jarrett, age 83, with one of her family history books, Washington, D.C., 1987.
Photograph by Paul Wagner.

oldest member of an extended family. Ira Augustus Hunt, Jr., became pain-
fully and acutely aware of his new role in this regard when he returned from
the funeral of an elderly aunt. He grieved not only for her passage, but for
the knowledge she took to the grave with her. "I had questions to ask her,"
he told his daughter, "and now there is no one alive who knows the an-
swers."[30]

At 75, Tom Brown reluctantly moved up a notch as an elderly master
trapper when his friend Bill Lee died at the age of 80. "I wish I had a third of
the knowledge that he had in his head when he died," Brown laments.[31]

Death is the ultimate rupture, a rupture that may be mended through
private and collaborative rituals of separation. In the wake of an elder, a
sense of the incompleteness of the knowledge that remains may give rise to
an effort to tie both knowledge and a sense of the departed to items that be-
come signs. Thereafter the deceased may take up a kind of metaphysical resi-
dence in artifacts, songs, rituals, recipes, or other expressions, some of
which are bequeathed in advance as gifts, and some of which arrive much
later as unexpected surprises.

For example, in Washington, D.C., sometime after Carla Weatherford's
mother had died, Carla was cleaning out a drawer where some of her moth-
er's things were stored. She came across a small box, in which she discovered
her mother's charm bracelet. The tinkling sound it made as she lifted it from
the box flooded her mind with the memory of her mother dressing for a par-
ty years ago. The sound was ineffably her mother.[32]

It is in ways of passing the self along and in ways of receiving it that we
find a great deal of creativity among benefactors and beneficiaries. Any ex-
pression—an artifact, gesture, aroma, or tune—no matter how simple, may
become a repository of great significance, a locus where meanings and selves
may become powerfully distilled.

Some elders forecast their legacies in the ephemeral and recurrent aspects of everyday life. Moishe Sacks, an elderly leader at one of the last synagogues in the South Bronx, is also a baker who prides himself on his distinctive chocolate *bapkes*. The taste of those bapkes is his special bequest to his friends. "People will recall the taste and remember me," he says.[33]

In a similar vein, a touchstone experience that provided Richard Saviet with a rare glimpse of his grandmother's childhood in Russia also gave him a song to remind him of her childhood memories, a legacy he gratefully received. "I would like to tell a memory of my grandmother," he said,

Ella Katz. She died in 1979 at the age of 84. My grandmother was born in Minsk, in the county of Pinsk, which is now Russia. She emigrated to the U.S. around 1917 during the revolution—she was smuggled across the border after paying bribes to certain well-placed guards and made her way across Europe, across the ocean, to Ellis Island, and eventually to Philadelphia where she settled and married my grandfather, Morris Katz, who had left Russia about the same time but had gone via Japan. . . . The specific story I want to tell is about the time I went with my grandmother, just she and I, to the Academy of Music in Philadelphia to hear Eugene Ormandy. On the program was a piece [orchestrated] by Rimsky-Korsakov, "Pictures at an Exhibition"—and it was about three-quarters of the way through the piece that my grandmother heard a theme in the music that Rimsky-Korsakov had interwoven—and that theme was, she later told me, from a folk song that she would sing and play children's games to when she had been living in Pinsk—80 years before that time, and when she heard that theme, tears started to come to her eyes, and I guess for her it was just a strong, very poignant feeling as she connected the city of Philadelphia, sitting in that seat with so much distance in time and space back years ago to Minsk—so it was a real strong personal experience because it was a glimpse into my grandmother's past 80 years before that. I could never have gotten such a strong connection but for that theme she heard in the piece there. It's one of the more moving memories I have of my grandmother.[34]

The bequeathing and inheriting of cultural identity is a transaction that requires commitment and effort on both sides. Where the elder was unable to prepare a legacy, the responsibility may fall to the heirs. "I wanted to leave something more than a name on a tombstone," says Jehu Camper of his legacy of whittled miniatures.[35] But for Boris Blum, a name on a tombstone was not something to take for granted. His grandparents were killed in a pogrom in the Ukraine, his parents died in the Holocaust. A survivor of the Warsaw ghetto, Majdanek, Buchenwald, and Dachau, he had witnessed corpses piled high and burned. Once, a doctor conducting a medical history asked him to name any fatal diseases that had taken members of his family. He had no answer for the doctor, since no family member in living memory had died a natural death. If Boris Blum received a funeral and a tombstone, he would be the first member of his family in three generations to do so. To him it would be a sign of triumph. As he puts it, "It's like being published."

He was a printer from a family of printers, and a gifted storyteller. "Americans," says his daughter, Toby, "think of European Jewry by the way they died.

But he got to the other side of it, and he memorialized those people in story. You always got the feeling that each person—whether they survived or not—was an individual, not a faceless blur. He talked about his experiences in forced labor under the Nazis. He and his friends saw degradation all around them. One day they were sitting around wondering what is the level at which a man becomes an animal. One man, I believe he was an architect, took out a handkerchief and said, "I am different from you because I have a handkerchief from home." To this man, it symbolized civilization. He would take out his handkerchief and look at it and know he was still a person.

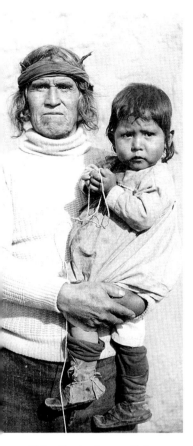

Helen Cordero's grandfather, Santiago Quintana, with one of his many grandchildren, ca. 1906.
Photograph courtesy of the National Anthropological Archives, Smithsonian Institution.

Pueblo potter Helen Cordero of Cochiti, New Mexico, making a Storyteller *figure, ca. 1979.*
Photograph by Al Abrams.

Boris Blum died suddenly of a heart attack on Passover in 1985. His family worked hard on the tombstone that meant so much to him, inscribing it not only with the dates of his birth and death, but the date of his liberation from the camps. And they placed on it a memorial to all the members of the family who died without a tombstone. At the head of the stone is an epigram from a sacred text, appropriate for a printer and a printer's son: "The scrolls burn, but the letters rise."

Boris Blum's tombstone is a legacy that works in two directions, an artifact that at once engages his children, his grandchild, his parents, and his grandparents in an enduring commemorative act.[36]

Lodestones and Artifacts that Bind

Just as touchstones may enable the elderly person to experience all stages of life simultaneously, certain artifacts and behaviors keep us simultaneously in the company of generations before and after us, even in their literal absence.

Like the *churinga*, the bull-roarer, a ritual object that represents the essential unity of all those who hear and understand it, the prayer, the quilt, the landmark, or the song, when reenacted or witnessed reaffirm a sense of belonging for those who own and use them.[37]

At the center of the human unit of time, some elderly artists emblematically gather together all of its members into single artifacts. When Helen Cordero was 50 years old she reproduced in clay her grandfather telling stories to his grandchildren, herself among them. "It's my grandfather," she says of the figure:

He was a wise man with good words. His eyes are closed because he's thinking. His mouth is open because he's singing. There were always lots of us grandchildren around him, and we're all there, in the clay.[38]

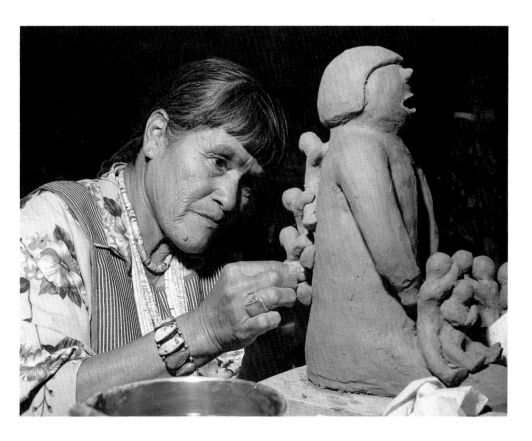

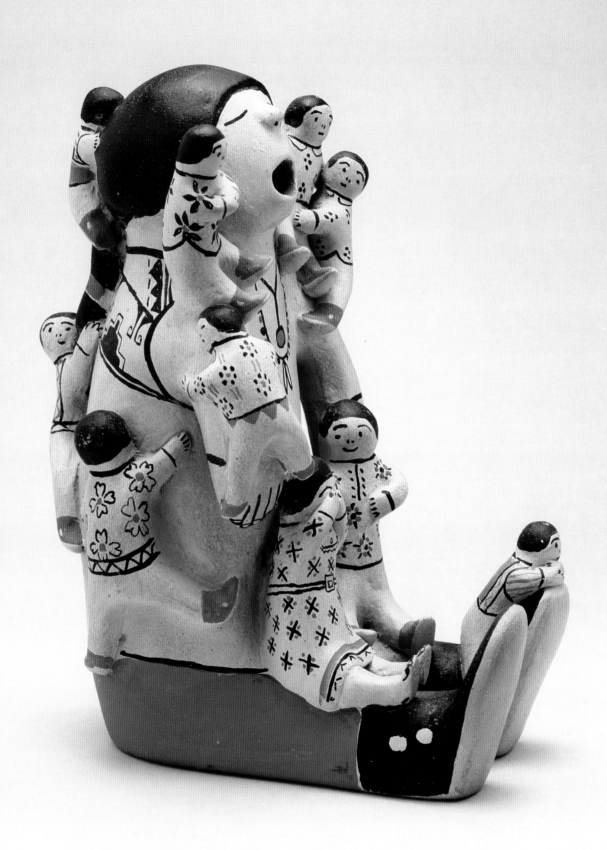

"LeMoyne Star" quilt made by Kathryne Petersen, age 78, of Arden, Delaware, 1976 (cat. 28).

Cochiti Storyteller *figure made by Helen Cordero, Cochiti, New Mexico, ca. 1977 (cat. 9).*

Now, when Helen Cordero is a grandmother at 72, her own grandchildren are there too, listening to their great-great grandfather's stories in clay.

Folklorist Kim Burdick writes of the function of Kathryne Petersen's quilt to symbolically unite members of an extended, separated family.[39] Stitched together from pieces of fabric from her daughter's and granddaughters' dresses and other old scraps of material collected and saved over many years, her "LeMoyne Star" quilt is a patchwork of family memories spanning three generations. "I gave this quilt to my daughter," says Mrs. Petersen, aged 78.

It has some of her daughter's dresses in it. I never discarded those old odds and ends of material, and when my grandchildren and daughters see my quilts, they say, "Oh, I remember that dress!" It makes me feel so good.[40]

The quilting process itself is a legacy, an activity that overcomes generational and spatial distance for southern-born women who quilt at the Concord Baptist Church Nursing Home in Brooklyn. Though she may not have the pieces of her grandmother's clothing, Mrs. Arlene Love stitches her grandmother's view of the night sky into a star quilt:

My mother taught me, and my mother's mother taught her. Grandmother lived in a little log house that at times was all broken down, so they could see the stars through the roof. Grandmother got the idea of making the star quilt when she saw the stars so beautiful one night.[41]

Thus in her quilting Arlene Love keeps the living warm and memories of ancestors alive.

Other landscape features can also be heirlooms, as we saw in the case of the Apache grandmother who shot her granddaughter with a narrative arrow. That "arrow" resonates every time the granddaughter passes the place connected with the story. "I know that place," she says. "It stalks me every day."[42]

The contours of the places of greatest significance to Ed Hazelton are reflected in the shape of the Barnegat Bay sneakbox, a duck-hunting boat developed and used by his ancestors on the Jersey coastal marshes. He speaks of how such places get handed down "from father to son and keep right on going," until the knowledge spans several lifetimes:

Down through the years, going back a couple hundred years, the old timers, they knew where the ducks were traveling, on what winds. So they passed the word on to me. They said, "Ed, when the wind's southeast, you want to gun such-and-such a point. Now when the wind's northwest, you want to gun such-and-such a point. The ducks'll be travelin' there. The wind'll be pushin' them over. It's gonna make them pay over. You want to be there tomorrow." . . . It's hard to put it in words in a few minutes—what you've learned in a lifetime, or somebody else's lifetime too.[43]

Tom Brown, 76-year-old trapper, has strewn the landscape around Millville, New Jersey, with an unusual multigenerational compendium. The name of each child, grandchild, and great-grandchild descended from Brown is somewhere inscribed on the shell of a box turtle. This living registry of Brown's descendants moves through the environment he knows so intimately.

Now I got a box turtle that's come back every year for 27 years. Twenty-seven years ago I put "Pop-pop" and "Dawn" on it, and put the date, and it come back again this year. . . . And this year, one I did for the great-granddaughter Muriel—I only just did that in '81—that one come back.[44]

Emblems that tie multiple generations together may be wrought of the most everyday items. Stephanie Bernard's fondest memories of her Cajun

Rolling pin made by Celeste Roy Hufford's grandfather, Denys Arsenault from Rumford, Maine, ca. 1920 (cat. 66).

grandfather were born in the conversations they had over coffee poured from an old-fashioned aluminum drip coffee pot in his kitchen in Lafayette, Louisiana. When she moved away they wrote to each other over coffee. And when she stood in his kitchen with her father after her grandfather's death, her father asked her what she would like. Her eye fell on the coffee pot, and that was the only thing she took. Now in Washington, D.C., her grandfather is present to her, daily, in the taste and smell of Community coffee, brewed in the old pot.[45]

For Celeste Roy Hufford, 33, of Lorton, Virginia, it is a rolling pin that serves as an enduring reminder of Denys and Alice Arsenault, her French-speaking grandparents from Rumford, Maine. Like her grandmother, she bakes the bread for her family, and the act of baking the bread is enriched by several generations of hands that have used that rolling pin. "My grandmother," she recalls, "was a wonderful cook. She had 15 children and made seven loaves of bread a day. My grandfather was a woodworker. He made this rolling pin for my grandmother, and to have something that both of them are in is very special."[46]

Helen Salerno DeJana's implement is a cooking spoon, used by her mother, and which her own children use to stir the spaghetti sauce. The spoon is worn down from years of use. "I don't think we've ever used another spoon to cook pasta!" says Mrs. DeJana:

My father gave this spoon to my mother in 1911 when they were first married, and she used it almost every day right up until she died at the age of 93. She just couldn't do without that spoon—it was a part of her. And we still use it, that's the important thing—and not a day goes by that we don't think of her.[47]

Papa Manteo uses his father's hammer in the same way, valuing the aura attached to the old and worn, over the flash of the new. "This was my father's hammer," he says.

Over 70 years old. Look at how rusty it is! You think I'm a cheapskate, that I don't want to buy a new hammer. But this is what I like. These are my father's tools—they give me inspiration![48]

Stephanie Bernard's coffee pot, a remembrance of her Cajun grandfather, Fernand Bernard, Lafayette, Louisiana, ca. 1950.

Helen Salerno DeJana's most treasured family keepsake—her mother's cooking spoon, 1911 (cat. 59).

These household items, owned by people at the centers of their human units of time, are young compared to artifacts that embody many generations of family history. Such artifacts, saved because of the stories connected with them, become a means of saving the stories.

Souvenir heirlooms like the spoon and hammer can accumulate great significance over generations, becoming the visual evidence of the human unit of time, often embedded in ritual recitations about the ancestor who owned the item, uniting the once and future generations. In contrast to the autobiographical resonance[49] characterizing the life review project, such items are redolent with generational memory, which Tamara Hareven defines as "the memories which individuals have of their family's history, as well as more general collective memories of the past." This commodity is at a premium among Americans, according to Hareven:

> By comparison to other cultures, for most Americans generational memory spans a relatively brief period. . . . Most people do not even remember, or never knew, their grandfathers' occupation or place of birth. . . . A sense of history does not depend on the depth of generational memory, but identity and consciousness do, because they rest on the linkage of the individual's life history and family history with specific historical moments.[50]

When he was a boy in southern Indiana, Francis G. Hufford's maternal grandfather, Arburt Newton Buck, told him the story of how *his* maternal ancestor, a man named Craig, had come to this country as a fugitive from the British Isles during the Cromwellian persecutions. Craig, having led an unsuccessful insurrection, was a marked man whose friends packed him and his wife in a hogshead and shipped them overseas. Before sealing the hogshead they gave Craig a hammer and saw so that he and his wife could break out of the hogshead and continue the journey as stowaways. And Grandfather Buck had the hammer, which he often showed to the young Griff Hufford, to whom he told the story. Colonel Hufford, 88, in Louisville, Kentucky, is now, as he writes, the hammer's caretaker. With the exception of the handle, which he says was at one time replaced, the hammer now spans seven generations of family history, extending to his great-grandchildren, to whom he tells the story of his great-great-great grandfather's passage to America.

The Dargan family possesses an artifact once used to celebrate the five generations that coexisted around the turn of the century in Darlington, South Carolina, when Rosa Evans was born there. Her great grandmother Jane Wallace gave her a silver cup, and tradition quotes Jane's mother as having said: "Arise my daughter and go to your daughter for your daughter's daughter has had a daughter." In the Dargan family, the quote and the cup are invoked to illustrate the multigenerational presence of the extended family to this day. Though the saying is not unique to the Dargan family, it is significant to them because it illustrates that their family has stayed so close together for so long that it would have been possible for four generations to witness the birth of a fifth-generation child.

The unbroken chain of cultural transmission over the generations is the exception rather than the rule. When we talk about the life cycle or the cycle of generations, we often imagine that life conforms to some larger plan; but life hardly ever goes according to plan. The more prevalent pattern is that of mending ruptures. The "culture-wrights" presented here have spent many years distilling, encapsulating, passing along, and pulling out the legacies needed for cultural survival. Their artistry—whether it be Ethel Mohamed stitching together the fabric of life after the death of her husband or Earnest

Now in its seventh generation, this hammer has become a tool for keeping a family story alive. According to the story, it was first used by an 18th-century ancestor of Col. F. G. Hufford of Louisville, Kentucky, to escape religious persecution in Great Britain.

The Dargan family baby cup,
early 19th century (cat. 53).

A connecting thread through
three generations of weddings,
this lace was worn by Edith
Mellon in Haverford,
Pennsylvania, in 1911, by her
daughter in Pittsburgh in 1951,
and by her granddaughter in
Washington, D.C., in 1987.

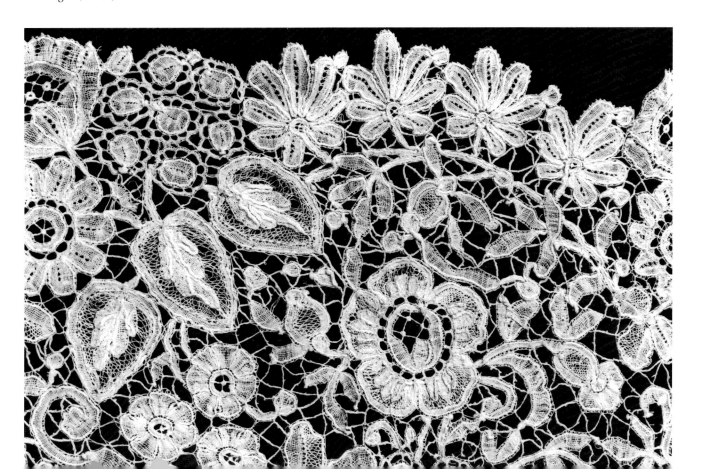

*Whittled chain carved by
Earnest Bennett, age 82, of
Indianapolis, Indiana, 1987
(cat. 5).*

*Mrs. Annie Mason, from
Franklin County, Mississippi,
shows her grandson the family
bible.*
Photograph by Roland L. Freeman.

Bennett responding to the death of his sons by reviving the woodcarving skills he had practiced as a boy—represents a kind of triumph over breaks in the generational cycle.

Old people need to leave impressions and young people need to be impressed. The emergence of new forums where this basic human interchange can take place merits our attention. Schools, festivals, and museums are no less likely or valid a setting for cultural transmission than the hearth, the general store, or the barbershop.[51]

At the Indianapolis Children's Museum, for example, Earnest Bennett and his wife Dorothy enliven the exhibits with demonstrations of chain carving and quilting. Simon Bronner describes how Bennett simultaneously crafts chains and builds audiences:

Earnest usually draws a crowd by brandishing a small pocketknife and releasing links from wood. People stop to see the duel between a man's simple tool and the wood. He stops and holds it up, tempting the children to touch it. As they gently finger the links, you can hear "Neat" or "Wow," or "How do you do that Mister?"[52]

Moving his knife along the single block of wood, Earnest Bennett carves one link and then another, creating a seamless wooden chain. He unleashes hooks and swivels, anchors, hearts, pliers, joints, and balls-in-cages—riddles for children that suggest a metaphor for life, for the long process of self-definition and for the bonds among generations. The trick is to individuate without breaking the continuity among components. It's something an old carver knows that is still a mystery to those who ask, "How did that ball get in there?"

Notes

Introduction

1. See John Ellis, *One Fairy Story Too Many: The Brother Grimm and Their Tales* (Chicago: University of Chicago Press, 1983).
2. Bess Lomax Hawes, "Folk Arts and the Elderly," in *Festival of American Folklife Program Book*, Thomas Vennum, ed. (Washington, D.C.: Smithsonian Institution, 1984), p. 31.
3. I would like to thank Steven Zeitlin for sharing his thoughts with me on this subject.
4. See Robert Butler, "The Life Review: An Interpretation of Reminiscence in the Aged," *Psychiatry* 26, vol. 1 (1986): 65–76.
5. See Marc Kaminsky, "The Uses of Reminiscence: A Discussion of the Formative Literature," in *The Uses of Reminiscence* (New York: Hayworth Press, 1984), pp. 137–56.
6. See Barbara Kirshenblatt-Gimblett, "Authoring Lives," paper presented at the American-Hungarian Folklore Conference on Life History as Cultural Construction and Performance, Budapest, August 1987.

Chapter 1

1. Some of the material in this chapter was presented previously in Mary Hufford, "All of Life's a Stage: The Aesthetics of Life Review," in *Festival of American Folklife Program Book*, Thomas Vennum, ed. (Washington, D.C.: Smithsonian Institution, 1984), pp. 32–35, and Steven Zeitlin, "Folk Customs of Passage," paper presented at the Conference on Folk Custom, Washington, D.C., American Folklife Center, Library of Congress, 1979. For a discussion of rites of passage and the life cycle see Victor Turner, *The Ritual Process* (Chicago: Aldine Publishing Company, 1965); Arnold van Gennep, *The Rites of Passage* (Chicago: University of Chicago Press, 1960); and Barbara Myerhoff, "Rites of Passage: Process and Paradox," in *Celebration: Studies in Festivity and Ritual*, Victor Turner, ed. (Washington, D.C.: Smithsonian Institution Press, 1982).
2. Peter and Iona Opie, *The Oxford Dictionary of Nursery Rhymes* (London: Oxford University Press, 1951), pp. 392–93. See also Herbert and Mary Knapp, *One Potato, Two Potato: The Secret Education of American Children* (New York: W.W. Norton, 1976).
3. Philippe Ariès, *Centuries of Childhood: A Social History of Family Life* (New York: Alfred Knopf, 1962).
4. Tamara Hareven, "The Last Stage: Historical Adulthood and Old Age," *Daedalus* 105, no. 4 (1976): 15. Cited in Barbara Kirshenblatt-Gimblett, "Authoring Lives," paper

presented at the American-Hungarian Folklore Conference on Life History as Cultural Construction and Performance, Budapest, August 1987. We are grateful to Barbara Kirshenblatt-Gimblett for bringing this work to our attention.
5. See Bernice Neugarten, "Age Groups in American Society and the Rise of the Young-Old," in *The Annals of the Academy of Political and Social Science* 415 (September 1974), pp. 190–91.
6. William Shakespeare, *As You Like It*, Act II, Scene VII, in *The Complete Works of William Shakespeare*, William Albis Wright, ed. (New York: Doubleday and Co., Inc., 1936), p. 677.
7. Douglas C. Kimmel, *Adulthood and Aging* (New York: John Wiley and Sons, 1974), p. 5.
8. Interview, Tools for the Harvest project, November 1981.
9. Erik Erikson, *Childhood and Society* (New York: W.W. Norton, 1963), pp. 247–75.
10. McDowell points out that folklore genres make visible the child's progress from what Piaget calls the "preoperational stage" into his "stage of concrete operations." See John McDowell, "Children's Folklore," in *Handbook of American Folklore*, Richard Dorson, ed. (Bloomington: Indiana University Press, 1983), p. 320. "Early narratives," McDowell points out, "may stumble over the creation of temporal disjunction, a necessary sequencing of two events, without which there can be no narrative."
11. Ibid., p. 319. See also Barbara Kirshenblatt-Gimblett, *Speech Play* (Philadelphia: University of Pennsylvania Press, 1976); Brian Sutton-Smith, "A Developmental Psychology of Play and the Arts," *Perspectives on Education*, spring 1971: 8–17; and Roger Abrahams and Alan Dundes, "Riddles," in *Folklore and Folklife: An Introduction*, Richard Dorson, ed. (Chicago: University of Chicago Press, 1972).
12. Quoted in Daniel Goleman, "The Aging Mind Proves Capable of Lifelong Growth," *The New York Times*, February 21, 1984, pp. C1, C5. See also Loraine K. Obler and Martin L. Albert, "Language Skills Across Adulthood," in *Handbook of the Psychology of Aging*, James E. Birren and K. Warner Schaie, eds. (New York; Van Nostrand Reinhold, 1985), pp. 463–73.
13. Barbara Myerhoff, *Number Our Days* (New York: Simon and Schuster, 1978), p. 94.
14. Interview with Marjorie Hunt, November 1979.
15. In some traditional rural settings, where hunting is seen as a training ground for manhood, a youth is admitted into the society of drinking men when he shoots his first deer. Only a generation ago, young girls in rural America

prepared for marriage by making quilts for their hope chests. For most Americans today, the passage out of adolescence may begin with the conferral of legal rights and obligations, like the right to drink and vote, and the responsibility to defend the country. The age for such privileges varies from state to state, with the average hovering at 18 years.

16. Jack Santino, "The Community That Works Together," in *Festival of American Folklife Program Book*, Jack Santino, ed. (Washington, D.C.: Smithsonian Institution, 1979), p. 30. See also Robert McCarl, "Occupational Folklife: A Theoretical Hypothesis," in *Working Americans: Contemporary Approaches to Occupational Folklife*, Robert Byington, ed., *Smithsonian Folklife Studies* 3(1978): 3–18.

17. Interview, Grand Generation project, June 1984.

18. Personal communication to Steven Zeitlin, October 1985.

19. Barbara Kirshenblatt-Gimblett, "In Search of the Paradigmatic: Ethnic Symbol Building Among Elderly Immigrants," paper presented at the International Symposium on Ethnic Symbol Building, Hungarian Academy of Sciences and American Council of Learned Societies, Budapest, July 1982.

20. Margaret Yocom, "Growing Up into Art: The Richard Family of Rangeley, Maine," manuscript in progress. We would like to thank Margaret Yocom for sharing her research and field work with the Richard family with us.

21. Simon Bronner, *Chain Carvers: Old Men Crafting Meaning* (Lexington: The University Press of Kentucky, 1985).

22. Interview, Kim Burdick, summer 1983.

23. Alan Jabbour, "Creativity and Aging: Some Thoughts from a Folk Cultural Perspective," in *Perspectives on Aging: Exploding the Myth*, Priscilla W. Johnston, ed. (Cambridge: Ballinger Publishing Company, 1981), p. 144.

24. Personal communication to Steven Zeitlin, 1979.

25. Susan Stewart, "Sociological Aspects of Quilting in Three Brethren Churches of Southeastern Pennsylvania," *Pennsylvania Folklife* XXIII, no. 3 (1974): 26.

26. Interview, Grand Generation project, June 1984. See also William Ferris, *Local Color: A Sense of Place in Folk Art* (New York: McGraw Hill, 1982).

27. Simone de Beauvoir, *The Coming of Age*, Patrick O'Brian, trans. (New York: Warner Paperback Library, 1973), p. 567.

28. Matilda White Riley, "Age, Social Change, and the Power of Ideas," in *Daedalus* 107, no. 4 (1978): 50.

29. Karl Mannheim, "The Problem of Generations," in *Essays in the Sociology of Knowledge*, Paul Keeskemeti, ed. (New York: Oxford University Press, 1952), p. 283.

30. As Pinder wrote, "Everyone lives with people of the same and of different ages, with a variety of possibilities of experience facing them all alike. But for each 'the same time' is a different time, that is, it represents a different *period of his self*, which he can only share with people of his own age." *Kunstgeschichte nach Generationen. Zwischen Philosophie und Kunst* (Gottingen, Germany: 1926), p. 21, cited in Mannheim, op. cit., p. 283.

31. Interview with Doris Kirshenblatt, Grand Generation project, June 1984.

32. de Beauvoir, op. cit., p. 536.

33. Bluma Purmell, *A Farmer's Daughter: Bluma* (Los Angeles: Hayvenhurst Publishers, 1984), p. 255.

34. Graham Rowles, *Prisoners of Space? Exploring the Geographical Experience of Older People* (Boulder, Colorado: Westview Press, 1978), p. 31.

35. Interview with Rosina Tucker, Grand Generation project, June 1984.

36. Myerhoff, op. cit., p. 1.

37. Robert Coles, *The Old Ones of New Mexico* (Albuquerque: University of New Mexico Press, 1973), p. 28.

38. Rowles, op. cit., p. 166.

39. Elizabeth Mathias, "The Game as Creator of the Group in an Italian-American Community," *Pennsylvania Folklife* XXIII, no. 4 (summer 1974): 22–30.

40. Ibid., p. 30.

41. Stewart, op. cit., p. 26.

42. Interview with Doris Kirshenblatt, Grand Generation project, June 1984.

43. Interview with Jehu Camper, Grand Generation project, June 1984.

44. Interview with Doris Kirshenblatt, Grand Generation project, June 1984.

45. Linda Degh, "Two Old World Narrators in an Urban Setting," *Kontakte und Grenzen: Festschrift fur Gerhard Heilfurth* (1969), p. 79.

46. Ibid., p. 71.

47. Ibid., pp. 76, 84.

48. Interview, Amanda Dargan with Lucas Dargan, December 1986.

49. Jack Kugelmass, *The Miracle of Intervale Avenue* (New York: Schocken Books, 1986).

50. Myerhoff, op. cit.

51. Elizabeth Kolbert, "Storytelling Is Tribute to Student of the Aged," *The New York Times*, Sunday, December 15, 1985, p. 64.

52. Myerhoff, op. cit., pp. 210–11.

Chapter 2

The opening quote was taken from Thomas J. Cottle and Stephen L. Klineberg, *The Present of Things Future* (New York: Free Press, 1974), p. 49, cited in Graham Rowles, *Prisoners of Space? Exploring the Geographical Experience of Older People* (Boulder, Co.: Westview Press, 1978), p. 36.

1. Bluma Bayak Rappoport Purmell, *A Farmer's Daughter: Bluma* (Los Angeles: Hayvenhurst Publishers, 1981), p. 25.

2. Robert D. Bethke, "Farm Folklife in Wood," in *By Land and By Sea: Studies in the Folklore of Work and Leisure*, Roger D. Abrahams, Kenneth S. Goldstein, and Wayland D. Hand, eds. (Hatboro, Pa.: Legacy Books, 1985), p. 29.

3. Interview, Grand Generation project, June 1984.

4. Purmell, op. cit., p. x.

5. Marc Kaminsky, *The Uses of Reminiscence: New Ways of Working with Older Adults* (New York: Hayworth Press, 1984), p. 137.

6. See especially Robert Butler, "The Life Review: An Interpretation of Reminiscence in the Aged," *Psychiatry* 26, no. 1 (1968): 65–76.

7. Barbara Myerhoff, *Number Our Days* (New York: Simon and Schuster, 1978), p. 222.

8. Ibid., p. 108.

9. Kent Bloomer, "Memory and the Poetics of Architectural Time," *Crit* 18 (spring 1987): 23–30.

10. Edward S. Casey, "Keeping the Past in Mind," *Review of Metaphysics* 38, no. 1 (1983): 77–95.

11. Myerhoff, op. cit., p. 225.

12. Yi Fu Tuan, *Topophilia* (Englewood Cliffs, New Jersey:

Prentice-Hall, 1974), p. 10.

13. Interview, Grand Generation project, June 1984.
14. Ibid.
15. Frank Brady, "Grandma Mignerey's Special Cornbread," in Jason A. Shulman, *Grandma's Kitchen: Recipes for Food the Way You Remember It* (New York: Simon and Schuster, 1985), p. 30.
16. Tuan, op. cit., p. 10.
17. Margaret Yocom, "Blessing the Ties That Bind: Storytelling at Family Festivals," in Steven J. Zeitlin, Amy J. Kotkin, and Holly Cutting Baker, *A Celebration of American Family Folklore* (New York: Pantheon Books, 1982), p. 251.
18. Steven J. Zeitlin and Paul Wagner, *Free Show Tonight* (produced by the North Carolina Folklife Institute, North Carolina Department of Cultural Resources, in cooperation with the Smithsonian Institution, and distributed by Benchmark Films, 1984).
19. Arvid Asplund, "Via Dolorosa," in *Folklife Annual 1986*, Alan Jabbour and James Hardin, eds. (Washington, D.C.: Library of Congress, 1986), pp. 132–53.
20. Barbara Kirshenblatt-Gimblett, "In Search of the Paradigmatic: Ethnic Symbol Building Among Elderly Immigrants," paper presented at the International Symposium on Ethnic Symbol Building, Hungarian Academy of Sciences and American Council of Learned Societies, Budapest, July 1982. See especially Barbara Kirshenblatt-Gimblett, "Authoring Lives," paper presented at the American-Hungarian Folklore Conference on Life History as Cultural Construction and Performance, Budapest, August 1987.
21. Barbara A. Babcock, "Modelled Selves: Helen Cordero's 'Little People,'" in Victor Turner and Edward Bruner, *The Anthropology of Experience* (Urbana: Illinois University Press, 1986), p. 321.
22. We would like to thank John Moe for sharing his research on Elijah Pierce with us. See John Moe, *Elijah Pierce: The Life of an Afro-American Woodcarver* (Athens: University of Georgia Press), forthcoming.
23. Asplund, op. cit., p. ix.
24. Jane C. Beck, *Always in Season: Folk Art and Traditional Culture in Vermont* (Montpelier: Vermont State Council on the Arts), p. 25.
25. Purmell, op. cit., p. ix.
26. Jeff Todd Titon, "Of Separation and Survival," in Jabbour and Hardin, op. cit., pp. 166–68. See also Jeff Todd Titon, "The Life Story," *Journal of American Folklore* 93, no. 3 (1980): 276–92.
27. Interview, Grand Generation project, April 1987. We would like to thank Doris Francis Erhard for bringing Mr. Hartter's work to our attention.
28. Purmell, op. cit., p. 25.
29. Interview, Grand Generation project, 1984. See also William Ferris, *Local Color: A Sense of Place in Folk Art* (New York: McGraw Hill, 1982), pp. 101–32.
30. Interview, Grand Generation project, February 1987.
31. Interview, Doris Francis Erhard with John Hartter.
32. Letter to Allen Eaton, in Beck, op. cit., p. 27. We would like to thank Jane Beck for bringing the work of Ina Grant and Amber Densmore to our attention.
33. Interview, Grand Generation project, February 1987. We would like to thank Suzi Jones for bringing Viola Hanscam to our attention. See Suzi Jones, *Webfoots and Bunchgrassers: Folk Art of the Oregon Country* (Salem: Oregon Arts Commission, 1980).

34. Beck, op. cit., p. 25.
35. Kurt Dewhurst and Marsha MacDowell, *Michigan Folk Art: Its Beginnings to 1941* (East Lansing: Michigan State University, 1976).
36. Interview, Tom Carroll with Joe Reid, November 1983 American Folklife Center, Library of Congress, Washington, D.C.
37. John Dorst, "Art/Work, Ideology and Edna Young's Fence," paper presented at the American Folklore Society meeting in Baltimore, 1986.
38. Mihayli Cziksentmihalyi and Eugene Rochberg-Halton, *The Meaning of Things: Domestic Symbols and the Self* (Cambridge, England: Cambridge University Press, 1981), p. 92.
39. We would like to thank Barbara Kirshenblatt-Gimblett for sharing her observations on the transformation of tools into symbols with us.
40. Interview, Grand Generation project, 1984.
41. Interview, Grand Generation project, June 1984.
42. Interview, Grand Generation project, May 1987. See especially Margaret Yocom, "Growing Up into Art: The Richard Family of Rangeley, Maine," work in progress.
43. Bethke, op. cit., p. 24.
44. We would like to thank C. Kurt Dewhurst and Marsha MacDowell for bringing the work of William Drain to our attention, and Caroline de Mauriac of the Con Foster Museum in Traverse City, Michigan, for her helpful comments and assistance.
45. Susan Stewart, *On Longing: Narratives of the Miniature, the Gigantic, the Souvenir, the Collection* (Baltimore: Johns Hopkins University Press, 1984), p. 68.
46. Tom Carroll, field notes, October 9, 1983 (Washington, D.C.: American Folklife Center, Library of Congress PFP83-FTC1009).
47. Martin Heidegger, "An Ontological Consideration of Place," in *The Question of Being* (New York: Twayne Publishers, 1958), p. 24.
48. Interview, Marjorie Hunt with Michael Alpert, April 10, 1987.
49. We would like to thank Kathy Mundell for bringing Mr. Burghardt's mural to our attention.
50. Cited in Mary Hufford et al., "The Mountains Stay With Us: Southern Upland Folklife in the Midwest," in a report to the Great Lakes Arts Alliance (Cleveland, Ohio, October 1981).
51. Elena Bradunas, "Folklife in Miniature," *Folklife Center News* 5, no. 1 (1982): 10–11.
52. Joseph Sciorra, "Reweaving the Past: Vincenzo Ancona's Telephone Wire Figures," *The Clarion*, spring/summer 1985, pp. 48–53. See also Maxine Miska and I. Sheldon Posen, *Tradition and Community in the Urban Neighborhood: Making Brooklyn Home* (New York: Brooklyn Educational and Cultural Alliance, 1983), pp. 28–29.
53. Sciorra, op. cit., p. 52.
54. Sciorra, op. cit., p. 51.
55. Purmell, op. cit., p. 19.
56. Kirshenblatt-Gimblett, op. cit.
57. Correspondence, Edythe Siegel to Marjorie Hunt.
58. Stewart, op. cit., pp. 68–69.
59. Stewart, op. cit., p. 44.
60. Miska and Posen, op. cit., p. 26.
61. Csikszentmihalyi and Rochberg-Halton, op. cit., p. 92.
62. Csikszentmihalyi and Rochberg-Halton, op. cit., p. 37.
63. Miska and Posen, op. cit., p. 27.

64. Beck, op. cit., p. 22.
65. Tom Carroll, field notes, November 17, 1983. (Washington, D.C.: American Folklife Center, Library of Congress PFP83-FTC1117).
66. Sciorra, op. cit., p. 50.
67. Stewart, op. cit., p. 139.
68. We are grateful to Geraldine Johnson for introducing us to Zenna Todd's quilting. For more on the work of Zenna Todd, see Geraldine Johnson, " 'Plain and Fancy': The Socioeconomics of Blue Ridge Quilts," *Appalachian Journal* 10, no. 1 (1982): 12–35.
69. We are indebted to Suzi Jones for directing us to Rod Rosebrook. For more on Rosebrook's artwork, see Suzi Jones, *Webfoots and Bunchgrassers: Folk Art of the Oregon Country* (Salem: Oregon Arts Commission, 1980), pp. 102–03.
70. Dorst, op. cit.
71. Personal communication, Ray Faust to Barbara Kirshenblatt-Gimblett.
72. Kirshenblatt-Gimblett, op. cit.
73. Bethke, op. cit., pp. 24–25.
74. Robert Frost, "Two Tramps in Mudtime," in *The Road Not Taken: An Introduction to Robert Frost* (New York: Holt, Rinehart and Winston, 1976), p. 130.
75. Interview, Grand Generation project, March 1984.
76. Interview, Grand Generation project, February 1987.
77. Beck, op. cit., p. 29.
78. Nancy Cacioppo, "Burghardt's Mural Conjures Up Memories," *The Rockland County Journal News*, p. F3.
79. Interview with Rod Rosebrook, Grand Generation project, April 1987.
80. Interview with Vincenzo Ancona, Grand Generation project, April 1987.
81. Ibid.

Chapter 3

1. Marjorie Hunt, "Between Labor and Art: An Ethnography of Craftsmanship," Ph.D. dissertation in progress, University of Pennsylvania.
2. Rita Moonsammy, "Smart Boats, Able Captains: The Schooner as Metaphor," *New Jersey Folklife* 12 (1987): 41.
3. Robert Plant Armstrong, *The Powers of Presence* (Philadelphia: University of Pennsylvania Press, 1981), pp. 10–12.
4. Bess Lomax Hawes, "Folk Arts and the Elderly," in *Festival of American Folklife Program Book*, Thomas Vennum, ed. (Washington, D.C.: Smithsonian Institution, 1984), p. 30.
5. Interview, Grand Generation project, April 1987.
6. See Charles Camp, " 'The Craft So Longe to Lerne:' Traditional Craftsmanship and Its Uses in American Society," in *Traditional Craftsmanship in America* (Washington, D.C.: National Council for the Traditional Arts, 1983), pp. 13,15.
7. Interview, Grand Generation project, April 1987.
8. Interview, Grand Generation project, March 1987.
9. Simone de Beauvoir, *The Coming of Age*, Patrick O'Brian, trans. (New York: Warner Paperback Library, 1973), p. 566.
10. Karl Mannheim, "The Problem of Generations," in *Essays in the Sociology of Knowledge by Karl Mannheim*, Paul Keeskemeti, ed. (New York: Oxford University Press, 1952), p. 296.
11. Interview, Grand Generation project, January 1987.
12. Interview, Tom Carroll with Joe Reid, November 1983 (Washington, D.C.: American Folklife Center, Library of Congress).
13. Guy Miles, Frances Hurley, and Faye Miles, *Mamoo's Soggy Coconut Cake* (Knoxville: Miles Documentaries, Inc., 1979), p. 17.
14. Ibid., p. 23.
15. Interview, Grand Generation project, June 1984.
16. Robert Coles, *The Old Ones of New Mexico* (Albuquerque: University of New Mexico Press, 1973), p. 36.
17. Barbara Kirshenblatt-Gimblett, "An Accessible Aesthetic: The Role of Folk Arts and the Folk Artist in the Curriculum," *New York Folklore*, winter 1983: 13.
18. Interview, Grand Generation project, April 1987.
19. Interview, Grand Generation project, April 1987.
20. Interview with Betty Chia-Karro, Grand Generation project, June 1984.
21. Interview, Grand Generation project, April 1987. See also Mary Hufford's discussion of environmental masters in *One Space, Many Places: Folklife and Land Use in New Jersey's Pineland National Reserve* (Washington, D.C.: Library of Congress, 1986), p. 102.
22. Interview, Grand Generation project, January 1987. See also Jane C. Beck, *On My Own: The Traditions of Daisy Turner, A Teacher's Guide* (Montpelier: The Vermont Folklife Center, 1986) for a discussion of the importance of older tradition bearers as sources of folklore and oral history.
23. Walter Benjamin, "The Work of Art in the Age of Mechanical Reproduction," in *Illuminations*, Hannah Arendt, ed. and Harry Zohn, trans. (New York: Schocken Books, 1969), pp. 221–22. See also Kirshenblatt-Gimblett, op. cit., p. 10.
24. Interview, Grand Generation project, June 1984.
25. Interview, Grand Generation project, April 1987.
26. Joseph Sciorra, "Reweaving the Past: Vincenzo Ancona's Telephone Wire Figures," *The Clarion*, spring/summer 1985: 49.
27. Interview, Marjorie Hunt with Villiana Hyde, June 1985. See also Susan Dyal, *Preserving Traditional Arts: A Toolkit for Native American Communities* (Los Angeles: UCLA American Indian Studies Center, 1985).
28. Interview, Grand Generation project, April 1987. See also *Michigan Hmong Arts: Textiles in Transition*, C. Kurt Dewhurst and Marsha MacDowell, eds. (East Lansing: Michigan State University, 1983).
29. David Gates, "Pickin' on Tommy's Porch," *Newsweek*, September 17, 1984, p. 78.
30. Interview, Grand Generation project, April 1987.
31. de Beauvoir, op. cit., p. 565.
32. Interview, Grand Generation project, June 1984.
33. David Pye, *The Nature and Art of Workmanship* (Cambridge, England: Cambridge University Press, 1968), p. 4.
34. Interview, Marjorie Hunt with Roger Morigi and Vincent Palumbo, October 1981.
35. Interview, Tom Carroll with James Reid, October 1983 (Washington, D.C.: American Folklife Center, Library of Congress).
36. John Vlach, *Charleston Blacksmith* (Athens: University of Georgia Press, 1981), p. 130. See also Barbara Kirshenblatt-Gimblett on the importance of the art of lifelong learning in "An Accessible Aesthetic: The Role of Folk Arts and the Folk Artist in the Curriculum," *New York Folklore*, winter 1983: 11.
37. Interview, Marjorie Hunt with Roger Morigi, April 1987.
38. Gates, op. cit., p. 78.

39. Interview, Marjorie Hunt with Randy Severe, April 1987.
40. Ibid.
41. Interview with Susan Roller Whittington, Grand Generation project, April 1987.
42. Interview, Marjorie Hunt with Roger Morigi, October 1981.
43. Elizabeth Mathias, "The Game as Creator of the Group in an Italian-American Community," *Pennsylvania Folklife* XXIII, no. 4 (summer 1974): 30.
44. Interview, Grand Generation project, 1986. See also Jack Kugelmass, *The Miracle of Intervale Avenue: The Story of a Jewish Congregation in the South Bronx* (New York: Schocken Books, 1986).
45. Interview, Tom Carroll with James Reid, November 1983 (Washington, D.C.: American Folklife Center, Library of Congress). See also *Pinelands Folklife*, Rita Moonsammy, David Cohen, and Lorraine Williams, eds. (New Brunswick, N.J.: Rutgers University Press, 1987), p. 172.
46. Vlach, op. cit., p. 134.
47. Mary Hufford, "Culture and the Cultivation of Nature: The Pinelands National Reserve," *Folklife Annual 1985* (Washington, D.C.: Library of Congress, 1985), p. 24.
48. de Beauvoir, op. cit., p. 573.
49. Interview, Joseph Sciorra with Sam Cangiano, June 1981.
50. Sheldon Posen and Joseph Sciorra, "Brooklyn's Dancing Tower," *Natural History*, June 1983, pp. 35–36. See also Maxine Miska and I. Sheldon Posen, *Tradition and Community in the Urban Neighborhood: Making Brooklyn Home* (New York: The Brooklyn Educational and Cultural Alliance, 1983), p. 34–36.
51. Henry Glassie, *Passing the Time in Ballymenone* (Philadelphia: University of Pennsylvania Press, 1982), p. 62.
52. Henry Glassie, *Irish Folk History: Texts from the North* (Philadelphia: University of Pennsylvania Press, 1982), p. 14.
53. Henry Glassie, *Passing the Time in Ballymenone*, p. 63.
54. Ibid., p. 63.
55. Keith Basso, "Stalking with Stories: Names, Places and Moral Narratives Among the Western Apache," in *Text, Play, and Story: The Construction and Reconstruction of Self and Society*, Edward M. Bruner, ed. (Washington, D.C.: American Ethnological Society, 1984), p. 39–40.
56. Margaret Mead, *Blackberry Winter: My Earlier Years* (New York: William Morrow and Company, 1972), p. 48.
57. Ibid., p. 50.
58. Dennis Folly, "Getting the Butter from the Duck: Proverbs and Proverbial Expressions in an Afro-American Family," in Steven Zeitlin, Amy Kotkin, and Holly Cutting Baker, *A Celebration of American Family Folklore* (New York: Pantheon Books, 1982), pp. 232–41.
59. de Beauvoir, op. cit., p. 567.
60. Coles, op. cit., p. 26.
61. Interview, Grand Generation project, June 1984.
62. Hawes, op. cit., p. 29.
63. Interview, Marjorie Hunt with Michael Alpert, April 1987.
64. Hawes, op. cit., p. 29.
65. Interview, Grand Generation project, January 1987.
66. Mannheim, op. cit., p. 301.
67. Interview, Grand Generation project, January 1987.
68. Barbara Myerhoff, "Life Not Death in Venice: The Transmission of an Endangered Tradition," *Festival of American Folklife Program Book*, Thomas Vennum, ed. (Washington, D.C.: Smithsonan Institution, 1984), p. 38.
69. Gates, op. cit., p. 78.

Chapter 4

1. Mihalyi Csikszentmihalyi and Eugene Rochberg-Halton, *The Meaning of Things: Domestic Symbols and the Self* (Cambridge, England: Cambridge University Press, 1981), p. 33.
2. Karl Mannheim, "The Problem of Generations," in *Essays on the Sociology of Knowledge*, Paul Keeskemeti, ed. (New York: Oxford University Press, 1952), p. 276. There are exceptions in the butterfly world. Monarch butterflies, for example, have gotten around the problem of winter, as many elderly humans have, by migrating south during that season.
3. Ibid., p. 283.
4. Margaret Mead, *Blackberry Winter: My Earlier Years* (New York: William Morrow and Company, 1972), p. 311.
5. Ibid., p. 311.
6. Margaret Mead, "Celebrating the Bicentennial Family Style," *Redbook*, April 1975, p. 33.
7. Personal communication to Marjorie Hunt, November 1986.
8. Steven Zeitlin, Amy Kotkin, and Holly Cutting Baker, *A Celebration of American Family Folklore* (New York: Pantheon Books, 1982), pp. 180–81.
9. Susan Kalčik, "Gifts to America," in *Festival of American Folklife Program Book* (Washington, D.C.: Smithsonian Institution, 1976), pp. 12–13. See also Maxine Miska and I. Sheldon Posen, *Tradition and Community in the Urban Neighborhood: Making Brooklyn Home* (New York: Brooklyn Educational and Cultural Alliance, 1983).
10. Rita Moonsammy, "Smart Boats, Able Captains: The Schooner as Metaphor," *New Jersey Folklife*, 1987: 41.
11. Mannheim, op. cit., pp. 305–06.
12. Interview, Phyllis May-Machunda with Annie Lee Harris, April 1986 (Washington, D.C.: Smithsonian Institution, Office of Folklife Programs).
13. Interview, Grand Generation project, June 1984.
14. Miska and Posen, op. cit., p. 39.
15. Barbara Kirshenblatt-Gimblett, "In Search of the Paradigmatic: Ethnic Symbol Building Among Elderly Immigrants," unpublished manuscript, 1981.
16. Kurt Dewhurst and Marsha MacDowell, *Michigan Hmong Arts: Textiles in Transition* (East Lansing: Michigan State University, 1984), p. iii.
17. Interview, Sally Petersen with Pang Xiong Sirirathasuk, 1986 (Washington, D.C.: Smithsonian Institution, Office of Folklife Programs).
18. Guy Miles, Frances Hurley, and Faye Miles, *Mamoo's Soggy Coconut Cake* (Knoxville, Tennessee: Miles Documentaries, Inc., 1979), p. viii.
19. *Haa Shagoon* (film by Joseph Kawaky produced by the Chilkoot Indian association and distributed by the University of California Extension Media Center, n.d.)
20. Personal communication with Barbara Kirshenblatt-Gimblett, May 1987.
21. Elizabeth Mathias, "The Game as Creator of the Group in an Italian-American Community," *Pennsylvania Folklife* XXIII, no. 4 (summer 1974): 28.
22. Interview, Mary Hufford with George Heinrichs, September 1979.
23. Jane Beck, "Newton Washburn: Traditional Basket Maker," in *Traditional Craftsmanship in America*, Charles Camp, ed. (Washington, D.C.: National Council on the Traditional Arts, 1983), p. 76.
24. Ibid., p. 75.

25. Ibid., p. 76.
26. Interview, Grand Generation project, May 1987.
27. Zeitlin, Kotkin, and Cutting Baker, op. cit., p. vii.
28. Mary Hufford, *One Space, Many Places: Folklife and Land Use in New Jersey's Pineland National Reserve* (Washington, D.C.: Library of Congress, 1986), p. 102.
29. Simone de Beauvoir, *The Coming of Age*, Patrick O'Brian, trans. (New York: Warner Paperback Library, 1973), p. 545.
30. Interview, Grand Generation project, April 1987.
31. Hufford, op. cit., p. 122.
32. Interview, Family Folklore project, Smithsonian Institution, 1976.
33. Interview, Grand Generation project, 1986.
34. Interview, Grand Generation project, July 1984.
35. Interview, Grand Generation project, June 1984.
36. Interview, Grand Generation project, May 1987.
37. Csikszentmihalyi, op. cit., p. 34.
38. Barbara Babcock, Guy Monthan, and Doris Monthan, *The Pueblo Storyteller* (Tucson: The University of Arizona Press, 1986), p. 97. See also Barbara Babcock "Modeled Selves: Helen Cordero's 'Little People,'" in *The Anthropology of Experience*, E. Brunner and Victor Turner, eds. (Urbana: University of Illinois Press, 1986).
39. Kim Rogers Burdick, "Grandma's Quilt: Reflections on the Nature of Creativity," lecture for Winterthur-in-Odessa, June 1986.
40. Interview, Grand Generation project, April 1987.
41. Miska and Posen, op. cit., p. 25.
42. Keith Basso, "Stalking with Stories: Names, Places and Moral Narratives Among the Western Apache," in *Text, Play and Story: The Construction and Reconstruction of Self and Society*, Edward Bruner, ed. (Washington, D.C.: American Ethnological Society, 1984), p. 40.
43. Hufford, op. cit., p. 58.
44. Hufford, op. cit., p. 104.
45. Interview with Stephanie Berrard, Grand Generation project, April 1987.
46. Interview with Celeste Hufford, Grand Generation project, April 1987.
47. Interview with Helen DeJana, Grand Generation project, April 1987.
48. Interview with Michael Manteo, Grand Generation project, April 1987.
49. See Barbara Kirshenblatt-Gimblett, "An Accessible Aesthetic: The Role of Folk Arts and the Folk Artist in the Curriculum," *New York Folklore*, winter 1983: 10.
50. Tamara K. Hareven, "The Search for Generational Memory: Tribal Rites in Industrial Society," *Daedalus* 107 (1978): 137.
51. In recent decades, a number of publicly funded programs have placed elderly tradition-bearers in community settings, supporting performances and workshops in schools, museums, and festivals. See Mary Hufford, *A Tree Smells Like Peanut Butter: Folk Artists in a City School*, (Trenton: The New Jersey State Council on the Arts, 1979); Eliot Wigginton, ed., *Foxfire*, vols. 1–9 (New York: Doubleday, 1971–86); Ormond Loomis, *Cultural Conservation: The Protection of Cultural Heritage* (Washington, D.C.: Smithsonian Institution, American Folklife Center, 1983); Marsha MacDowell, *Folk Arts and Education: A Resource Handbook* (East Lansing: Michigan State University, 1987); and Rita Moonsammy, "Teaching in Tandem: Folk Artists and School Teachers" (Trenton: New Jersey State Council on the Arts, work in progress).
52. Simon Bronner, *Chain Carvers: Old Men Crafting Meaning* (Lexington: The University Press of Kentucky, 1984), p. 107.

Selected Bibliography

Abrahams, Roger, ed. *A Singer and Her Songs: Almeda Riddle's Book of Ballads.* Baton Rouge: Louisiana State University Press, 1970.

Ariès, Philippe. *Centuries of Childhood: A Social History of Family Life.* Translated by Robert Baldick. New York: Alfred Knopf, 1962.

Bethke, Robert. "Farm Folklife in Wood." In *By Land and By Sea: Studies in the Folklore of Work and Leisure,* edited by Roger Abrahams, Kenneth S. Goldstein, and Wayland Hand. Hatboro, Pa.: Legacy Books, 1985.

Beck, Jane. *Always in Season: Folk Art and Traditional Culture in Vermont.* Montpelier: Vermont Council on the Arts, 1982.

Bronner, Simon. *Chain Carvers: Old Men Crafting Meaning.* Lexington: The University Press of Kentucky, 1984

Butler, Robert N. "The Life Review: An Interpretation of Reminiscence in the Aged." *Psychiatry* 26, no. 1 (1968): 65–76.

Coles, Robert. *The Old Ones of New Mexico.* Albuquerque: University of New Mexico Press, 1973.

Csikszentmihalyi, Mihaly, and Eugene Rochberg-Halton. *The Meaning of Things: Domestic Symbols and the Self.* Cambridge, England: Cambridge University Press, 1981.

de Beauvoir, Simone. *The Coming of Age.* Translated by Patrick O'Brian. New York: Warner Paperback Library, 1973.

Degh, Linda. "Two Old World Narrators in an Urban Setting." *Kontakte und Grenzen: Festschrift fur Gerhard Heilfurth.* Gottingen, Germany: 1969.

Dewhurst, C. Kurt, and Marsha MacDowell. *Rainbows in the Sky: The Folk Art of Michigan in the Twentieth Century.* East Lansing: Michigan State University, 1978.

Francis-Erhard, Doris. *Older Cleveland Folk Artists.* Cleveland: The Cleveland Department of Aging, 1982.

Erikson, Erik H. *Childhood and Society.* New York: W.W. Norton, 1963.

Glassie, Henry. *Passing the Time in Ballymenone: Culture and History of an Ulster Community.* Philadelphia: University of Pennsylvania Press, 1982.

Hawes, Bess Lomax. "Folk Arts and the Elderly." In *Festival of American Folklife Program Book,* edited by Thomas Vennum. Washington, D.C.: Smithsonian Institution, 1984.

Hufford, Mary. "All of Life's a Stage: The Aesthetics of Life Review." In *Festival of American Folklife Program Book,* edited by Thomas Vennum. Washington, D.C.: Smithsonian Institution, 1984.

Jabbour, Alan. "Some Thoughts from a Folk Cultural Perspective." In *Perspectives on Aging: Exploding the Myth,* edited by Priscilla Johnston. Cambridge: Ballinger Publishing Company, 1981.

Jones, Suzi, ed. *Webfoots and Bunchgrassers: Folk Art of the Oregon Country.* Salem: Oregon Arts Commission, 1980.

Kaminsky, Marc, ed. *The Uses of Reminiscence: New Ways of Working with Older Adults.* New York: Hayworth Press, 1984.

Keith, Jennie. "The Best Is Yet to Be: Toward an Anthropology of Age." *Annual Review Anthropology Journal,* 1980: 333–64.

Kirshenblatt-Gimblett, Barbara. "In Search of the Paradigmatic: Ethnic Symbol Building Among Elderly Immigrants." Unpublished paper, 1981.

———. "An Accessible Aesthetic: The Role of Folk Arts and the Folk Artist in the Curriculum. *New York Folklore,* winter 1983.

Kugelmass, Jack. *The Miracle of Intervale Avenue: The Story of a Jewish Congregation in the South Bronx.* New York: Schocken Books, 1986.

Mannheim, Karl. "The Problem of Generations." In *Essays on the Sociology of Knowledge,* edited by Paul Keeskemeti. New York: Oxford University Press, 1952.

Mathias, Elizabeth. "The Game as Creator of the Group in an Italian-American Community." *Pennsylvania Folklife* XXIII, no. 4 (summer 1974): 22–30.

Mead, Margaret. *Blackberry Winter: My Earlier Years.* New York: William Morrow and Company, 1972.

———. "Celebrating the Bicentenial Family Style." *Redbook* 144 (April 1975): 31, 33, 37.

Miska, Maxine, and I. Sheldon Posen. *Tradition and Community in the Urban Neighborhood: Making Brooklyn Home.* New York: Brooklyn Educational and Cultural Alliance, 1983.

Myerhoff, Barbara. *Number Our Days.* New York: Simon and Schuster, 1978.

————. "Rites of Passage: Process and Paradox." In *Celebration: Studies in Festivity and Ritual,* edited by Victor Turner. Washington, D.C.: Smithsonian Institution Press, 1982.

Myerhoff, Barbara, and Andrei Simic. *Life's Career— Aging: Cultural Variations in Growing Old.* Beverly Hills, Ca.: Sage Publications, 1978.

Ohrn, Steve, ed. *Passing Time and Traditions: Contemporary Iowa Folk Artists.* Des Moines: Iowa Arts Council, 1984.

Riley, Matilda White. "Aging, Social Change, and the Power of Ideas." *Daedalus* 107, no. 4 (1978): 39–52.

Rowles, Graham D. *Prisoners of Space? Exploring the Geographical Experience of Older People.* Boulder, Co.: Westview Press, 1978.

Stewart, Susan. *On Longing: Narratives of the Miniature, the Gigantic, the Souvenir, the Collection.* Baltimore: The Johns Hopkins University Press, 1984.

Tuan, Yi-Fu. *Topophilia: A Study of Environmental Perception, Attitudes and Values.* Englewood Cliffs, N.J.: Prentice-Hall, 1974.

Turner, Victor. *The Ritual Process,* Chicago: Aldine Publishing Co., 1969.

Van Gennep, Arnold. *The Rites of Passage.* 1908. Reprint, translated by M.B. Vizedom and G.L. Caffee. Chicago: University of Chicago Press, 1960.

Wigginton, Eliot, ed. *Foxfire.* 9 vols. New York: Doubleday, 1971–86.

Zeitlin, Steven, Amy Kotkin, and Holly Cutting Baker. *A Celebration of American Family Folklore.* New York: Pantheon Books, 1982.

Exhibition Checklist

All works lent by the artist unless otherwise noted.

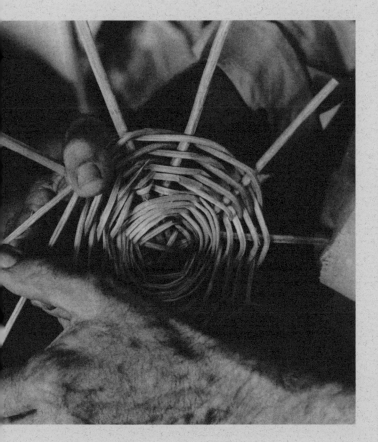

Vincenzo Ancona
Brooklyn, New York

1. *The Cowherd*, ca. 1978
 telephone wire
 11″ L × 6½″ H × 6½″ W

2. *The Hunter*, ca. 1978
 telephone wire
 7″ L × 9″ H × 6″ W

Virginia Ancona
Brooklyn, New York

3. Crocheted Square for a Baby Coverlet, 1987
 cotton
 6½″ L × 5″ W
 Lent by Frances Favaloro and Virginia Ancona

4. Crocheted Square for a Baby Coverlet, 1987
 cotton
 5¼″ L × 4½″ W
 Lent by Frances Favaloro and Virginia Ancona

Earnest Bennett
Indianapolis, Indiana

5. Whittled Chain, 1987
 bass wood
 47″ L × 1″ W

6. Miniature Flail, 1987
 bass wood
 10½″ L × ⅓″ W

7. Miniature Wheat Cradle, 1987
 bass wood
 5⅓″ L × 6⅞″ H × 3½″ W

8. Miniature Winnower, 1987
 bass wood
 2⅓″ L × 1½″ H × 2⅔″ W

14. *Journeyman Steamfitter and Apprentice Threading a Pipe*, 1985
papier mâché, paint, wire, metal
9¼" L × 7½" H × 8½" W

Ed Hazelton
Manahawkin, New Jersey

15. Miniature Barnegat Bay Sneakbox, 1987
cedar, paint
12" L × 4" W × 4½" H

Martha Alice Hunt
Springfield, Missouri

16. *Life Story of Mother Hunt*, 1956
paper
7" L × 10" W
Lent by Marjorie Hunt and Ira Madsen

Abraham Hunter
Percy Creek, Mississippi

17. Cornshuck Mule Collar, 1975
cornshucks
20" L × 5½" H × 17" W
From the Roland L. Freeman Collection, Washington, D.C.

Helen Fretz Jarrett
Washington, D.C.

18. *Billy Jarrett's Treasure Chest*, 1982
tin trunk, miscellaneous mementos
11" L × 7½" H × 8¼" W

Jesse Jones
Clinchport, Virginia

19. Split-Oak Basket, ca. 1980
white oak
11" H × 14" diameter
Lent by Kyle and Dora Bowlin

Agrippino Manteo
Brooklyn, New York

20. Hammer, ca. 1923
metal, wood
9½" L × 3" W
Lent by Michael Manteo

Agueda Martínez
Medanales, New Mexico

21. Rag Rug, 1987
wool, cotton
35¼" W × 69½" L

Helen Cordero
Cochiti, New Mexico

9. Cochiti Storyteller Figure, ca. 1977
clay, paint
8" L × 10½" H × 8" L
International Folk Art Foundation Collections in the Museum of International Folk Art, a unit of the Museum of New Mexico

Ray Faust
New York, New York

10. *Blessing the New Moon in the Wintertime*, 1969
oil on canvas
23⅔" L × 18" W
Lent by the Edythe Siegel Gallery of Jewish-American Folk Art, Stamford, Connecticut

Ina Hackett Grant
Chelsea, Vermont

11. *Farm and Home Memories* Quilt, 1939–46
muslin, single-strand cotton thread
70" L × 72" W
Lent by Marjorie Herrick

Viola Hanscam
Harbor, Oregon

12. Stair Rugs, 1961
wool rags, burlap, cotton
35" L × 14" W
Lent by the Chetco Valley Historical Society Museum, Harbor, Oregon

John Hartter
Brooklyn, New York

13. *Difficult Water-Meter Reading*, 1985
papier mâché, paint, wire
9" L × 11" H × 7" W

Ethel Mohamed
Belzoni, Mississippi

22. *Three Stages of Life* Embroidery, 1984
 cotton
 42¾" L × 25¼" W
 Lent by the Jackson Heart Clinic, Jackson, Mississippi

23. *Depression Days* Embroidery, ca. 1970
 cotton
 17" L × 25¾" W

24. *The Storm* Embroidery, ca. 1970
 cotton
 28" L × 21½" W

25. *The New Baby* Embroidery, ca. 1970
 cotton
 17¾" L × 17" W

Genevieve Nahra Mougin
Bettendorf, Iowa

26. Needlelace Doily, ca. 1985
 linen thread
 8½" L × 6" W
 Private Collection

27. Needlelace Doily, ca. 1985
 linen thread
 5¼" diameter
 Private Collection

Kathryne Petersen
Arden, Delaware

28. "LeMoyne Star" Quilt, 1976
 cotton
 92" L × 84" W
 Lent by Betty Cantera

Elijah Pierce
Columbus, Ohio

29. Walking Stick, ca. 1950
 carved and painted wood, rhinestones
 36" H × 1⅜" W
 Lent by Alexis G. Pierce, the artist's granddaughter

Bluma Bayuk Rappoport Purmell
Philadelphia, Pennsylvania

30. *Picking Cranberries at Peterson's Bog*, 1976
 oil on canvas
 23½" L × 19½" W
 Lent by Michèle Rappoport, the artist's
 granddaughter

31. *Recollections of My Homestead*, 1977
 oil on canvas
 23⅓" L × 19½" W
 Lent by Michèle Rappoport, the artist's
 granddaughter

Norman Rankin
Visalia, California

32. *Sheepherders' Camp*, 1975
 carved and painted wood, metal, cloth
 Lent by the National Museum of American History,
 Smithsonian Institution

Rodney Richard, Sr.
Rangeley, Maine

33. Miniature loggers, 1985
 bass wood
 5" H × 2½" W × 1" D

Duff Severe
Pendleton, Oregon

34. Miniature Saddle, 1984
 leather, rawhide
 7" L × 9" H × 5 ¼" W

35. Miniature Quirt, 1984
 rawhide
 12' L × 7 ½" W

36. Miniature Hobbles, 1984
 rawhide
 5½" L × 1½" W × 1¼"

37. Miniature Bosal, 1984
 rawhide
 6" L × 3½" W × ¾"

The Sew and Sews of the Tabernacle Methodist Church
Tabernacle, New Jersey

38. "Tumbling Blocks" Friendship Quilt, 1977
 cotton, polyester
 89" L × 74" W
 Lent by the Tabernacle Historical Society

Pang Xiong Sirirathasuk
Philadelphia, Pennsylvania

39. Hmong Decorative Square, 1984
 cotton
 11¾" L × 11¾" W

Lottie Stamper
Cherokee, North Carolina

40. Cherokee Double-Weave River-Cane Basket, ca. 1968
 river cane, vegetable dyes
 13¾" L × 9" H × 8¼" W
 Collection of the Indian Arts and Crafts Board, U.S.
 Department of the Interior

Alex Stewart
Sneedville, Tennessee

41. Churn, ca. 1970
 red cedar, white oak
 36" H × 11" W
 Lent by Bill Henry, Oak Ridge, Tennessee

42. Whittled Doll, ca. 1970
 red cedar
 4¾" H × 2" W × ¾"
 Lent by the Children's Museum of Oak Ridge,
 Oak Ridge, Tennessee

43. Pair of Whittled Shoes, ca. 1970
 red cedar
 3" L × 1½" H × ¾" W
 Lent by the Children's Museum of Oak Ridge,
 Oak Ridge, Tennessee

44. Whittled Jackstraws, ca. 1970
 red cedar
 3½" to 7½" Long
 Lent by the Children's Museum of Oak Ridge,
 Oak Ridge, Tennessee

Rick Stewart
Sneedville, Tennessee

45. Bucket, 1987
 red cedar, white oak
 10" H × 9" W

Margaret Tafoya
Santa Clara, New Mexico

46. Santa Clara Blackware Jar, ca. 1982
 blackware
 8½" H × 9½" W
 Lent by Andrea Fisher

George Winkler
Bend, Oregon

47. *Roping a Cow*, ca. 1978
 carved wood
 43¼" L × 18¼" H × 4⅜" W

Burleigh Woodard
West Charleston, Vermont

48. *Horse-Powered Saw*, ca. 1950
 carved and painted wood, leather, cloth
 11½" L × 10" H × 11½' W
 Lent by the Orleans County Historical Society,
 Old Stone House Museum, Orleans, Vermont

Bao Yang
Xieng Khouang, Laos

49. Hmong Apron Sash, 1953
 cotton, silk
 29" L × 4¼" W
 Lent by Pang Xiong Sirirathasuk

Artists Unknown

50. Jewish "Stages of Life" Greeting Card,
 early 20th century
 printed on paper
 3½" H × 3¾" W
 Lent by Barbara Kirshenblatt-Gimblett

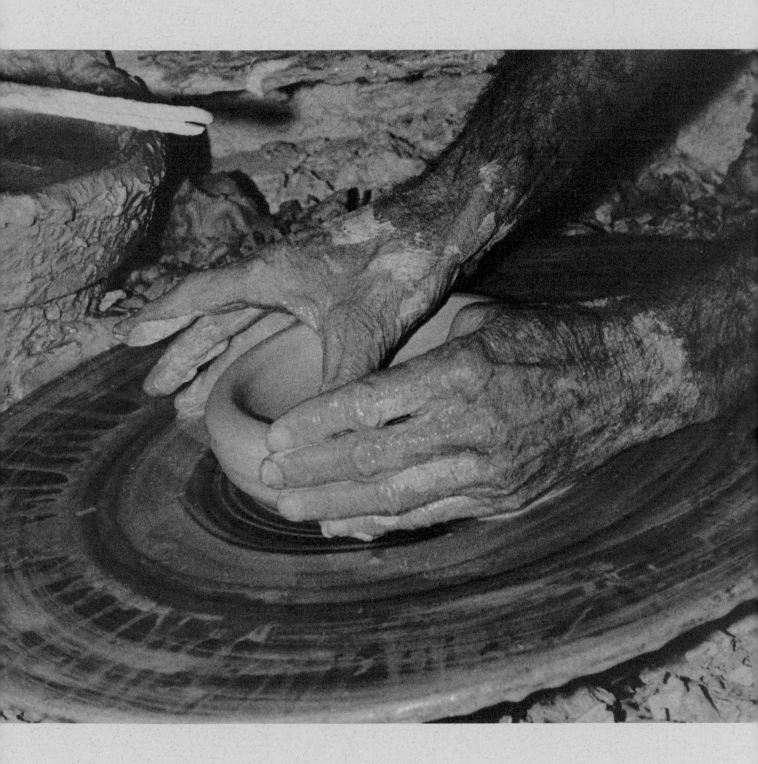

51. Jewish "Stages of Life" Greeting Card,
early 20th century
printed on paper
3" H × 3¾" W
Lent by Barbara Kirshenblatt-Gimblett

52. Branding Irons, 20th century
iron
23" to 45" L
Lent by Rod Rosebrook

Memorabilia

53. Baby Cup, ca. 1850
silver
3⅓" H × 2¼" W
Lent by Lucas and Frances Dargan, Darlington,
South Carolina

54. Baby Cup, ca. 1950
silver
2¼" H × 3½" W
Lent by Mary Hufford, Washington, D.C.

55. Candlestick Telephone, ca. 1915
metal, plastic
12" H × 5" W
Lent by the National Museum of American History,
Smithsonian Institution

56. Child's Handmade Card, ca. 1955
crayon and pencil on paper
8½" W × 5½" L
Lent by Gen. and Mrs. Ira A. Hunt, Jr., McLean,
Virginia

57. Child's Handmade Card, ca. 1955
crayon and pencil on paper
12" W × 7" L
Lent by Gen. and Mrs. Ira A. Hunt, Jr., McLean,
Virginia

58. Chisels (2) ca. 1920
metal
10" L × ½" W
Lent by Vincent Palumbo, Upper Marlboro,
Maryland

59. Cooking Spoon, ca. 1911
metal
11¾" L × 2½" W
Lent by Helen Salerno DeJana, Port Washington,
New York

60. High School Diploma, 1907
printed on paper
20" L × 16" W
Lent by Gen. and Mrs. Ira A. Hunt, Jr., McLean,
Virginia

61. Ice Card, ca. 1920
printed on paper
9" L × 9" W
Lent by Jane D'Alelio, Ice House Graphics

62. Ice Tongs, ca. 1920
metal
18½" L × 9" W × 4"
Lent by Jane D'Alelio, Ice House Graphics

63. Mallet, ca. 1920
cherry wood
10" H × 4½" W
Lent by Roger Morigi, Hyattsville, Maryland

64. Model T Crank, ca. 1920
metal
13" L × 9¾" W × 2¼"
Lent by the Office of Folklife Programs, Smithsonian
Institution

65. Pocket Watch, ca. 1950
silver
2" diameter × ¼" thick
Lent by Gen. and Mrs. Ira A. Hunt, Jr., McLean,
Virginia

66. Rolling Pin, 20th century
wood
17″ L × 2¼″ diameter
Lent by Celeste Roy Hufford, Lorton, Virginia

67. Sheet Music, 1918
printed on paper
14″ W × 10½″ L
Lent by Abraham Lass, Flushing, New York

68. Wedding Invitation, 1920
printed on paper
4½″ W × 7″ L
Lent by Gen. and Mrs. Ira A. Hunt, Jr., McLean,
Virginia

69. Wedding Brooch, 1920
cloth, metal
4¼″ L × 1½″ W
Lent by Gen. and Mrs. Ira A. Hunt, Jr., McLean,
Virginia

70. Wooden Top, ca. 1910
wood, paint, cotton string
3″H × 2½″ W
Lent by the National Museum of American History,
Smithsonian Institution

Photo credits for hands: American Folklife Center, Library of Congress, p. 122 (Carl Fleischhauer), topmost p. 126 (Lyntha Scott Eiler), p. 127 (Dennis McDonald); Morton Broffman, p. 124; Rosemary Joyce, p. 121; National Geographic Society, Bruce Dale, bottom p. 126; Smithsonian Institution, p. 125; Tennessee Valley Authority, Robert Kollar, p. 123.

Mary Hufford is a folklife specialist at the American Folklife Center, Library of Congress and is the author of *One Space, Many Places: Folklife and Land Use in New Jersey's Pinelands National Reserve*, and *A Tree Smells Like Peanut Butter: Folk Artists in a City School*, as well as a number of articles on cultural conservation and sense of place.

Marjorie Hunt is a folklife specialist with the Smithsonian Institution's Office of Folklife Programs and is the co-producer and co-director of *The Stone Carvers*, an Academy-Award-winning documentary about traditional stone carvers working on the National Cathedral in Washington, D.C. She is currently completing her Ph.D. dissertation on the stone carvers, and has written articles on traditional craftsmanship and cultural conservation.

Steven Zeitlin is the director of City Lore: The New York Center for Urban Folk Culture. He is the co-author of *A Celebration of American Family Folklore* and the co-producer of *Free Show Tonight*, a documentary about the traveling medicine shows of the 1920s and 1930s.

Barbara Kirshenblatt-Gimblett is chair of the Department of Performance Studies at the Tisch School of the Arts, New York University. Her publications include *Image Before My Eyes: A Photographic History of Jewish Life in Poland, 1864–1939* and *Speech Play: Research and Resources for Studying Linguistic Creativity*. She has written a number of articles on folklore, culture, and aging. Dr. Kirshenblatt-Gimblett is also a research associate at YIVO Institute for Jewish Research and chairperson of the board of City Lore.